Black and White
in Photoshop CS4 and Photoshop Lightroom

Black and White
in Photoshop CS4 and Photoshop Lightroom

A complete integrated workflow solution for creating stunning monochromatic images in Photoshop CS4, Photoshop Lightroom, and beyond

Leslie Alsheimer *and* Bryan O'Neil Hughes

ELSEVIER

AMSTERDAM • BOSTON • HEIDELBERG • LONDON • NEW YORK • OXFORD
PARIS • SAN DIEGO • SAN FRANCISCO • SINGAPORE • SYDNEY • TOKYO
Focal Press is an imprint of Elsevier

Focal Press is an imprint of Elsevier
Linacre House, Jordan Hill, Oxford OX2 8DP, UK
30 Corporate Drive, Suite 400, Burlington, MA 01803, USA

First published 2009

British Library Cataloguing in Publication Data
Alsheimer, Leslie.
 Black and white in Photoshop CS4 and Lightroom : a complete
 integrated workflow solution for creating stunning
 monochromatic images in Photoshop CS4, Photoshop Lightroom,
 and beyond.
 1. Adobe Photoshop. 2. Adobe Photoshop lightroom.
 3. Photography – Digital techniques. 4. Black-and-white
 photography.
 I. Title II. Hughes, Bryan O'Neil.
 770.2'85536-dc22

Library of Congress Control Number: 2009921364

ISBN: 978-0-240-52159-6

For information on all Focal Press publications
visit our website at www.focalpress.com

Printed and bound in China

09 10 11 12 12 11 10 9 8 7 6 5 4 3 2 1

Working together to grow
libraries in developing countries

www.elsevier.com | www.bookaid.org | www.sabre.org

ELSEVIER BOOK AID International Sabre Foundation

Redesign and layout by Leslie Alsheimer, SanteFeDigitalDarkroom.com

CONTENTS

Contents

Contents

COPYRIGHT NOTICE

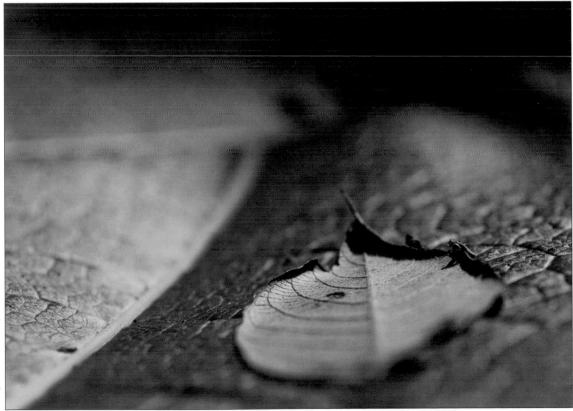

© Bryan O'Neil Hughes

ACKNOWLEDGEMENTS

The first honor, tribute and, my humble gratitude must go to the most significant teachers of my life: the many extraordinary people I have met and photographed around the world – whose faces adorn the pages of this book, my image collections and beyond. Your gracious gifts in shared life moments, friendship, and profound trust for communicating your stories have touched my heart and soul with the most sacred honor of my life. To the NGOs and grassroots humanitarian projects with whom many of the images in this book were made: Soft Power Health, Dr. Jessie Stone, ReachOut, Connect Africa Foundation, Dr. Lynn S. Auerbach, Kalule Charles, Uganda Youth Development Link, Action for Youth Development, Rotary International of Kampala, and Empowerment International, your profound dedication to making a difference in the world will forever be my greatest inspiration!

To all of our readers and workshop friends, thank you for your continued support. It is your interests and passion as fellow photography aficionados that has made this book what it is today. I am grateful for all I have learned from those that I have been fortunate enough to know. I would also like to thank the special people in my life who gave me the support and encouragement to make this book: the entire Alsheimer family – especially my

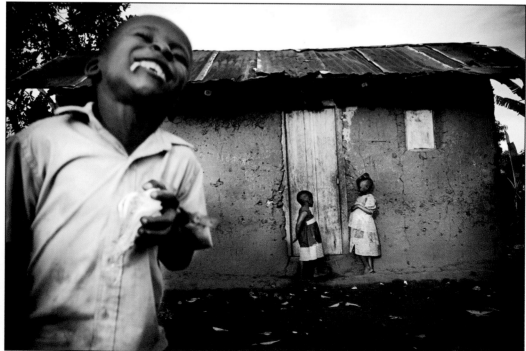

© Leslie Alsheimer

mom, Nancy Alsheimer, Kelly, Colin, Quinn, Connor, Sam and Gracen for being my supermodels, Bryan and Alex Hughes for your initiation efforts, extraordinary expertise and magnanimous dedication, and to Jamie Baldonado who is, and will forever be, my superhero!

Lastly, in loving memory of my father, Col. Robert Alsheimer, a master translator of anything complex. It is some of your gifted ability to simplify and infinite curiosity that led me to become an author and educator. And to my dog Chucho, who graced my life with 15 years by my side down rivers, through snow, up mountains, and at my feet for almost every page of this book. I will miss and love you both always!

Leslie Alsheimer

Together, we would both like to thank all of our friends at Focal Press, especially to Lisa Jones, Ben Denne, Valerie Geary, and our copy-editor Emily Crawford – without whom this book would not have been possible. Above and beyond the call of duty, you have each been extraordinarily helpful, patient and made the process so much more fun!

Leslie & Bryan

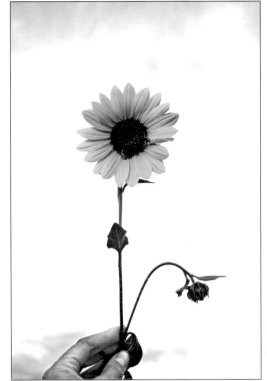

© Leslie Alsheimer

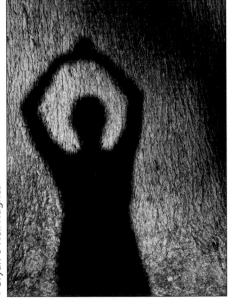

© Bryan O'Neil Hughes

First and foremost, I'd like to thank my lovely wife Alex, I couldn't do half of what I do without her support and understanding. Again, I'd like to salute everyone found in the credits of the Adobe applications discussed within this text, I'm privileged to work with all of you. On a sad note, I'd like to remember and acknowledge Marcus Riess – a friend, colleague, loving father and husband – we all miss you. To Leslie, my co-author, thank you for keeping the bar so high and giving this your all – you continue to impress me with your unique eye and teaching style. Lastly, to my unborn son, I hope you find this world as full of beauty as I do.

Bryan O'Neil Hughes

SALUTATIONS

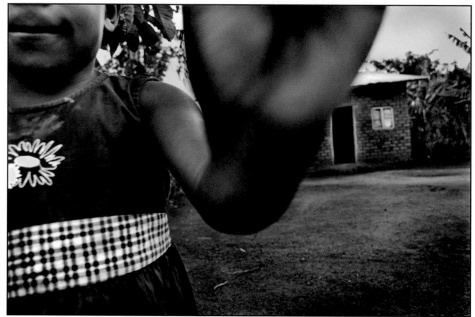

© Leslie Alsheimer

While the digital landscape has become less complex with the latest software releases, I also recognize that I am standing on the shoulders of giants. I salute the Photoshop gurus and divas who navigated the complexities of the digital world before me, who were not only willing, but enthusiastic and passionate enough to pass on their wisdom, knowledge and expertise. Because of their perseverance and dedication, the technology is where it is today. Hats off to all those folks for laying the foundation and paving the way for the rest of us!

Special acknowledgement and appreciation must also go out personally to all of my many mentors who challenged my vision and ignited the passion for the digital world that carried me into my career as a professional photographer and educator. To Katrine Eisman, Julieanne Kost, and Maggie Taylor as the pioneering women of the industry, and my high school photography teacher Karen Jenks, each of whom inspired me with great impetus and will forever be my industry heroines and role models!

Thanks also to Jonathan Singer, Norman Mauskoph, Thatcher Cook, Stephen Johnson, Andrew Rodney, Ed Ranney, Mac Holbert, Jeff Schewe, George DeWolfe, John Paul Caponigro, Jack Davis, Jerry Courvosier, Michael "Nick" Nichols, Dan Burkholder, David Alan Harvey, Sam Abell, Vincent Versace, Reid Callanan, David Lyman, David Julian, Miguel Gandert, and Jay Maisel. Also thanks to my colleagues and friends, Stafford Squire, Genevieve Russell, Randall Gann, Tom Gaukel, Josh Withers, Elizabeth Hightower and Cece Kurtzweg.

FOCUS ON IMAGERY

Thank you for choosing *Black and White in Photoshop CS4 and Photoshop Lightroom*. This book presents a fully integrated, color managed workflow solution designed for the black and white photographer. Black and White photography and its artistry is this book's central focus, not dazzling smoke and mirror software techniques. From the highest quality capture to practical workflow practices, black and white conversion methodologies, non-destructive digital darkroom image processing, creative adjustments, and the latest printing techniques, we have attempted to make this text about the foundation principles and craft of Black and White utilizing the new tools and latest technology. It is our goal to make a book that condenses and simplifies the technology into a format that is user-friendly, informative and hopefully even fun and inspiring.

Software and digital imaging techniques can present a seemingly overwhelming amount of information to take in through textbooks alone, especially if the subject matter is not our full-time job. Most books focused on digital photography and Photoshop have historically taken either an extremely technical or an all-encompassing (usually overwhelming) approach to the subject matter. In contrast, as creative users ourselves with extensive experience as workshop educators, we have uniquely developed and presented information much as we would deliver a workshop. Technical content is condensed and directed specifically toward practical photographic application techniques for the art of creating imagery in the black and white medium.

When teaching many of my workshops, I often ask my students two questions. How many books on digital imaging have they purchased? How many of those books have actually been read? The overwhelming majority own an average of three to four texts, most of which have never been extensively read. For the average user, whether professional or hobbyist, the interest in digital technology is practical. Most users know something about photography already and enjoy making images. How to apply this new technology to existing knowledge and skills without getting lost and inundated tends to be the question of the day.

In this text, we go to great lengths to present concepts as simply as possible. We use metaphor extensively to describe complex topics, in order to make the material more accessible and easier to understand. Most important, however, we have weeded out the majority of superfluous information available in the digital domain and focus on practical and digestible information specific to black and white craft and artistry, utilizing Photoshop CS4 and Lightroom. After all, any book that is too complex, too technical or too overwhelming to actually read will not help to advance your photographic passions through use of this new technology.

Mac vs PC

We have used Mac Key commands in this book. The following is a conversion chart for PC users:

Mac	PC
CMD	CTRL
OPT	ALT
CTRL	Right mouse click
Delete	Backspace

CRAFT, VISION, ARTISTRY
It Is Time to Get Back to Making Images

Whether photography is your profession, your recreation, or just an aspiration, we hope this book will provide a whole new inspiration for making images in the digital world.

Learning and effectively integrating the latest imaging hardware and software is an important step for stimulating new avenues of creativity and, ultimately, for realizing your creative goals. Although the digital age in photography has brought us many great technological advances and a tremendous leap in ease and speed of creative and photographic processes, the technology has also introduced many new challenges for the traditional craft. For many of us – visually adept and technically inept – these challenges have been difficult to surmount.

With the onslaught of a seemingly endless array of choices it is almost impossible not to get caught up in the hype, become overwhelmed, and lose sight of one's photographic goals and passions. Cameras, equipment, computer technology, image manipulation programs, software, hardware, peripherals, and along with them countless books, how-to manuals, guides, tutorials, classes, workshops, training seminars and DVDs – all changing and evolving rapidly and continuously. The industry conveyor belt just keeps moving ahead, either with you or without you. So whether you abandon your traditional roots altogether, embrace the digital world without ever using film, or want to try to integrate the best of the old and the new, at some point most of us will have to get on that conveyor belt and hang on for the ride.

Albeit a dazzling ride, with the latest and greatest in ease and speed, the industry continuously sells us more stuff, more techniques, more lessons, more algorithms, more plug-ins. Each new method, device or manual promises more advanced methods to help you create better pictures, take better pictures – or even more enticingly – to make better pictures *for* you.

Although much of the latest equipment has made astounding improvements to our quality of capture and reproduction, and some of the increasingly difficult techniques are in fact necessary and exciting to master, it is not necessary to conquer every trick available in the digital domain. While learning to use better, faster and more efficient tools, let us not forget that digital photography is more than just digital, it is also photography and goes far beyond the technical.

Photography has never been about techniques alone, but rather about images, visual expression, formal arrangements, intuition, light, shadow, gesture, motion, line, shape, form, texture, composition, time – and above all it is about capturing the essence of a mood, a place, or a moment.

Not just anyone can pick up a plastic toy camera and make a beautiful fine art image. It takes a unique vision intertwining craft and technique with a moment to create interesting work with such rudimentary equipment. For the same reason, all the technology money can buy – the most advanced software, the

© Leslie Alsheimer

finest camera, most expensive lens, or latest, greatest computer on the market does not guarantee a beautiful fine art image. Although the techniques may be easier with more recent expensive gadgets and gear, it still takes an artful eye to skillfully apply craft, technique and technology to create something unique and beautiful. Just as a computer alone did not write this book for us, a computer or camera alone cannot make artful images, nor make our photography better. In my opinion, learning advanced techniques and the many finite nuances of technology to "fix" images can be useful in certain circumstances, but more often than not serves only to stagnate our creative spirit and distract our attention from the mission at hand – making artful images.

Traditional photography students today still study the fundamental principles of the craft first and foremost, utilizing such principles as the Zone System for controlling exposure and highlight and shadow detail in the darkroom. Remember that for many years the masters of traditional photography worked only with manually operated film cameras: focus, ISO/ASA, shutter speed and aperture alone combined to expose the film and control exposure with intention, and a limited variety of chemicals and developing techniques were employed to process prints in the darkroom.

Black and white processes are the roots of the photographic medium, and those roots remind us that simple tools, combined with craft and artistry, have made important and beautiful images for decades. We must be mindful to not get lost in the hubbub of technology. Craft and artistry must guide our technical journey.

It is time in this new digital era to shift our focus back to the photography of the black and white medium. It is also time to revisit our photographic goals and question whether we should be fixing mistakes because we now have the technology to fix them, or capturing our images properly in the first place.

With all the books on the market outlining every possible technique technology can achieve, we decided it was a time for a text that filtered the technology for the sole purpose of making photographs. With highest quality capture and exposure techniques, coupled with an effective non-destructive digital darkroom integrated workflow, you should be free to concentrate again on your photographic vision. Let this book serve as your guide to simplify the technology into a manageable system for image capture and processing. Learn these concepts and techniques as a foundation for your digital darkroom workflow and then tantalize your inner nerd with the more technical variations possible as you learn and grow as a digital user. It is my hope that this text will help you harness your vision and realize your photographic imaging projects with the new tools available – without getting mired in by the technology.

© Leslie Alsheimer

"Photography has not changed since its origin except in its technical aspects, which for me, are not a major concern." ~Henri Cartier-Bresson

"Of course, there will always be those who look only at technique, who ask 'how,' while others of a more curious nature will ask 'why.' Personally, I have always preferred inspiration to information." ~Man Ray

"Black and white photography is like chiseling a diamond – it discards the inessential to reveal the substance". ~Carol Devillers

License to Drive

Put another way, learning about digital technology and new methodologies is similar to the process of learning to drive a car. Knowing about the rules of the road, signalling a turn, how to parallel park and when to stop for the school bus is enough to get a new driver out on the road with a license to drive. The rest of a driver's education is acquired on the road experientially over time, potentially hitting a few curbs and bumpers in the process. Learning how to change a tire, the engine oil or how to jumpstart a dead battery, however, are not license requirements, and whether or not one chooses to learn these skills is optional. Although there is an enormous amount of complex mechanical information buried under the

hood of an automobile that can be extremely useful in a breakdown, a driver can still get to many exciting places with just a license (and maybe an AAA card). The process of learning digital technology is very similar in that much of the more complex information on how and why things work can stay under the hood for the more technically curious and adept to explore when and if they choose. Remember the history of photography, and the many important and stunning images that pre-date digital technology, created with the simplicity of craft, vision and technique alone.

We hope this text will help you learn to drive the technology first, bringing you to fun places in the digital domain where you can play with your images, make mistakes, run into a few curbs, keep from crashing off the road and leave the engine to the mechanics until you have a desire or need for more complex technical information or practices. There are many technical books on the market today written by qualified experts. We do not intend to try and reinvent the wheel, nor replicate information found commonly in other texts. Rather, we hope to provide a practical and integrated color managed workflow – specific to black and white processes – focused and directed towards helping you understand the digital darkroom and its relationship to the traditional darkroom and, hopefully, driving your photographic passions to whole new level.

To that end, we present you with the latest information on Photoshop CS4 and Lightroom, condensed and simplified to focus on the foundations of

© Leslie Alsheimer

© Leslie Alsheimer

© Bryan O'Neil Hughes

the craft using new technology. Hopefully this book will also increase your imaging enjoyment and productivity and fuel your artistic vision. That is what it is all about anyway! Happy image making and best wishes in all your photographic endeavors!

Leslie Alsheimer

Why a New Version of this Book?

Software changes regularly, and for that alone there's always more to say. Beyond a predictable update and "rev" of this text, we also sought to improve upon what we delivered in the first version of this book. In the same way that Adobe listens to customers when building the next version of Photoshop or Lightroom, we combed through your comments from all over the web – from blogs to reviews – to give you more of what you wanted and less of what you didn't. What you find in this updated version reflects not just more text, more instruction and more imagery, but also more focus on your needs and wants.

Thanks to you for all your interest and feedback, and thus helping us create a better book!

Leslie & Bryan

FILM'S PLACE IN A DIGITAL WORLD

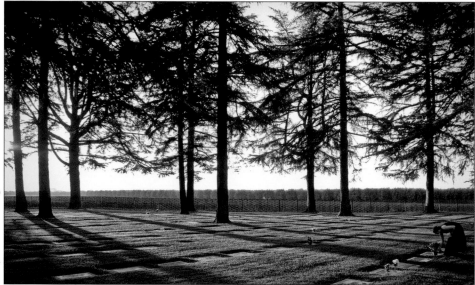

© Bryan O'Neil Hughes

When I first encountered digital cameras (less than one megapixel then) in the mid 1990s, film was an established leader; it took nearly a decade for the gear to rival high-end SLRs, but it happened. I think film faded a bit more quickly because of the cost of processing, lack of immediacy (how impatient we've all grown!) and environmental impact of chemicals used in a silver halide process.

Film lives on much like vinyl does for music, as a semi-retired medium that although full of practical shortcomings is not lacking in charm. Film has a warmth in tone, inconsistency and grain that can be hard to recreate digitally – many purists would say that "film grain is a limitation of film", but I still love the choppiness of TMAX 3200, the ridiculously high contrast of Tech Pan or the ethereal glow of infrared. Later in this book we look at some compelling methods for introducing these characteristics into digital images by way of plug-ins.

While I've wrapped my arms firmly around my DSLR, I recently grew nostalgic for the days when I could throw my trusty (and long since sold) Contax T2 in my pocket and wander foreign cities, snapping grainy black and white images. Thanks to the success of digital cameras, older cameras like my Contax can be had for a fraction of their original cost. Knowing I'd be traveling to Paris and Cologne on business, I impetuously bought one for the trip (as I rationalized to my wife, "for the book").

SEEING IN BLACK AND WHITE

I recall when shooting film that there was a mental shift necessary when I swapped from Velvia to TMAX; shooting in black and white required a different state of mind. Though much has changed in the never-out-of film, instant gratification world of digital, a change of mind is as important as ever.

In color you can have similar tonal values, but completely different colors, and so the two side by side can still create a dramatic image. The same colors in a black and white image simply blend together and appear drab. Looking back again to those distant days of film use, many times I would find myself before a brilliant, colorful sunset, only to realize that I was loaded with black and white film. As a young rookie, I would snap away, insisting that something so beautiful would surely be so with or without the accurate reproduction of color. While a white sun, white clouds and a dark red (almost black) sky helped with the wrong film, my images were never the same.

There are several techniques that can help make compelling images in black and white, many of which lend themselves uniquely to a monochromatic image. What follows are but a few ways to visualize and look for clues to create more impact in your black and white images.

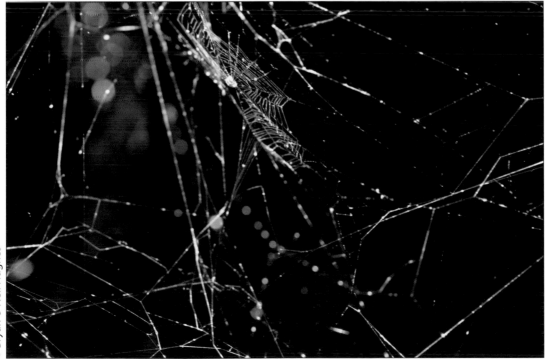

© Bryan O'Neil Hughes

1. *Look for texture*. Whether it is wood grain, sand, skin or hair, texture is just yet another thing that seems to "look better in black and white". Combine a macro lens with good, strong texture and see how much better that color image looks in black and white!

2. *Look for lines*. Lines can break and bisect an image, true, but they can also direct the eye. In a black and white image with strong contrast, lines are so powerful that they can be the sole subject matter.

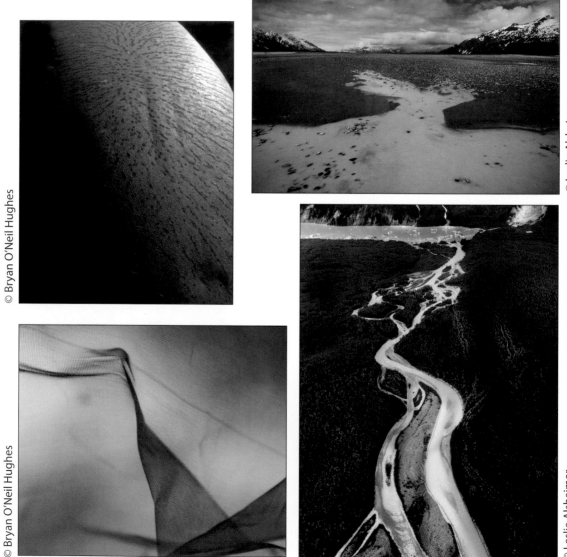

© Bryan O'Neil Hughes

© Bryan O'Neil Hughes

© Leslie Alsheimer

© Leslie Alsheimer

3. *Look for contrast*. Strong tonal differences in a color image can be both busy and confusing; in a monochromatic image, they can pull the eye and define the tone of the shot. Contrast is everything in a stunning black and white shot. Though you can digitally manipulate it after the fact, looking for it ahead of time helps greatly.

4. *Look for shapes*. Bold shapes, curves, edges and details become almost abstract in a black and white image – the same shapes can easily be lost in the splashy rainbow of a like color photo.

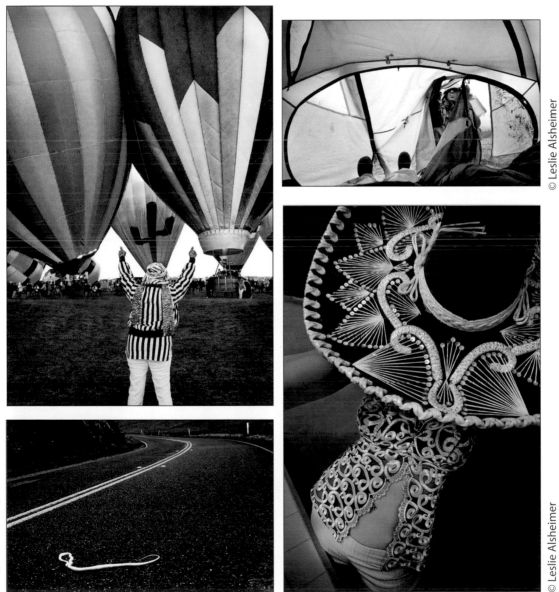

© Leslie Alsheimer

© Bryan O'Neil Hughes

© Leslie Alsheimer

© Leslie Alsheimer

Whether you see in black and white before or after the shot, you will soon find that some shots just lend themselves to the bold, classic tones of the masters.

5. *Look for shadows*. Deep, black shadows; thin, almost invisible, light shadows. The mirror of a subject in a gray mask is always appealing.

6. *Look for patterns*. The same repetitive grain, stitch, row of hedges, sea of brick or set of waves can be noise for your eyes in a color image, but the same in black and white can become mesmerizing.

7. *Look for silhouettes*. A striking outline of a backlit object always appears interesting, and in a black and white image it can be anything from surreal to sinister.

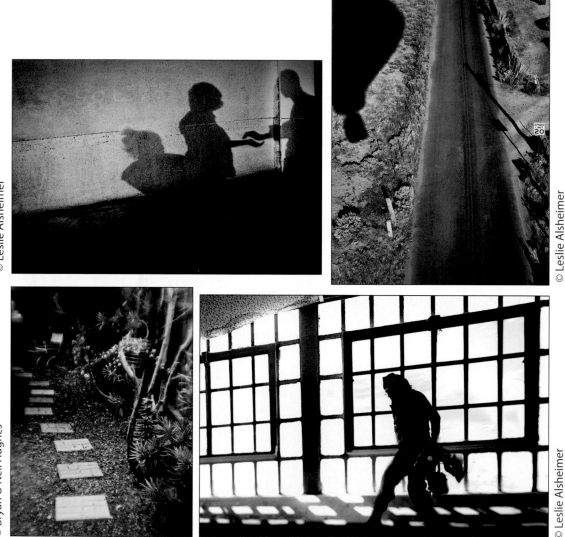

© Leslie Alsheimer

© Leslie Alsheimer

© Bryan O'Neil Hughes

© Leslie Alsheimer

BREAKING THE RULES
Finding Your Own Voice

With the absence of color, the medium of black and white photography is and always will be a unique form of photographic expression, demanding paramount attention to aesthetics. Light, shadow, form and texture coalesce in a confined visual space, communicating the essence of a mood, place, emotion, or a moment with its own special visceral language.

In my early photographic education, I was taught that good photography was about learning and following the formal rules of composition, design and process. These rules were established as proven aesthetic principles to assist in the organization and creation of successful imagery. Without question I thought that a good photographic image must be properly exposed and sharply focused. I knew that composition should fall into the "Rule of Thirds", and the elements of line, shape, form, texture, light and shadow were essential to good design. While it is true that a sharply focused image with a proper range of exposure values, composed with one or more of the standard principles, can indeed be a worthy goal. There are still no guaranteed steps for the successful creation of a stunning photograph, no matter how rigidly one may apply the rules. The serious photographer must be able to recognize when originality and creativity should take precedence over the accepted standards or techniques, and be ready to break the rules with intention.

Compositional guidelines and rules exist as suggestions to assist us in organizing the elements of a scene to safely achieve predictable results on a consistent basis. But predictable results – however technically perfect – produce predictable images. Predictable images will not win awards nor get your photography noticed. Creating a prize-winning photograph necessitates finding an aesthetic to visually represent subject matter in ways that we have never before seen, something that is new and exquisite.

Unfortunately there is no formula for success in creating new and interesting imagery with magical results. The photographic artist must blend an understanding of composition and rules with personal interpretation and even technical experimentation. She, or he, must be willing to try the unusual, and even to risk failure in order to explore new ideas and techniques.

The difference between a good photographer and a great photographer is that the latter continually presses to create images that have not yet been imagined. A good photographer can make successful imagery by emulating images others have created (with slight variances), while a great photographer creates the images that others set out to emulate. "This is the elusive 'voice' of a particular artist, that which identifies Irving Penn or Cartier-Bresson unmistakably. This is rare." ~Michelle Monroe, Monroe Gallery of Photography.

> Over the past 150 or so years, millions upon millions of photographs have been taken.
>
> What makes some images more noteworthy and memorable than others is the unique "voice" of an image or artist.

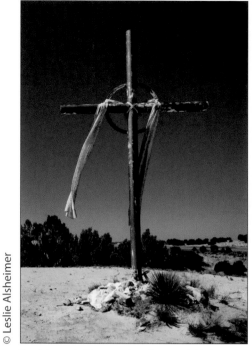

© Leslie Alsheimer

The obvious pedestrian approach can be somewhat boring

© Leslie Alsheimer

Changing perspective and center of interest can add life to the standard hackneyed approach

© Leslie Alsheimer

Shooting from underneath finds added elements of interest

© Leslie Alsheimer

Shooting into the sun, from a low angle, can also make the subject more dynamic and interesting

Finding your own voice is essential in making an artful image, as it is your vision and your voice that has not yet been seen. In order to find your voice you will have to try new things – even if it means failing in the attempt. Experiment, play and be willing to make mistakes. It is that which is uniquely you that creates the poetry in imagery, and it is this poetry, in your voice alone, that will bring you to creating your own personal work. Most people stop short of personal work because it requires deeper exploration, but it is the "personal" in the work that often makes the most profound difference between taking pictures and making images.

When I teach workshops, I encourage my participants to make images that emanate and speak from their hearts and souls as well as their eyes – to create work that truly reveals their signature. In the process of finding a personalized voice however, it will be necessary to decide when to adhere to the guidelines and when to break them – and only you can determine the process. You cannot, however, break or follow the rules unless you know what they are in the first place. As it is the intention of this book to remind readers to remember the artistry of photography, not to teach the fundamentals, I recommend taking some time to learn the history of photography and explore the work of the masters.

"Every artist dips his brush in his own soul, and paints his own nature into his pictures." ~Henry Ward Beecher

"You don't take a photograph, you make it."

~Ansel Adams

"One photo out of focus is a mistake, ten photos out of focus are an experimentation, one hundred photos out of focus are a style."
~Anonymous

"I am still learning."
~Michelangelo

© Leslie Alsheimer

ASSIGNMENT:
Project Refresh

© Leslie Alsheimer

Creativity is really about pushing ourselves. Regardless of how successful or accomplished we may be with our photography, I believe we should always make room to evolve and grow. Everyone gets stuck occasionally, or caught up in patterns emulating the styles of those photographers that we admire, or reproducing imagery we have already seen or created – forgetting the importance of photographing what inspires us. Often times the very formulas we may have found for bringing us successful imagery in the past can stagnate our growth and keep our creative image making from moving forward.

Originality will forever be elusive in the medium of photography, but I believe a passion for innovation will always create new directions, and new directions make exciting work. To energize or re-energize your work, try taking a detour from the style of photography that you usually pursue. This is an assignment to step out of the mold and make images that are not for an art director, not for your portfolio, not for a client, not for impressing your photography teacher/instructor/mentor, not for a grade, not for the walls, not for a show, not for impressing you friends and not for your family album. This is an assignment to make images that are completely and entirely *for* you, and no one else but you.

To begin this assignment, you will want to listen to your instincts and make images from your heart and soul as well as your eyes. It may be very difficult at first, but you will need to try and forget every image you have ever seen – or

made. Try and remember (or imagine) what it felt like to be a child with a camera in your hands. What would you photograph if no one else were looking upon or judging the imagery, if your only concept of a principle was the one that administrates your school, and that principal was not very much fun to encounter. Whether you come up with a preconceived idea, or you just go out and shoot intuitively, the most important part of this assignment is not to tell anyone about your project until you have decided it is finished and, even then, only if you want to.

Project Guidelines

- Commit to the project. Whether you commit for a week, a month, a year, or a lifetime – make a commitment to create a body of work just for yourself.
- Slow down. Stop for extended moments and look around you.
- Look even harder, and keep reminding yourself to slow down and really look.
- Try not to share your project with others until your project is complete.
- If you do share your project with others, it is really important that you do not get discouraged by what anyone else says or thinks – no mater who they are! (Remember that some of the most famous artists in history were once disparaged by others about their work.)
- You don't have to be outrageous, unless you really want to be. Remember that sometimes the simplest notions can be the most unique.
- Try new things, experiment, and make lots of mistakes.
- Keep your "mistakes" and revisit them over and over again.
- Keep editing your work until you are really satisfied.

Submit your project online at www. santafedigitaldarkroom. com. We want to see It!

Visit website for more contest details.

© Leslie Alsheimer

MISTAKES CAN BE MAGIC

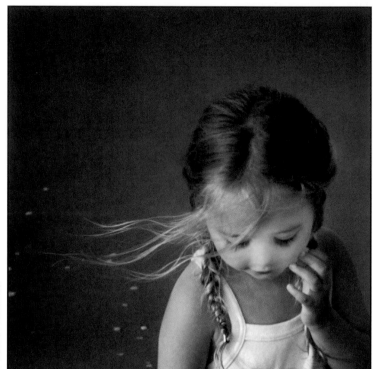

© Leslie Alsheimer

Knowing which images to keep is an extremely important part of the workflow process. One of the biggest discussions in almost all of my workshops is about deleting images in-camera, as I adamantly advocate a "no delete" policy. I think we often make images ahead of ourselves, and the possibility for realizing the artistic value of those images only exists over time. I adopted this policy after learning that one of Ansel Adams' most famous images, "Moonrise over Hernandez", was not actually printed until many years after the image was captured. The sky was extremely blown out in the negative and, if he had discarded the "mistake", he would have never been able to make such a profound and powerful print when his skill in the darkroom caught up with what he saw at the scene.

Sometimes we have a goal in mind when we begin to shoot, like a simple portrait, for example, destined for a brochure or website. During the course of the shoot, perhaps the model lowers her eyes in gesture, or the camera was set on too slow a shutter speed and the model or camera moved swiftly, blurring the image. Often times, we are only able to see within the bounds of the immediate goal of the shoot, and our first impulse may be to delete that image and any other mistakes that happen in the process. The anticipatory creative user, however, resisting the temptation to delete, may later realize that those mistakes have value in a more artistic setting. Gesture, motion and time may all combine to produce an image that is more beautiful and more profound than you were able to see the instant after the shutter snapped.

> "Creativity is allowing yourself to make mistakes; art is knowing which ones to keep."
>
> ~Scott Adams

I continually browse through old images and every time I do I am a different person with fresh eyes, able to see my images in a new and different light. I fortunately decided early on not to delete any images from my camera, and that turned out to be a wonderful gift to myself. Some of my most favorite images began as what, at the time, I thought were mistakes.

Frequently, I reference the words of Scott Adams who said, "Creativity is allowing yourself to make mistakes; art is knowing which ones to keep".

© Leslie Alsheimer

PHOTOSHOP CS4 AND LIGHTROOM:
AN INTEGRATED COLOR MANAGED WORKFLOW SOLUTION

The Quick Reference Chart below maps out the key stages of the color managed workflow outlined in this text.

- Phase 1 highlights the methodologies for the highest quality digital capture.

- Phase 2 covers importing, editing and making global image adjustments in Lightroom.

- Phase 3 integrates the value of Bridge into the workflow for navigation and transference of images into Photoshop for digital darkroom processing.

- Phase 4 explores the multitude of adjustments and conversion methods that can be made in Photoshop and Lightroom through traditional and creative digital darkroom processing techniques.

- Phase 5 walks you through the fundamentals of a color managed printing process.

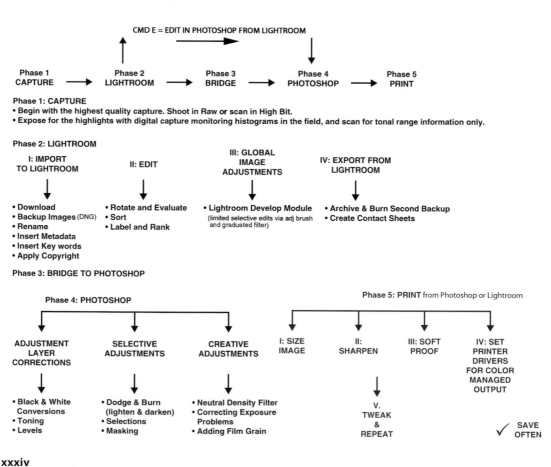

CMD E = EDIT IN PHOTOSHOP FROM LIGHTROOM

| Phase 1 CAPTURE | → | Phase 2 LIGHTROOM | → | Phase 3 BRIDGE | → | Phase 4 PHOTOSHOP | → | Phase 5 PRINT |

Phase 1: CAPTURE
- Begin with the highest quality capture. Shoot in Raw or scan in High Bit.
- Expose for the highlights with digital capture monitoring histograms in the field, and scan for tonal range information only.

Phase 2: LIGHTROOM

I: IMPORT TO LIGHTROOM
- Download
- Backup Images (DNG)
- Rename
- Insert Metadata
- Insert Key words
- Apply Copyright

II: EDIT
- Rotate and Evaluate
- Sort
- Label and Rank

III: GLOBAL IMAGE ADJUSTMENTS
- Lightroom Develop Module (limited selective edits via adj brush and graduated filter)

IV: EXPORT FROM LIGHTROOM
- Archive & Burn Second Backup
- Create Contact Sheets

Phase 3: BRIDGE TO PHOTOSHOP

Phase 4: PHOTOSHOP

ADJUSTMENT LAYER CORRECTIONS
- Black & White Conversions
- Toning
- Levels

SELECTIVE ADJUSTMENTS
- Dodge & Burn (lighten & darken)
- Selections
- Masking

CREATIVE ADJUSTMENTS
- Neutral Density Filter
- Correcting Exposure Problems
- Adding Film Grain

Phase 5: PRINT from Photoshop or Lightroom

I: SIZE IMAGE

II: SHARPEN

V. TWEAK & REPEAT

III: SOFT PROOF

IV: SET PRINTER DRIVERS FOR COLOR MANAGED OUTPUT

✓ SAVE OFTEN

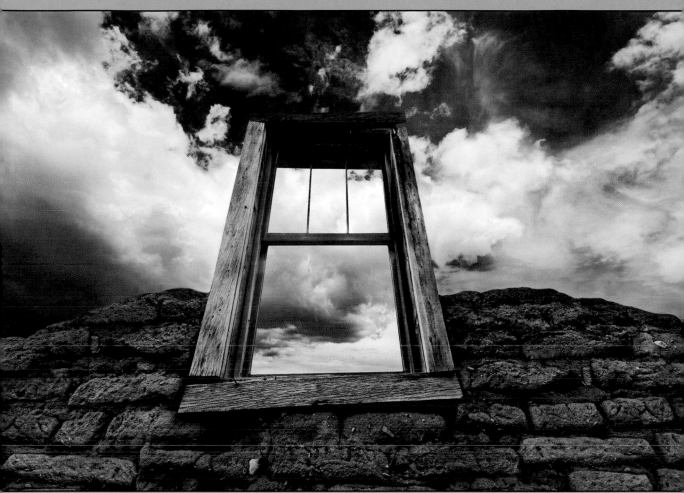

© Leslie Alsheimer

Color Management for Black and White *by Leslie Alsheimer*

Pre-Workflow: Color Management Integration

Color management for black and white, really? Sounds like a serious yawn fest!

Color management is an extremely complex topic and one that has haunted digital photographers since its inception. Most students' eyes glaze over when this topic comes up in my workshops. "Interesting, but a waste of time, not pertinent to black and white, already know it all, and even too technical" are the comments I hear in its wake. Color management was explained to me

several times by several different Photoshop experts before it all integrated effectively into my workflow. As an honor student in my undergraduate studies, as well as my graduate work, I typically do not consider myself particularly stupid, but this color management stuff twisted my head into knots for quite some time. As an experiential learner, I love to jump into new things with both feet and, as a result, I often end up doing things the wrong way first. Although I did have more fun in the beginning of my digital learning process, I eventually learned the hard way that skipping over color management was definitely not the best choice. Color management is without a doubt an absolutely essential piece of the workflow process. Although not the most exciting topic, color management is the foundation upon which everything in the digital darkroom process is built. So whether you work in color or black and white, learning the basics up front will serve you well in the digital process.

Unfortunately for the creative user, color management really is quite complex. There are reasons why there are in-depth, full-length texts devoted entirely to this topic alone. Fortunately, for most users, grasping the entire scope of all the technical information available is not an absolute necessity. For the purposes of this book, I have weeded through all of the technical jargon and simplified the majority of the complexity into five easy steps. These five steps will not only get you in the ball park … but probably all the way to third base with color knowledge in your own personal digital darkroom. The last bit – from third base to the home plate – is the volumes of information within those full-length texts that will either bore you to tears or tantalize your inner nerd beyond comprehension. So, for the sake of making this text user-friendly, I hope to avoid boring you to tears, while leaving the rest to the technical gurus who have already extensively detailed all the finer nuances of this topic. Check out the Digital Dog a.k.a. Andrew Rodney's *Color Management for Photographers: Hands on Techniques for Photoshop Users* published by Focal Press for more in-depth information.

What does color management have to do with Black and White anyway?

It is true that color management for black and white purposes just does not seem quite right. Managing your system for color, however, is actually the truest test for black and white accuracy. If you have a completely accurate color balanced system, you are in a position to produce more neutral black and white prints, make the best possible conversions, and assess contrast and tonality variations within an image. For the traditional photographer, this is the digital equivalent to standardizing development variables in a darkroom workflow: Dektol 1:1 at 68 degrees for example. Understanding what all this is about can actually help you create far better prints than ever before!

The Essential Overview

Color management defined

Color management is basically the ability to consistently control the reproduction of color and tonality in the digital environment; or more

simply, making the print match the image you see on the monitor. A color management system attempts to maintain the "appearance" of consistent color as an image is transferred between different devices, from the camera and/ or scanner, to the monitor and across other monitors, through software and ultimately to an output device such as the printer. We like to stress the term "appearance" of consistent color in our definition because each of these devices (the camera, scanner, monitor and printer) has a uniquely different ability to reproduce and interpret color. We can therefore draw the analogy that each device tends to speak in its own "language" of color. The differences in how each individual device – over the hundreds of makes, models and manufacturers – interprets and "speaks" in color can actually be astounding. In order to resolve these differences, color management creates a system whereby the different devices can "talk" to one another in a common language of color.

Why Do We Need Color Management?

We want color consistency as the image travels through the workflow process across various devices, so we can ultimately make prints that have some resemblance to the image we evaluate and process on the monitor through our digital darkroom practices. For black and white, color consistency is ultimately crucial as the neutrality, brightness, tone, contrast and shadow detail are all functions of the color management system. It is, therefore, extremely important – whether we work in color or black and white – to be relatively certain that what we are looking at on the monitor has some level of numeric accuracy in concurrance with the actual image before we begin the digital darkroom editing process.

Why colors change

All devices have a different and fixed range of colors they are capable of reproducing, dictated by the laws of physics. A monitor cannot reproduce a more saturated red than the red produced by the monitor's red phosphor. A printer cannot reproduce a green more saturated than the printer's green ink. The range of colors a device can reproduce is called color gamut. It is probably easiest to think of gamut as the assortment of crayons a device is able to color or reproduce your image with. Remember the box of Crayolas? The box of 64 crayons with the sharpener in the back had a larger gamut of

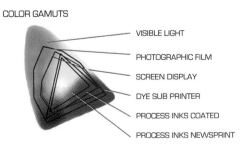

COLOR GAMUTS

— VISIBLE LIGHT

— PHOTOGRAPHIC FILM

— SCREEN DISPLAY

— DYE SUB PRINTER

— PROCESS INKS COATED

— PROCESS INKS NEWSPRINT

color than the boxes of 8, 16 and 32. Burnt sienna, carnation pink and ocean teal provided a much greater gamut for the Crayola artist to work with. It is important to note however that no device can reproduce the full range of colors viewable to human eyes, and no two devices have the same color space/color gamut (or set of crayons to color with).

- The visual spectrum includes 16.7 million colors.
- The human eye can physically see only 12 million colors of those 16.7 million colors.
- The average 4-color press can reproduce only about 70,000 colors.

As an image moves from one device to another, image colors may change because each device interprets color differently. When a color cannot be produced on a device, it is considered to be outside the color gamut of that particular device, or, in other words, simply **out of gamut**. You can view out-of-gamut colors by turning this option on in Photoshop, or when softproofing the image before printing. The out-of-gamut colors, or colors not reproduceable by the ink and paper combination you have chosen for a print, will be displayed with gray as a default, however one can view them in other colors by changing this in the preferences. (See image on page 5 and "Softproof", on page 27 for more information.)

As this is truly an imperfect process, we are really learning to use its strengths to our greatest advantage while simultaneously navigating the weaknesses of the system. It is important to know that it is actually impossible for all the colors viewed on a monitor to be identically matched in a print from a desktop printer. There are many reasons for this. First, a printer operates in a CMYK (cyan, magenta, yellow, black) color space, and a monitor operates in an RGB (Red, Green, Blue) color space, each with entirely different color gamuts. (See "What is a color space?" on page 8 for more information.) Also, some colors produced by printer inks cannot be displayed on a monitor, and some colors that can be displayed on a monitor cannot be reproduced using inks on paper. Paper surface types, such as glossy and matte, also have varying abilities to reproduce color. Further, a monitor produces an image from an illuminated light source, while a print is viewed by reflected light. If the print will never exactly match the monitor, than creating a good print may sound fairly hopeless at this point.

However, this is precisely where the color management system fits in, and why it is so important. Since images come in from many different devices, color management helps you produce more consistent colors by creating **profiles** (or, translators) to correctly transform and resolve color discrepancy as an image travels from one space, or device, to another. This allows devices to speak to one another in the same language of color. Colors in the digital environment are described with a series of numeric values for each corresponding color, and neutral. For example, middle gray can be described numerically in the RGB space as 128 Red, 128 Green, and 128 Blue; similarly a

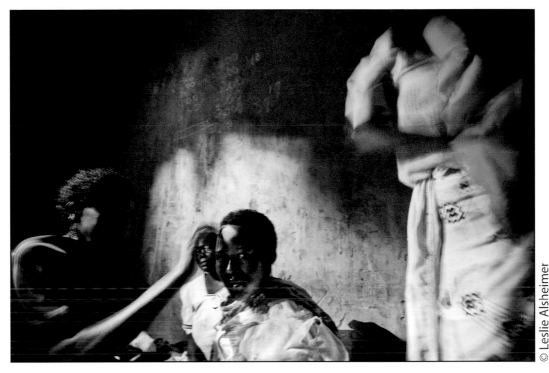

© Leslie Alsheimer

specific tone of red can be identified and matched by its numeric distribution between the red, green and blue values. Different numbers describe a different color.

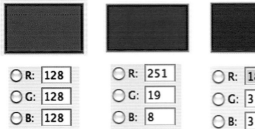

R:	128
G:	128
B:	128

R:	251
G:	19
B:	8

R:	187
G:	3
B:	3

View	Window	Help
Proof Setup		▶
Proof Colors		⌘Y
Gamut Warning		⇧⌘Y

Profiles are embedded into the image data providing a definition of what these color numbers mean in terms of actual colors we can see, and consequently make translations from one device to another. In this translation, the differences in the color spaces of each device are reconciled as much as possible. Precision matches, however, are incredibly difficult because there are inherently different abilities and limitations to reproduce color with each device.

This color interpretation is just like how international policy and issues of world affairs are discussed in the United Nations among ambassadors who speak many different languages. Profiles are the digital equivalent to the translators that interpret the dialogue between ambassadors from one

language to another. Therefore, it is extremely important to know how to set this profile information in your camera or scanner, to create one for your monitor, and learn to use them effectively as the image transfers from capture and editing to the output device (printer, paper and ink sets). If the digital devices that you work with are not tagging your document with profiles, the numbers for color become ambiguous to the devices, and maintaining consistent color in your workflow will ultimately be quite difficult.

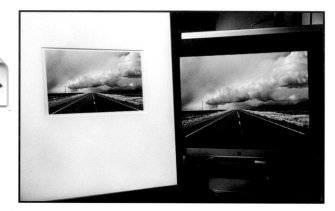

Managing color with profiles

1. *Camera Profile*: Digital cameras capture a wider range of colors than the human eye can see, and the camera's embedded profile determines the colors available to be processed.
2. *Monitor Profile*: Digital cameras also capture a wider range of colors than monitors can display, and the profile associated with the monitor determines what colors are actually displayed.
3. *Printer Profiles*: Digital cameras further capture a wider range of colors than most printers can print, and the profile associated with the printer determines which of the colors presented to it will be printed.

Outline: The Color Managed Workflow

The six basic components to managing color throughout the workflow process

Managing color as well as black and white processes – from film or digital capture to the final output print – is a challenge for even the most sophisticated user. However, before image editing begins there are some relatively painless steps one can take to standardize the process, such as setting up your workspace environment to optimize color consistency, as well as system preferences and software tools to conform to a color managed workflow. These basic steps will aid in maintaining the appearance of consistent color as an image is reproduced on different devices – from capture to the print.

**Keep in mind that the nature of different devices makes exact matches incredibly difficult.

I. Capture
Set camera's color working space or embed scanner profiles.

II. Workspace
Control ambient lighting conditions and working environment.

III. Monitor Control
Calibrate your monitor for color accuracy and consistency over time.

IV. Software Policies
Set Photoshop color management policies and color working spaces in accordance with capture and print output variables.

V. Print Profiling and Printer Settings
Set up the print driver with correct profiles for desired output.

VI. Softproof, Evaluate, Tweak and Repeat
View and evaluate the print under lighting conditions specific to the monitor calibration settings (6500 K for Adobe 1998 and D 50 for Color Match) and re-edit the image accordingly. (See Phase 5 "Print Profiling and Printer Settings," on page 25 for more information.)

I. Capture

Set Up Color Working Spaces

In order to achieve the best possible color from your digital camera, especially the latest pro digital Single Lens Reflex (SLR) cameras, dealing with the concept of color working spaces, both those you choose in the camera and those you use for editing, is a necessity. There are a few choices in the mix to evaluate, but choosing the best one for you will not be that difficult. It is not all that crucial to learn everything there is to know about color spaces in the beginning. To keep matters simple, most users will want to work in **Adobe RGB**, as it serves as the industry standard today, until more sophisticated decisions become necessary. You will have to consult your camera manual in order to establish this setting correctly for your specific camera make and model.

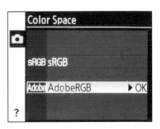

Camera settings: choose a color space
- **Adobe 1998**, also called Adobe RGB, is the current industry standard for most photographic purposes, such as stock submissions.
- **ProPhoto RGB** is a larger space many professionals are turning to, but this choice brings in a few more advanced complications. Also this choice is not available for all cameras.
- **sRGB** is the smallest color space available, and as such, functions best for web work.

What is a color space?

Color spaces define specific boundaries of color within the visual spectrum. A color space is like the box in the crayon analogy: all the colors inside the box are represented in that color space; any colors that are not inside the box are not represented in the space. The colors inside the box are referred to as the color space's color gamut. Effective color management requires that a color profile be attached to every image or graphic to indicate its "native" color conditions – also known as the color space – under which the file was created. Adobe was actually one of the innovators in creating and implementing the concept of a color management system, and introduced the idea of a "working" color space, with the ideal conditions for image reproduction and editing – not specific to any device. A device color space simply describes the range of colors, or gamut, that a camera can see, a printer can print or a monitor can display. Editing color spaces, on the other hand, such as Adobe RGB, sRGB, ProPhoto and Color Match RGB are device-independent. They also determine a color range, as their design allows you to edit images in a controlled, consistent manner.

The differences between the different RGB working spaces are predominantly defined by the color gamut of each space. However, as with many digital topics, there has been some recent debate over which color space is "best" for photographic purposes. The following definitions will outline some of the differences between the color working spaces and overview some of the advantages and disadvantages of each.

Note:
Notice how Adobe RGB extends into richer cyans and greens than does sRGB.

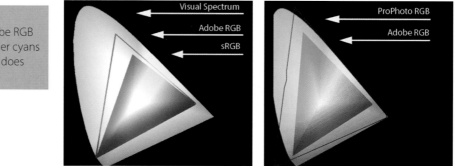

sRGB is the smallest working space. It is ideal for web work as it was developed by HP and Microsoft, to approximate the color space of a typical computer monitor. It therefore serves as a "best guess" for how another person's monitor produces color, and as such has become the standard color space for displaying images on the Internet. The downside of capture in the sRGB space is that most cameras and output devices are capable of producing a much wider gamut, or a lot more colors, than sRGB space contains.

Adobe 1998 (or **Adobe RGB**) was designed by Adobe Systems, Inc. to encompass most of the colors that can be generated by using only RGB primary colors on a device like your monitor. The Adobe RGB working space has been

widely adopted as the industry standard for the print world because it provides a relatively large and balanced color gamut that can be easily repurposed for reproduction on a variety of devices. Most users find that it contains a sufficient gamut for most output needs, while having only a slightly larger gamut than the monitor can display. Further, Adobe RGB improves upon sRGB's gamut significantly in cyan and green values. If your camera offers it, Adobe RGB is an excellent color space choice if your images are destined for the printed page, or both the printed page and the web.

ProPhoto RGB is the largest working space and contains even more colors than Adobe RGB. This space has many advocates, but is not available in all cameras.

Sensors on most high resolution digital cameras produced today are capable of capturing more colors than even the Adobe RGB color space allows. ProPhoto RGB is the only color space that can contain all of the colors digital cameras are capable of producing. At the moment, however, there are no monitors or printers even remotely capable of displaying or outputting the full array of colors ProPhoto RGB is capable of capturing, which therefore creates a large propensity for problems. At some point in the future, however, this may change. Many commercial photographers are starting to adopt this space as a "better" space, as it provides more freedom to grow into more colors as output devices get better.

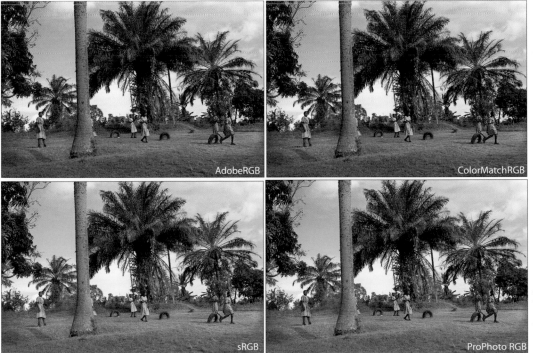

© Leslie Alsheimer

For a more in-depth discussion of color spaces and color management, check out Jeff Schewe and Bruce Fraser's *A Color Managed Raw Workflow – From Camera to Final Print* published on Adobe's website.

ColorMatch RGB. This color space is not an available option on any camera as a capture space, but is an available choice in editing spaces. Its color space is wider than sRGB, but not as broad as Adobe RGB. As a mid-sized editing space, it can often help control oversaturation problems with images captured in Adobe RGB, as well as produce better skin tones. Some fine art printers advocate using this editing space with Piezography black and white printing, coupled with monitor calibration settings at D-50. (See Chapter 8, "Printing", for more information.)

Hopefully, you can see that changing the color space definition of an image changes the appearance of the image altogether. The numbers that describe each pixel in the image are meaningless without a color space associated with those numbers. The color space defines what color is represented by a set of numbers describing an image pixel; it defines, in effect, what the color of the pixel actually looks like. Since achieving the best-looking color (and ultimately best tonality in black and white) is what we are after, selecting the right color space in the camera and in your viewing software is a fundamental step in the process.

Color Space Recommendations
• *Grayscale Capture*: If your camera is capable of capturing in Grayscale, you will want to resist the temptation to choose this setting. Although it may be fast and easy, the results will be fast and easy as well. You get what you pay for, and image capture is no exception. The capabilities you gain with image quality as well as editing and conversion options are far superior with RGB capture and post production conversions.

• *Choose a Color Space Best for You*: If your camera offers a choice of sRGB and Adobe RGB, choose Adobe RGB (if you are interested in learning more about ProPhoto RGB, read Bruce Fraser's *Real World Color Management*). There are some interesting and valid reasons for moving into ProPhoto RGB. One must, however, really understand the complexities of color space, and the advantages and limitations well. The selection of a wider-than-sRGB color space does generally translate into an image with better color, and can be easily converted into smaller spaces. Going the other way, however, such as converting an image originally captured in sRGB to Adobe RGB, does not bring with it the benefits of shooting in a broader color capture mode such as Adobe RGB.

• *Syncronize Capture Color Space with Editing Color Space*: When editing your images, make sure that you set the software to view them in the corresponding color space chosen for capture. For instance, if you capture

an image in Adobe RGB, then you will want your image browser and image editor to display your images in Adobe RGB so that the colors maintain consistency across the devices. (See "Set Up Color Working Spaces," page 7.)

• *Embed scanner profile:* While scanning, be sure to embed the scanner's profiles into the image files so that Photoshop can make accurate conversions. (See Chapter 2, "Scanning Capture: an Overview," page 64.)

II. Workspace: Control Ambient Lighting Conditions and Working Environment

Control ambient lighting conditions

When I first moved out of the darkroom, I was so excited about being in the light that I moved my computer right in front of the biggest window with the best view. Because I skipped my color management lessons, I had no idea why my prints were not quite right. When you are performing color and tonal adjustments to images on screen, it is essential that your digital darkroom lighting conditions be controlled properly. If your computer is set up in front of a big bay window with light pouring in, it would be a good time to invest in a dark shade to pull down during the day. Lots of ambient light hitting and bouncing off the monitor can make your images appear brighter. Also, overhead light and sunlight produce reflections and glare on the monitor which can influence our ability to achieve consistent results. A working environment with consistent ambient, or room light, eliminates uncertain color and tonal results in image evaluation.

Controlled working space

© Bryan O'Neil Hughes

Problematic workspace

Set desktop to solid gray medium

This component is for the Macintosh user only, as the PC sets up Photoshop on a gray screen regardless. For those of you who just love seeing your favorite image from your last surf trip to Mexico or the happy snap of Christmas with the kids displayed while you work, this is going to hurt. Attempting to evaluate images on top of other images is not a very accurate way to evaluate color, nor the neutrality of grayscale images, as our eyes can play tricks on us based on the comparative differences. As illustrated with the color patches to the left, colors from surrounding sources can affect our color vision and influence decisions in the editing process in ways that we may not be aware of.

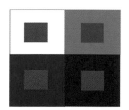

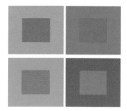

Problematic desktop

Not the best or most effective way to evaluate color or neutrality

Best practice!!!

In order to control this phenomenon, it is best to set your desktop to a neutral gray.

1. Under the Apple Menu choose "System Preferences"

2. Click "Show All"

3. Click "Desktop & Screen Saver"

4. Select "Solid Colors" from the Collection

5. Choose "Solid Gray Medium"

Set monitor resolution and color preference

Under Apple Menu > System Preferences > Displays, set colors to millions. This is also where you can adjust the resolution of the monitor. Depending on the size of your monitor, this number will be different (1152×720 or 1440×900 are recommended).

Under the Display Preferences or Colorsync Preferences, you can also check to make sure the Display profile created from a calibration device is correctly chosen.

III. Monitor Control

Calibrate your monitor and change settings

Have you ever been to the home electronics store and noticed how every television set displays the same broadcasted information differently? While one set's display may look a little magenta compared to another with a lighter more cyan appearance, we would probably be most inclined to pick the one that looks the best and most pleasing to our eyes. Computer monitors are exactly the same in that each and every monitor right out of the box will display the same data differently. Monitors will age over time, and colors tend to shift with usage. Without several monitors in our home side by side how do we know if our monitor might be the slightly magenta one, or the lighter one with a more cyan cast? Although the side by side comparison for the most pleasing display may work fine for the television, it is important that what we see on our monitor is relatively accurate if we ultimately want our prints to match what we see on the monitor. If the monitor is not calibrated, or the calibration is inaccurate, we can end up making changes to data based on a false interpretation of the colors presented on the display, and, ultimately, maintaining consistent color results as the document crosses through different devices will be difficult at best.

In order to control the monitor output most accurately for color consistency, it needs to be calibrated. When you calibrate your monitor, a profile is created to adjust the behavior of the monitor so it conforms to known color specifications, and describes how the numeric color values in an image must be converted so that colors are displayed accurately on screen. Calibration neutralizes any color casts the monitor displays, and adjusts its gamma (brightness of the midtones) to set black and white points for accurate color

© Leslie Alsheimer

viewing. All monitors not only display color differently like the TV sets, they also vary their color output display over time as they age, just as a light bulb, or enlarger bulb, will dim with use. Calibration, therefore, also keeps monitors operating in a stable way and returns the display to an accurate and known value.

How do I calibrate?

To calibrate and profile your monitor, you can use visual calibrators like Adobe Gamma as a starter; however, these are not highly recommended as they rely on the human eye and one's perception of color, which is inherently inaccurate by nature. The best method is to use third-party software and measuring devices for more accurate results. There are many devices on the market today at many different price points. The devices are always packaged with their corresponding software as well as instructions on how to use them. Typically, the software has a "wizard" or instructional feature to guide you through the process with ease.

The hardware calibration device affixes to the monitor and reads patches of color generated on screen by the software in order to create a profile that "fingerprints" the monitor. The software will typically prompt the user to make a few adjustments in brightness and contrast during the process. The profile created then tells other applications (like Photoshop) how to convert or translate the color settings embedded from the capture device so that the image is displayed accurately on the monitor.

How often should I calibrate?

Just as you may want to change the oil in your vehicle every 3000 miles, or wax and edge your skis to maximize their optimum performance periodically, a monitor needs the same kind of regular tune-ups and care to perform well over time.

- Monitors should be calibrated every 2–4 weeks depending on the amount of usage.
- For the most accurate results, be sure to let the monitor warm up for at least 30 minutes in order to stabilize before calibration is performed.
- Periodic calibration will help maintain consistent color display on the monitor over time.

Settings for calibration will vary depending on your output. If you are working in your own closed loop system – that is your own camera, printer and monitor – our best recommendation for most users would be to work with daylight settings, 6500 K and Gamma 2.2 as a starting point. This setting is usually best for working with Adobe 1998. If working with Piezography inks, results have often been more accurate using a D-50 or 5000 K calibration setting. You will need to experiment to find the best settings consistent with your workflow and output variables.

IV. Software Policies

Set Photoshop color management policies and color working spaces

The next step in our color management system is to set up the software color policies to interpret the color information correctly on your calibrated monitor! Just like the choices we have in setting the digital camera to a specific color capture space, we will want to set Photoshop policies to match the camera capture settings.

There are very few image browsers that offer control over the viewing color space. Instead, most software applications can only display the images in the color space of the operating system. In Windows XP, as well as most older versions of Windows, that would be sRGB (remember that is the smallest working space, which is not recommended for print reproduction work). Images captured in the Adobe RGB working space will appear on screen somewhat flat and desaturated when (incorrectly) viewed in sRGB.

Photoshop is, however, an incredibly color savvy software that offers the best environment in which we can view Adobe RGB images, ProPhoto RGB, or images defined by any other color space. You can, with accurate color display for each space, simultaneously view an sRGB image in a side by side comparison with an Adobe RGB image.

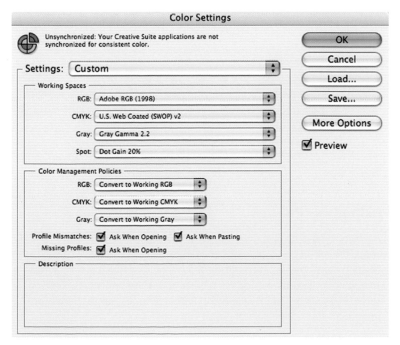

Photoshop default color working space and default color policies. Notice the RGB is set to sRGB

Photoshop color working space for Digital Darkroom print reproduction with inkjet printers

To specify color settings in Mac OS, choose Edit Menu > Color Settings and in Windows choose Photoshop Menu > Color Settings to bring up the Color Settings dialog box in Photoshop. This dialog box is the single most important place where color management information is gathered and controlled – one box, one convenient location. As incredibly color savvy as Photoshop is, however, it unfortunately ships out to users set with sRGB as the default working space, which is not the most ideal setting for print-oriented photographers. It is therefore necessary to make some changes in color setting policies before image editing begins.

Photoshop Color Management Policies and the Editing Color Working Space

Color management policies are simply a set of rules defining protocol for opening files into Photoshop with or without embedded profiles. The color working space specifies what colors (brightness and hues) will be available when working in Photoshop. Whichever color working space you choose to work in directly effects how many colors you will be able to see on your monitor and potentially reproduce in the print. The color space choices for image editing in Photoshop are Adobe RGB (1998), ProPhoto RGB, ColorMatch and sRGB. (See "Set Up Color Working Spaces", page 7 for definitions.)

Working Gray Policies

Grayscale does have its own governing profiles independent of RGB or CMYK. However, it is important to note that the grayscale profiles do not contain any information about the papers nor the color of the inks, which are all factors in creating neutral values in producing black and white prints with desktop printers. (See Phase 5 "Print Profiling and Printer Settings", page 25 for more information.)

The Gray working space determines how a grayscale image will look on your monitor. Within the Grayscale working space, we have access to gamma settings, dot gain curves and the ColorSync Gray Working Space (Mac only) as well as the ability to customize the dot gain to specific requirements.

1. Gamma settings define the brightness of the midtone values on screen. The choices of gamma settings enable you to base the display quality equivalent to either a Macintosh (1.8) or PC (2.2) monitor, although there is evidence that all monitors have become 2.2 these days, whether they are Mac or PC.
 Gray Gamma 2.2 is probably the best for most users, but feel free to experiment. This setting anticipates the viewing conditions of a PC monitor (important for web graphics), and the darkening is roughly equivalent to a 25% dot gain setting.

2. The dot gain settings, choices of either 10%, 15%, 20% or 30%, depend on your printing conditions. The dot gain settings darken the on-screen image, effectively anticipating the effect of the ink dot gain (or spread) during on-press reproduction.
 (To set your own dot gain profile, choose "Custom" from the top of the pop-up.) Note that these values only lighten or darken the appearance of an image, while the actual output values are not affected.

If you are outputting primarily to inkjet printers, matching the Gray working space to the RGB color space is a good move. Simply translated, if you are working in Adobe RGB or sRGB, use Gamma 2.2. If you are working in ProPhoto RGB or Colormatch RGB, choose 1.8. This prevents any additional gamma adjustments as we switch back and forth between color and grayscale images.

If you work in a prepress environment, it is best to match the grayscale space to the dot gain of the black ink. North American Prepess 2 setting presets will create this match. However, it is always wise to consult your service provider for customized settings in accordance with press specifications.

CMYK Working Space

Desktop inkjet printers from most of the major manufacturers (like Epson, HP and Canon) actually require RGB data rather than CMYK data to produce prints, even though these printers operate in a CMYK working space. What this means to the average user is that the choice you make for CMYK settings will have no influence in the actual image output (to an inkjet printer). Therefore, the CMYK settings are better left to the default U.S. Web Coated (SWOP) v2 until you need to work with offset press. As press settings vary considerably, and getting accurate color or neutrality on press is incredibly difficult, you will need to consult your service provider for the best conversion settings according to the specifications of the printer and output variables (and pray you get to work with someone who actually knows what they are doing).

CMYK working spaces are essentially printing processes characterized by various ink-and-paper combinations, dot gain settings and separation options such as ink limits. If you have a custom press profile, you would select it as your CMYK working space. When you perform a mode change to or from CMYK, Photoshop will use the CMYK working space profile for the conversion. Photoshop will also use the CMYK working space profile when you open a CMYK image that lacks an embedded profile.

If you need to convert images to CMYK but do not have a custom press profile, and one is not available from your printer, you will have to select one of the profiles provided by Adobe, basing the selection on the type of printing process and paper that will be used, such as U.S. Web Coated (SWOP) v2. The results however, will unfortunately be fairly disappointing.

As with RGB working spaces, Photoshop provides the ability to create custom CMYK working space profiles. This is useful if your print provider does not have a profile but can tell you what separation settings to use when converting your images to CMYK. Good luck!

Spot Working Space

The Spot working space is somewhat similar to the grayscale space, but for spot colors. The options available are a series of five preset dot gain settings and the means for customizing the dot gain curve if desired. The Spot working space provides a setting for spot colors, such as Pantone colors, that may be

used in the printing process. Similar to CMYK settings, spot settings are the most crucial when working with offset press and depend on ink and paper combinations to be determined. Leave this setting unchanged at the default until press specifications require otherwise.

Spot: Dot Gain 20%

 Dot Gain 10%
 Dot Gain 15%
✓ Dot Gain 20%
 Dot Gain 25%
 Dot Gain 30%

Color Management Policies

Color management policies therefore determine how to handle documents that do not match your chosen color working space. These policies provide guidelines for how Photoshop should proceed when a document is opened and color data is imported into an active document with color spaces that do not match the set policies. With specified predefined color management settings, Photoshop can proceed within the user defined color management workflow as standard protocol for all documents and color data that you

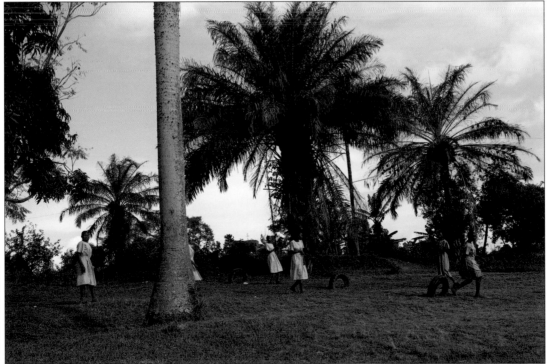

© Leslie Alsheimer

open or import. These color management policies look for the color profile associated with a document or imported color data, and compare the profile (or lack of profile) with the current editing working space settings in order to make default color management decisions for conversion and color display. If the profile is missing or does not match the working space, Photoshop displays a warning message that indicates the default action for the policy (as long as the alert option is selected in the color settings). For a newly created document, the color workflow usually operates behind the scenes; unless otherwise specified, the document uses the working space profile associated with its color mode for creating and editing colors.

In this text, we are going to set the color management policies to convert all incoming documents to the specified working space. This simply means the active radial button will be automatically preset to "Convert to the Working space". However, you will always be able to choose otherwise.

Profile mismatches

If you are presented with an "Embedded Profile Mismatch" dialog when you open an image, this means that the image was captured or created in a different working space than your chosen working space policies. This warning dialog is how you tell Photoshop to proceed with opening the document. Your choices are the following: (1) Use the embedded profile (instead of the working space), (2) Convert document's colors to the working space, and

(3) Discard the embedded profile (do not color manage). In most instances, it is best to go ahead and convert everything over to your set working space in order to simplify and standardize your workflow, unless of course there is reason to keep the image in the space in which it was created.

It is important to note that the optimum color space will not always be a match for what you set in the camera. With midtone heavy and/or overly saturated Adobe RGB images captured from the D1X and EOS-1D, for example, assigning the ColorMatch RGB color space often offers a more realistic and pleasing color translation with problem images.

Missing profile

This warning dialog box is not a good one to receive. This means that the document file does not have any profiles or translators to convey information about the color of the image. Photoshop will not know where this file came from, nor how to translate its color information accurately. Photoshop can do a darn good job at guessing, but that is akin to me giving a blank piece of 4×5 film to my students and asking them to shoot the image and process it in the chemical darkroom without knowing its ISO or film type. It would be fairly difficult for even a well-seasoned pro to render a good exposure and development time with virtually no information about the film. In this case the profile will need to be assigned. If you know that the image came from an sRGB space, for example, you would first assign sRGB, or the known space, and then convert to the working space. If the incoming source is unknown, assign the working RGB and move on from there.

How to set: Photoshop color management policies

Setting up your Photoshop color management policies and preferences is absolutely essential before you begin working in Photoshop. Remember, these are the settings that specify the handling of color profiles associated with the RGB, CMYK and Grayscale color modes in every document. This means that the color management settings affect how images are displayed on screen, and how Photoshop operates color separations. These profiles are known as working spaces. Being aware of your color settings and image

profiles will help you produce consistent color results for the most common on-screen and print output conditions.

Edit Menu > **Color Settings** You may choose a preset color management configuration from the settings menu or customize one of your own. Adobe sets the default workspace for web work, which is far too limiting for print output with high quality photographs. We are going to create custom settings for print output.

RGB > **Adobe RGB (1998)** is today's industry standard. This space is best for RGB print production work. You may want to research ProPhoto RGB for details on whether it might work for you.

Color Match > this space can be an excellent choice when working with offset press and converting to CMYK. It is also recommended for working with Piezography ink sets.

sRGB > is an excellent choice for images destined for the web.

Custom setting configurations can be saved and renamed.

Choose RGB working space in accordance with workflow and output variables. Adobe RGB (1998) is a good choice for most users doing print production work.

Save custom configuration with personalized title and description.

Gray policy. For most users 2.2 is an excellent choice.

Color Management Policies standardize working space protocol and activates alert system for mismatches.

Save and Name

It is important to save your custom settings so that they can be reused and shared with other Adobe applications that use the same color management workflows, as well as with other users. The color management settings that you customize in the Color Settings dialog box are contained in a preferences file called Color Settings.

Comment

Enter your own description of the settings you created for future reference.

V. Print Profiling and Printer Settings

Set up the print driver with correct profiles for output

Once a color space tagged image makes it from the camera (or scanner) and passes onto a calibrated monitor, and is edited through Photoshop and Lightroom, the next step is to pass the image out through the printer onto paper or other surfaces. This phase of the workflow requires a print profile. A print profile tells the printer how to translate and convert the colors from the monitor so that the image outputs correctly onto the paper. This translation is specified according to the type of printer, paper, surface and ink the image will be output onto. Every paper, however, will require a different profile because every paper, ink, printer combination has a different color gamut, or ability to reproduce colors. For instance, glossy papers have the ability to produce more saturated colors than matte surfaces. Most printers come with a number of common paper profiles installed with their drivers. These "canned" profiles are a great start in facilitating the monitor to print color translation. At some point, however, you might want to invest in custom profiles, made specifically for your printer, paper and ink combinations. Custom profiles can be purchased online at an exceptional price from Santa Fe Camera's online store: www.santafecameracenter.com or call (866) 922-6372 for more information.

Because every paper, ink and printer combination requires a different profile, and the print settings in both the Photoshop and Printer dialog boxes are neither simple nor user-friendly, many common mistakes inevitably happen. If the print driver options are not set correctly, using the correct profile, it will be difficult to even come close to replicating the image you see on your monitor

to the output print. See Chapter 8, "Printing", for more in-depth step-by-steps on print profiles and printer driver settings.

Output and Media Considerations

Another significantly influential piece of the color reproduction puzzle involves the variable gamuts of chosen media surfaces. Glossy surface papers tend to have a much larger reproduction gamut than do matte and fine art surface papers. Larger gamuts allow for more saturated and richer color and black reproduction. It is often a difficult sacrifice for a photographer to lose color saturation in order to work with textured fine art papers. But if saturation is the look you are after, you may get the best results moving to glossy surface papers. Notice the difference in the color output reproduction gamut between Epson Matte and Semigloss papers.

Softproof, Evaluate, Tweak and Repeat

As we are limited by the boundaries of the laws of physics, the final component of both the print workflow and the color management system is the softproof, tweak and repeat system we apply in order to resolve the remaining differences in color and output consistency. The process of softproofing and tweaking is the final phase of practice that brings an image from the third base to the home plate in the otherwise nerdy tech speak world for achieving color accuracy within the system.

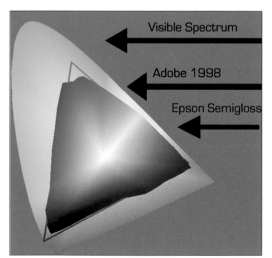

Glossy papers have a larger gamut than matte surfaces

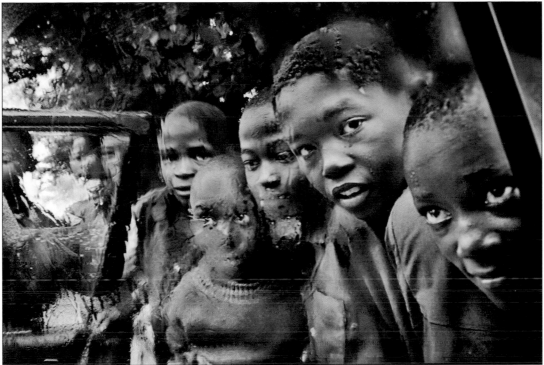

© Leslie Alsheimer

Softproof

This is a technique to simulate on your monitor what your image will look like when it is printed, before actually printing the image. This offers you a "reality check", or the ability to view the physical differences between what is displayed on the monitor and how the image colors will translate on to the chosen paper with the applied profile. Photoshop CS4 incorporates softproofing into the print dialog interface with match print colors, show paper white, and gamut warning previews. Keep in mind, however, that the reliability of the softproof depends upon the quality of the monitor, as well as the monitor profiles, and the ambient lighting conditions of your work environment. Softproofing can also be simulated full-screen under the View Menu > Show all Menu Items, View > Proof Setup > Custom. (See Chapter 8, "Printing", page 249 for more information.)

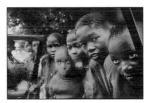

Softproof for Epson Matte paper MK ink

Evaluate

As various lighting sources have distinctive differences in color temperature, it is important to be sure to evaluate prints under the same lighting source as they are intended to be displayed under. The kitchen fluorescent or office floor lamp will have a distinctively different influence on color interpretation than daylight or a D-50 gallery flood light. Be sure to evaluate prints under

the correct lighting source; try using a viewing booth in order to eliminate discrepancies and maintain more color evaluation accuracy.

Tweak – making digital darkroom adjustments based on output results

This editing component is the heart and soul of color management and the print making process. Tweaking is truly the "art" of the fine art print. The process of tweaking occurs after you have followed all of the previous steps and suggestions in the color management workflow, and your print still does not exactly match what you see on the monitor. Just as your first print in the traditional darkroom provided the visual feedback to drive any number of refined re-prints, the digital darkroom is no different. Tweaking is the process of making corrections again and again until you are happy with the translation of the image onto the output surface. This is the test print phase of the workflow. (See Chapter 8, "Printing", page 249 for more information.)

Now wake up! The rest will be much more fun I promise!

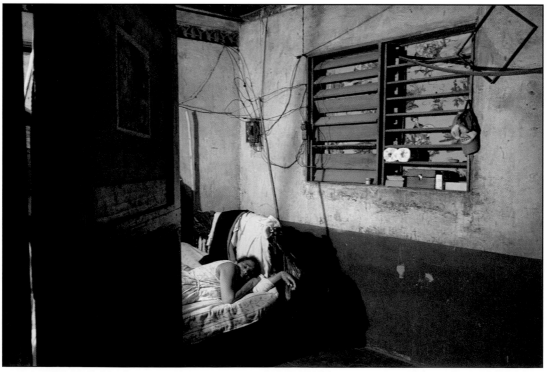

© Leslie Alsheimer

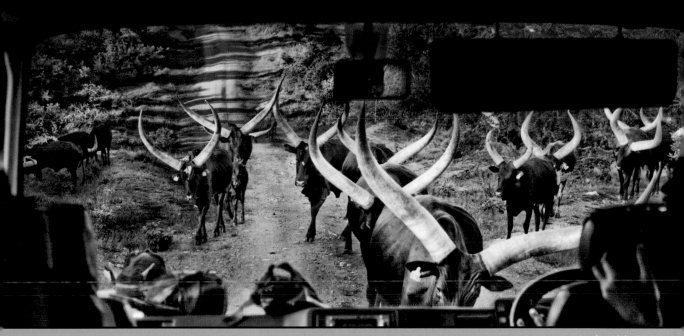

© Leslie Alsheimer

Highest Quality Capture: Workflow Phase I

by Leslie Alsheimer, with contribution by Bryan O'Neil Hughes

T he best black and white workflow practices begin with the highest quality images and a non-destructive editing philosophy. Many of the masters of traditional photography focused on the craft of working with light in-camera, and rarely, if ever, manipulated images. Just as the quality of exposure affected the quality of darkroom prints, one of the greatest factors in determining the quality of digital prints is the integrity of the originating pixels. Therefore, as the first phase of the digital workflow process, this chapter outlines the most important components of capture for acquiring the highest quality images possible.

I. Capture in Color

As outlined in Chapter 1, if your camera is capable of capturing in a Grayscale mode, you will want to resist the temptation to choose this setting. Although it may seem fast and easy, the results will be fast and easy as well. You get what you pay for, and image capture is no exception. For the highest quality capture, the capabilities you gain with image quality, as well as editing and conversion options, are far superior with RGB capture and post production conversions.

II. Digital Capture File Formats
JPEG vs. Raw Capture

Those of you with digital SLRs or high-end point-and-shoots have a choice when it comes to the file format that your camera writes: JPEG (the world and web standard for photographic imagery) and raw (a proprietary, unprocessed, "negative" of your image file). As raw files are exponentially larger than JPEG files, many users find they can "buy" three to four JPEGs for the cost of one raw file, and thus never bother to explore the many advantages raw capture has to offer. The raw format does have significantly powerful advantages and those not (yet) shooting raw should consider all of the following benefits.

Raw files are larger, but they are also uncompressed, high bit depth unaltered originals. This means many things as you bring them into your imaging application: first, you have the best image fidelity that your camera can muster, the greatest amount of capture information, and the most control over image processing. Further, the raw format maps to the image settings applied at capture, and every subsequent editing change applied in processing, sits alongside the raw file as an external reference component associated with each image file. Since changes and edits are not applied directly to the raw image file, all raw processing adjustments are completely non-destructive and infinitely editable.

Although programs like Adobe Camera Raw and Lightroom can now read JPEGs, the application of controls such as "temperature" and "exposure" are hacked into the JPEG file artificially.

While a raw file contains the unprocessed and uncompressed image data captured by the digital camera sensor, images captured in JPEG format are compressed in the camera in order to make them smaller. This compression process, known as lossy, is extremely destructive to image data. Artifacts can easily be seen in magnified viewing on screen. In addition, both JPEG and TIFF formats process the image data in-camera, manipulating the image data by adding adjustments to all images unilaterally such as contrast and saturation. For this reason, JPEG files tend to look much better initially, but remove a great deal of control over image processing. JPEGs also freeze applied capture criteria and bake the settings into the pixels which, unlike raw, cannot be undone. JPEGs can be extremely useful and beneficial if memory is essential, if the number of images you can capture on a card must be increased, if general pre-processing speed outweighs custom image processing, or if images are destined for the web.

Keep in mind, however, that quality is significantly compromised in the exchange. Best practice therefore is to use JPEGs when resolution and image control are not as important, and use raw for everything else!

Digital Negative (or DNG) Format

Most camera manufacturers have created and maintain their own unique proprietary formats for raw image files, differentiated by unique file extensions. For example, NEF defines a Nikon raw file and CRW defines a Canon Raw File. As for CS4, Adobe Photoshop (via Camera Raw 5.0) and Photoshop Lightroom 2.0 support over 200 unique, proprietary raw camera formats. But with the rapid advancement of technology, it is not safe to assume that the camera companies that make each format will continue to support them once they become outdated. The proprietary files that can be converted with manufacturer's solutions now are not likely to be supported years down the road, and will certainly never be archival enough to last a lifetime. Furthermore, they presume that someone else that might want to read them will have the same camera and software!

For this reason, and with an eye toward the long-term future, Adobe proposed a universal, free specification format called DNG. The DNG format has the advantages of being future-proof publicly available, free of cost and, in classic Adobe style, it even compresses the footprint of the characteristically large raw files (lossless, of course).

Unlike a proprietary raw file which stores settings in an accompanying "sidecar" text file, a DNG encapsulates those settings in the file itself – so there's no worry about separating the image from the instructions that tell it what it looks like. An additional advantage of the DNG format is that it enables the user to read new camera formats in older software via DNG conversion (drag and drop converter).

While several major companies such as Leica and Hasselblad have written to DNG natively, any file can be converted easily to DNG with any of the following methods:

• DNG drag and drop converter

DNG = Digital Negative Universal Raw format created by Adobe

- Camera Raw

Save Options

Destination: Save in New Location

Select Folder... /Users/bhughes/Desktop/

Save
Cancel

File Naming
Example: IMG_7958.dng

Document Name +

+

Begin Numbering:

File Extension: .dng

Format: Digital Negative

☑ Compressed (lossless) JPEG Preview: Medium Size
☐ Convert to Linear Image
☐ Embed Original Raw File

- Bridge CS4 via the Photo Downloader

Adobe Bridge CS4 – Photo Downloader

Source
Get Photos from:
<None Detected>
No Device Found

Import Settings
Location: /.../Pictures/[Shot Date] Choose...
Create Subfolder(s): Shot Date (yyyymmdd)

Rename Files: Do not rename files
 +
Example:
☐ Preserve Current Filename in XMP

☑ Open Adobe Bridge
☑ Convert To DNG Settings...
☐ Delete Original Files
☐ Save Copies to:
 /.../Pictures Choose...

Export

Preset: Export one selected photo to:
▷ Lightroom Presets
▷ User Presets Files on Disk

▼ Export Location
 Export To: Specific folder
 Folder: /Users/bryanhughes/Desktop Choose...
 ☐ Put in Subfolder:
 ☐ Add to This Catalog ☐ Stack with Original
 Existing Files: Ask what to do

▼ File Naming
 Template: Custom Name – Sequence
 Custom Text: jdi Start Number: 1
 Example: jdi–1.jpg

▼ File Settings
 Format: JPEG Quality: _____ 100
 Color Space: sRGB

▼ Image Sizing
 ☑ Resize to Fit: Width & Height ☐ Don't Enlarge
 W: 1000 H: 1000 pixels Resolution: 240 pixels per inch

▼ Output Sharpening
 ☐ Sharpen For: Screen Amount: Standard

▼ Metadata
 ☐ Minimize Embedded Metadata
 ☐ Write Keywords as Lightroom Hierarchy
 ☐ Add Copyright Watermark

▼ Post-Processing
 After Export: Do nothing
 Application: Choose an application... Choose...

Add Remove

Plug-in Manager... Cancel Export

- Lightroom 2.0

Import Photos

4 photos, taken from Nov 28, 2004 to Mar 24, 2006 Preview

File Handling: Add photos to catalog without moving

☑ Hughes Portfolio Images 4

☐ Don't re-import suspected duplicates

Information to Apply
Develop Settings: None
Metadata: None
Keywords: Lightroom Samples, Black and White, Santa Fe, New Mexico
Initial Previews: 1:1

☑ Show Preview Cancel Import

Image Quality

- NEF (RAW)+JPEG Fine
- NEF (RAW)+JPEG Normal
- NEF (RAW)+JPEG Basic
- NEF (RAW) ▶ OK
- JPEG Fine
- JPEG Normal
- ? JPEG Basic

File Formats: Quick Reference

Raw:

Advantages:
- Highest image quality available
- High bit data maximizes capture to include the greatest amount of image data possible
- Less destructive editing
- Image files are uncompressed and unprocessed. Image processing versatility and flexibility far exceed all other file types
- Faster capture rate than TIFF

Disadvantages:
- Large files
- Less images on card
- Requires raw conversion process
- Storage

JPEG:

Advantages:
- Smaller files more images per card
- Best email format
- Pre-processed to look better initially
- Universally recognized file format that can be managed by almost every software type

Disadvantages:
- Image files are compressed to become smaller unwanted artifacts in images that reflect compression process
- 8-bit capture does not maximize data therefore less image information captured
- More destructive editing pre-processed for contrast and saturation

TIFF:

Advantages:
- High quality image files (high bit image data)
- Uncompressed images
- No compression artifacts
- Highly functional file that can be managed by almost every software type
- No conversions necessary

Disadvantages:
- Largest file
- Less images on card
- Slower capture rate
- Storage

III. Bit Depth: The Advantage of High Bit Capture

Bit depth, also called pixel depth or color depth, measures how much color information is available to display or print each pixel in an image. Greater bit depth (more bits of information per pixel) means more available colors and more accurate color representation in the digital image.

For the technically curious, the explanation of bit depth requires some complicated math. For the less technically adept, however, all you really need to know is that more bits are more better! Working in high bit provides exponentially more information within the image file.

Fundamentally speaking, a pixel with a bit depth of 1 has two possible values: black and white, it can be 1 or 0, on or off.

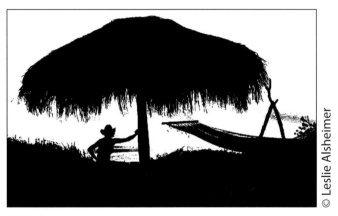

© Leslie Alsheimer

2-bit image

8-bit image with same editing results in banding and posterization

High-bit image with some editing contains more image data

Digital files can be:

1. Low bit: (8-bit) = Most of the digital world operates with 8-bit images. This includes inkjet printers, most monitors and all JPEG files.
 A pixel with a bit depth of 8 = 2^8 has 256 possible values.

2. High bit: (16, 24, 32 or 48 Bit) = A high-bit image in contrast can have 65,536 (2^{24}) levels of information, which is significantly more than the 256 levels that an 8-bit image contains. The significantly greater amount of information available in the image file makes a dramatic difference when moving pixels and image data in the editing process. Only **raw** capture, and high bit scanning can give you the advantage of high-bit images and Photoshop can now process up to 32-bit.
 Less destructive editing means less spikes and gaps in the histograms, and smoother gradations cause less banding and posterization. (See "So what is a histogram?," page 42 for more information.)

IV. Exposure

Exposure is, without a doubt, the single most important component of the image creation process. However, with the dawning of this new digital era and the many great technological advances it brings, exposure may also have become the most forgotten. While it is true that today's hardware and software afford us many possibilities for "fixing" almost any mistake in post production – albeit fun and exciting – achieving accurate image capture in this first place is actually a far more demanding and critical task.

Proper exposure in the capture phase of the workflow can save you countless hours and unnecessary frustration in the post production digital darkroom. As they say, "garbage in, garbage out". Why accept the industry notion we need to learn all the software "tricks" possible to salvage a poor capture, negative, or scan when we can invest a little time in learning how to make exposures accurately in the first place? Being in control of exposure allows you the ability to control difficult light, and affords you the freedom to use your time in the digital darkroom more creatively – which I think is far more fun, practical and productive in the long run!

What is exposure?
There is a range of tonal information that a camera can record onto film or a digital sensor, and that range is limited. Knowing how to set your camera to compensate for this range and it's limitations will assure you capture all the necessary tonal information to create an attractive print, and give you more time to celebrate your achievements.

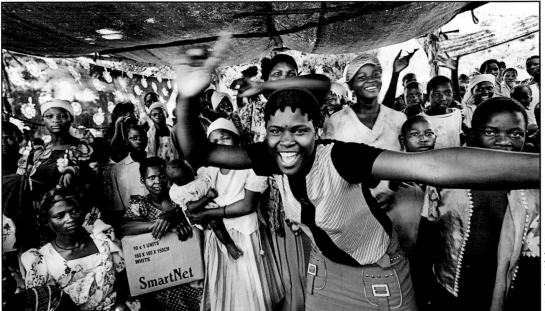

© Leslie Alsheimer

V. Exposure Essentials: the Zone System Applied

Although the latest high-end DSLR cameras have developed truly amazing exposure evaluation and metering systems, the fact of the matter is, no matter how fancy, expensive or sophisticated the camera, digital exposure meters are still relatively clueless about the image, mood, or scene a photographer is attempting to capture. The built-in camera metering systems cannot read minds, nor apply aesthetic judgment to the image capture process. While many digital photographers can be getting good results much of the time with an automatic exposure mode and a decent camera, great exposures all the time with the camera system alone, however, can be a difficult challenge.

In the early days of film, Ansel Adams developed the Zone system to address the complications in achieving proper exposure in the field. The Zone system is widely known to most traditional photographers as one of the fundamental aspects of the photographic craft. It is a systematic methodology designed to break the exposure process down into parts that can be examined and controlled to produce photographic images that match the photographer's visualization. Ansel Adams was able to use his Zone system to visualize an aesthetic, and then expose, develop, and print his negatives in order to achieve an image that conveyed the essence of what he saw in a scene or moment.

Zone system overview

The Zone system methodology breaks down into three basic components: visualization, exposure control, and contrast control. First, visualization happens within our minds, while exposure control happens next in the camera, and contrast control in post production (darkroom/digital darkroom). The photographer will therefore adjust the camera aperture, shutter speed, and ISO with the visualized image in mind in order to achieve the desired exposure. And then, in post production traditional terminology, the photographer then actualizes the visualized image as recorded by controlling contrast during the negative development and printing processes.

In describing his technique, Ansel Adams stated "visualization is a conscious process of projecting the final photographic image in the mind before taking the first steps in actually photographing the subject". His basic rule was "expose for the shadows; develop for the highlights". Although visualizing our future prints in the field may sound ethereal, we can use the application of the system to expose for the elements of a scene that we want to capture, which will ultimately result in better prints down the road.

For the purposes of this text and its focus on the application of processes in the digital domain, we will look more at a "simplified" Zone system rather than addressing the "full" Zone system. The simplified Zone system deals with controlling exposure alone, while the full Zone system additionally controls development and processing in combination with exposure. Since we have moved beyond the days of a single contrast grade paper, and we now have total control over print contrast in the digital darkroom, the focus now is to expose film, or sensors, for optimum image quality – ensuring all the critical information is present.

As with most of the fundamental concepts of this book, the Zone system theory applies as much to color and digital photography as it does to traditional black and white. Although color film and digital capture tend to have fewer zones, this technicality is less pertinent than actually understanding the global application of the system, how these zones relate to one another and how they change throughout the photographic process. Therefore, the principles of the system's theory will function exactly the same in the digital format as in traditional film; however, the method, tools and application have changed. Whether you already have a firm grasp on the Zone system and need to apply the concepts to the digital domain, or this is your first introduction to the concept, this Zone system overview will get you well on your way to producing fine digital prints.

Although there are many ways, or possible systems one may utilize to evaluate the outcome of the final print or display as you photograph, the concept of having a system in and of itself allows you to understand and be in control of your image capture. This is a much more skillful approach than being forced to work with whatever you happen to get with the camera in automatic mode alone. The Zone system is one very effective method of getting a real and working sense of the process – from capture to print. It allows you to get the right exposure every time without guessing, does not require any special film development, and you never have to waste time with bracketing.

When you know what you're going to get on film or sensor, you can make changes in the field as you are photographing that will ultimately serve to improve and optimize your final prints. You will be able to concentrate more on making great images than worrying about the technicalities of technique and exposure, which can ultimately stifle the creative process.

Proper exposure
Shadow and highlight detail are extremely important in tonally rich, satisfying fine prints. With traditional film, achieving a great print with an underexposed negative has typically been incredibly difficult. Lost shadow detail, resulting in clear areas on the negative, left a film photographer with nothing to print in the areas where detail was absent. Though negative film can capture a huge tonal range, an overexposed negative would exhibit the opposite as dense

shadow areas, degrading the quality with lost sharpness and an exponential increase in grain but still offering some information in the printing process.

With slide film on the other hand, it is very important to monitor *overexposure* and the resulting loss of detail. Slides capture a much smaller brightness range than negatives, and therefore require more careful exposure. In digital capture, as with slides, overexposure resulting in blocked highlights is the most common problem. Digital sensors are linear and have abrupt endpoints. According to ISO measurements by Kodak, a digital sensor exposed for an 18% reflectance gray card will saturate at 106% reflectance (and reach a pixel level 255 out of 255.) This can result in blocked highlights in contrasty scenes. Many digital camera sensors reduce the severity of the blocking with built-in tonal response "S" curves. These curves are applied when raw capture files are converted, but are not the final solution for perfect exposure in the field. Digital photographers must still be ever vigilant in their attention to highlight information when setting exposure.

Therefore, for the highest quality image capture, especially in extreme and challenging lighting situations, raw capture is by far the best choice.

So what is the Zone system more specifically?

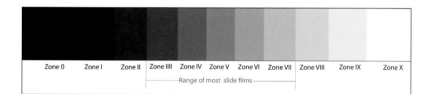

In essence, the Zone system describes the range of tonalities from light to dark, or pure white to pure black within an image. Ansel Adams divided this range of tonalities into 11 zones (0–X in Roman numerals), each zone being a single f-stop or aperture setting apart. The middle gray value corresponding to the 18% gray card is assigned to Zone V, and each of the remaining zones as a one stop exposure increase or decrease from Zone V. With 0 being pure black (black without detail), the darker tones were assigned lower zone numbers. With Zone X corresponding to pure white (white without detail), all the lighter tones were assigned higher zone numbers. Whereas the ends of the scale II and IX will show only a bit of detail, III, IV,VI and VII will clearly reveal subject detail and texture.

With the full range of tones established, Ansel Adams defined the dynamic range as the first useful values with detail as Zone I–IX. Exposure latitude was outlined as the range of values that a particular film (or now, digital sensor)

can record and is a function of both the subject luminance range and the characteristic curve of the film or sensor.

Zone 0 = Pure black

Zone I = Slight tonality, without texture

Zone II = Black with first suggestion of tonality

Zone III = Average dark, low values showing adequate texture

Zone IV = Average shadows

Zone V = Middle gray, 18% gray card

Zone VI = Shadows on snow in a sunlit snow scene

Zone VII = Lightest areas in a scene that retain some visible detail

Zone VIII = White areas with slightly visible texture

Zone VIX = Glaring white surfaces, highlights without texture

Zone X = Paper white, white with no detail, a lightsource

© Leslie Alsheimer

So what do all these numbers and values mean in the field?

Plain and simply put – exposure. Camera meters are designed with the assumption that all scenes have the same average middle gray tonal value, roughly Zone 5. If a scene is different, for example a snow scene as pictured below, the camera by itself will tend to expose incorrectly, wanting to portray the white in a scene as gray values. The white snow will read to the meter as a middle gray and ultimately result as an underexposed capture by meter alone.

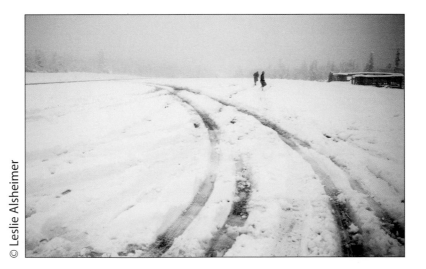

© Leslie Alsheimer

© Leslie Alsheimer

The same holds true for dark scenes, such as the image (left) of Dr. Robin Wallace, where the dark values would typically tend to expose as middle gray.

In more dynamic lighting situations, where both an extreme bright and extreme dark scene exist together (see image below), the meter would set the exposure to achieve neutral gray, which is under-exposed for white and overexposed for black. In order to get the right exposure, you will need a system to evaluate highlights and shadows in the field.

With the camera set in an automatic exposure mode, *every* scene will record with the same average middle gray density, regardless of subject. The results will eventually leave you with a fair number of bad exposures, lost moments, and ensuing frustration, especially in situations with difficult lighting.

The Zone system uses a spot meter that can measure the light in a small area of our photo. The photographer "pre-visualizes" the value desired for the area measured and adjusts the exposure appropriately. If the area measured needs to be almost black it is made into a Zone II or III, which is two or three f-stops less light than what the meter reads at Zone V, or a minus 3 easliy adjusted with the exposure compensation feature of most digital cameras.

© Leslie Alsheimer

Extreme lighting situation

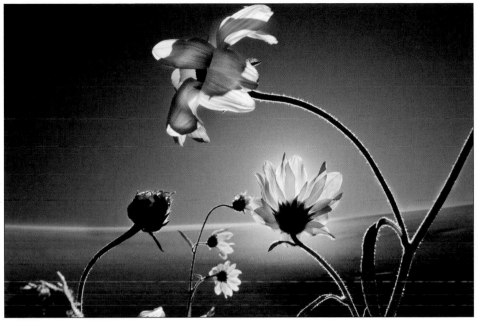

© Leslie Alsheimer

VI. The Zone System Applied: Exposure Evaluation with Histograms

Utilizing Histograms in the Field for Optimal Exposures with the Greatest Dynamic Range

Digital technology brings with it one of the most exciting and compelling reasons for its use altogether: the instant feedback and gratification we get from immediately seeing the image on the LCD screen on the back of the camera. Although it is fun to see the image instantly, it is important not to evaluate exposure accuracy by the display image alone. How many times did you think you had great exposures in the field, and come home to realize that the shot was not exposed properly? Due to variables in the field, like glares and reflections, it is unlikely that the preview you see in the field will provide an accurate representation of how the image will look on your monitor.

So if the LCD Stinks for Exposure Evaluation is There Another Way to Evaluate Exposure in the Field?

The histogram is, without a doubt, the greatest and most effective tool the digital photographer has for evaluating exposure and monitoring highlight and shadow information in the field; simultaneously, however, it might also be the most mysterious and least understood. Utilizing the digital camera's

41

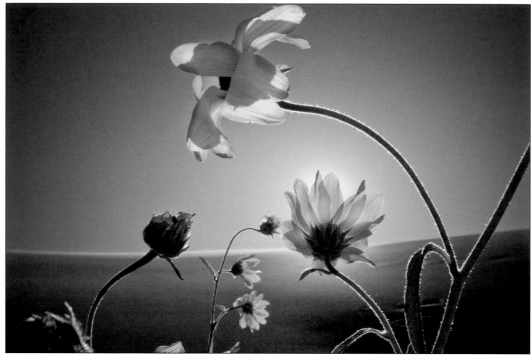

© Leslie Alsheimer

histogram feature in the field can show you clearly and immediately whether your images are overexposed, underexposed or well exposed – it is the applied Zone system theory with instant feedback! So, knowing how to read and evaluate histograms can guide you to make any necessary changes in exposure while still in the field. Therefore, taking the time to learn about histograms can help you not only gain mastery of the digital camera's image quality, but also improve your photography significantly.

Almost every digital camera on the market today – from the simplest point-and-shoot to the most advanced SLR – has the ability to display a histogram. In order to activate this feature, you will have to consult your camera manual to find out how to bring it up, as the method varies from camera to camera. The best approach for exposing digital capture is to keep your histogram active on the camera's rear LCD at all times, and make efforts not to evaluate too much about the image based on what you see on the image display.

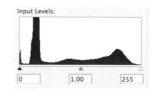

A camera histogram

So what is a histogram?

A histogram is a simple bar chart that graphs the brightness values of individual pixels absorbed by the camera sensor within a digital image. Basically, it displays where all of the brightness levels contained in the scene are found, from the darkest to the brightest. On a scale of 0–255,

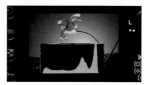

42

with 0 representing pure black (Zone 0) and 255 representing pure white (Zone X), the histogram maps out how many of the pixels within an image have each level of brightness (or luminosity) from black (0) to white (255). The portion of the histogram that is to the left of the chart shows the shadow information, or how much of your image is dark to black, while the part to the right shows the highlight information or the amount of the image that is light to white. The vertical height of the graph indicates the relative number of pixels that equate to each brightness level between white and black. Because each and every image is different, histograms are inherently unique for every image. The histogram provides invaluable information to the photographer in its mapping of tonal values within an image, which effectively monitors the dynamic range or range of input possible at the point of capture. Immediately, one can see where shadow and highlight information begins and what sort of tonal range exists. This allows the photographer to make re-exposure decisions accordingly. Although this may not make sense yet, after we introduce a few more concepts we can look at examples visually so that you can get more comfortable with this tool.

There are two places we will be looking at histograms throughout this text. First, we will use the histogram in-camera to evaluate exposure in the field and, second, we will also use the histograms in Photoshop to evaluate the image data as we process images in the digital darkroom. Although the camera histogram and the software histogram are not found in the same place, how they function and what they tell us is actually exactly the same. For demonstration purposes I am using the software histograms as seen with the Photoshop CS4 histogram palette instead of the camera histogram, as the software histograms are easier to see and they convey the same information as we would see if we were viewing them on the camera at the time of capture.

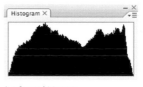

A software histogram

The relationship between the Zone system values and RGB and Grayscale tonality is illustrated below.

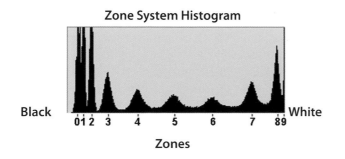

The diagram above indicates black to white with Zone 0 = RGB 0, Zone I = RGB 25, Zone II = RGB 51, Zone III = RGB 76, Zone IV = RGB 102, Zone V = RGB 128, Zone VI = RGB 153, Zone VII = RGB 229, and Zone X = 255.

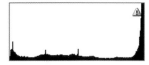

Lost highlight detail

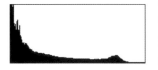

Lost shadow detail

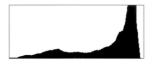

Preserved highlight and shadow information

What is dynamic range?

Dynamic range is basically the range of input a device can capture. For example, the range of light under which the human eye can see extends from the brightest sunlight to the dimmest moonlight, and this range of extremes defines the dynamic range of the human eye. The range of human vision far exceeds that of most cameras and computers. Because the dynamic range of film and digital capture is more limited than the human eye can see, photographers must be selective about what is important in a scene and expose with this scale of limitations in mind.

Like transparency film, if a part of a digital image receives too much light or overexposure that portion falls beyond the capability of the sensor (or film) to record image content and the result is rendered as pure white. Once that portion records as pure white, the information is effectively "blown out" or no longer holds any image data, which translates photographically as no image detail in the highlighted areas of the image. The same is true if a part of the image receives too little light, the capture data will fall beyond that which the sensor can record on the other end of the scale. The digital sensor will therefore underexpose the corresponding image information as pure black. A recognizable image is only recorded if the light hitting the film, or the digital sensor, falls within a range of about five f-stops. This is the approximate dynamic range of digital capture.

Exposing for digital capture is somewhat different than exposing for film, as digital cameras behave quite differently than film cameras do in the way they handle highlight and shadow information. With digital capture, extreme overexposure effectively saturates highlight information beyond recovery, and underexposure pushes shadow information and detail into noise, making quality rendering almost impossible. How sensors respond at the saturation limits at either end of the dynamic range limitations are also different from film, and how to deal with these characteristics are all embedded into the raw conversion and subsequent post-processing procedures. Although digital cameras today have a much greater exposure latitude than most 35 mm films do, it is unfortunately still much easier to blow out the highlights on a digital sensor than it is with film. The digital camera's imaging sensor is very similar to color transparency film when it comes to its sensitivity to light. For this reason, the best exposure strategy with digital is to expose for the highlights, breaking the rules of the film lessons that taught us to expose for the shadows and print for the highlights.

Exposing for digital capture

Proper exposure with film or digital is difficult to define, as the best exposure for any given image will depend on the image itself and corresponding circumstances. There is really no such thing as a perfect exposure, as artistic preferences should drive exposure to vary depending on the tones of an image,

and the resulting mood or impact the photographer creatively wishes to achieve. Predominantly, however, our general goal with exposure is to simply place the tonal values found in the scene most appropriately within the dynamic range of the camera's imaging sensor. "Most appropriately" means that the midtones found in the image fall roughly halfway between the darkest and the brightest values, while taking into account the importance of shadow and highlight information within the image. If a subject is exposed too far into either extreme, the limitations of the sensor will become more obvious. If the values fall too close to 0 (absolute black), there will not be an image at all, or the image will appear very dark and noisy. If the values fall too close to 255 (absolute white), the pixels will appear oversaturated with no image information or detail. The best exposure strategy for digital capture, therefore, is to keep highlights from reaching the maximum output value of the sensor, except for specular highlights that do not detract from the image if they are blown out.

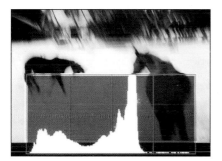

Histogram with all three channels combined and averaged (Red, Green and Blue)

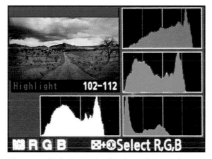

Histogram displaying each color channel separately so that you can monitor each channel individually

Once you have captured an image in the field, bring up the histogram on the back of the camera. The histogram data should indicate how the image data falls within the dynamic range of the camera at the time of exposure. Using that information, the photographer can evaluate what is important in the image, like highlight or shadow information, and which takes precedence, and re-expose the image based on creative interpretation of the data. You will have to consult your camera manual to find out how to turn this valuable camera feature on. Some cameras just have one histogram which is all three channels combined and averaged (Red, Green and Blue). Other more advanced cameras will show you the histogram for each color channel separately so that you can monitor each channel individually.

Reading and Interpreting Histogram Data

Clipping

Isolated lines or spikes or a pile at either edge of the data box is an indication of clipping or data loss within an image. Clipping indicates that improper exposure or image manipulation in the digital darkroom has caused some parts of the image to move beyond the maximum brightness level within the dynamic range of capture. Such a histogram shows that image data has been recorded as

pure black or pure white without image detail, meaning that the image is becoming "blown out" as if it were over- or underexposed.

Clipped Shadows

The histogram below indicates clipped shadow information, or lost detail in the shadows of the image. Notice the slam of data on the left wall of the histogram, indicating that the data exceeds the dynamic range of the camera in the shadow values. Highlight information is preserved, as we can see the data clearly ends before the histogram wall on the right.

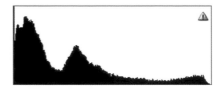

Clipped Highlights

The histogram below indicates clipped highlight information, or loss of detail in the highlight values. Notice the slam of data on the right side of the histogram. Shadow information is preserved, as we can see the data clearly ends before the histogram wall on the left side.

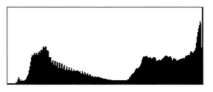

Whether this is "good" or "bad" exposure depends again on the corresponding image. If the histogram represented an image of a white flower, then this would be poor exposure because the detail in the highlights is lost. However, if this same histogram represented an image where highlight detail is not as important as preserving the shadow information, then this would indicate a good exposure for the corresponding image.

Clear as mud right? Do not worry if you are not seeing it all quite yet. Understanding histogram information and how to read and interpret the data for image capture requires looking at lots of images and their corresponding histograms in order to properly read and interpret the information they provide.

Clipped Highlights and Clipped Shadows

The following histogram indicates both clipped shadows and clipped highlights within the same image. The isolated spikes on the right and left indicate loss of both shadow and highlight detail.

This would indicate a great exposure for a "blown out arty" fashion magazine shot, while simultaneously indicating a poor exposure for an image hoping to

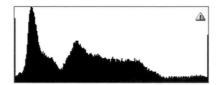

gain full tonal range in a print. In viewing a histogram such as this, evaluate whether highlight or shadow information should take precedence and re-expose for that information.

Preserved Shadow and Highlight Information

The histogram below would indicate an image exposed with full tonal range. Highlight and shadow information are preserved without clipping, as the data clearly ends before the walls of the histogram on either side.

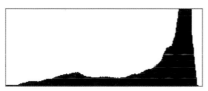

Contrast

The width of the data spread within a histogram reflects how much contrast the image contains. Narrow histograms indicate less contrast with a limited range of tones while wider histograms indicate greater contrast or a wider range of tones from light to dark.

High Contrast

The histogram below indicates high contrast within the corresponding image. Full tonal range is being utilized, without loss of detail in either shadow nor highlight information.

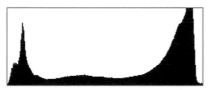

Low Contrast

The following histogram indicates a low contrast image. The full tonal range is not being utilized. The corresponding image will therefore appear flat with little contrast, as the information is weighted heavily by midtone values. Good or bad? Answer: depends on the image.

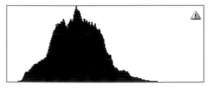

Note:
It is really important, however, not to get too overly obsessive about the histogram in a technical sense. The truth is a perfect histogram does not always equate to a good image and a bad histogram does not always dictate failure. Use the information to make creative decisions in the field and experiment with how far you can push the extremes and still create successful images.

Histograms and Images

Now that all those technical descriptions make perfect sense, let us look at some images to associate with the histograms and hopefully make better sense of it all. As the histogram maps the tonal values within an image, the instant the shutter is snapped you can immediately evaluate where shadow and highlight information begin, what sort of tonal range exists, and make important decisions in the field accordingly. Remember, there are no right or wrong histograms; as where data should fall will vary depending on the tones, content and the mood of an image. Here is how:

Example 1. Overexposed

One can determine and evaluate many things about an image capture in the field from the histogram data. If the image as seen on the next page is the scene you desire, but you see a histogram such as the one on the left (Fig. 1), you would know right away there was a problem. Notice the data slam into the right side of the chart. This histogram would indicate that the shot has been overexposed as shown below, with highlights and white values blown out. The scene of the doorway and heart shape need the highlights well exposed for detail in the those areas. Therefore, this histogram would indicate that exposure should be decreased via a faster shutter speed, narrower aperture, or lower ISO setting and re-exposed,

FIG 1: Overexposed image data for corresponding image pictured below

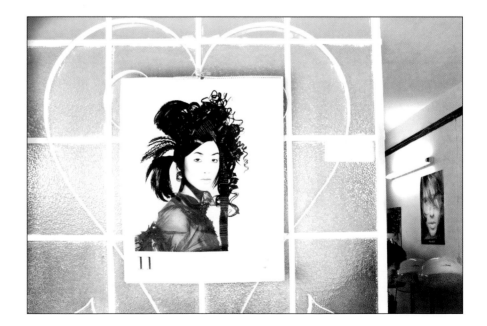

until the highlights (the data to the right) come back into the chart and are fully contained within the histogram chart, as seen in the next histogram example (Fig 2).

Example 2. Well Exposed for Corresponding Scene

The image below displays a "good" histogram for the corresponding scene because both the shadows and the highlights are fully contained within the parameters of the histogram chart from right to left. there is detail in the highlight values and the shadow values of the womans hair.

There are no spikes at either end of the chart, and the data clearly ends before the edge of the histogram chart for both the highlight and shadow information. This image spreads the tonal scale with image data ranging from white to black and virtually every brightness value in between. All of the light and dark levels of the scene have fallen within the dynamic range recordable by the image sensor.

FIG 2: Well exposed for desired representation of the corresponding Image below

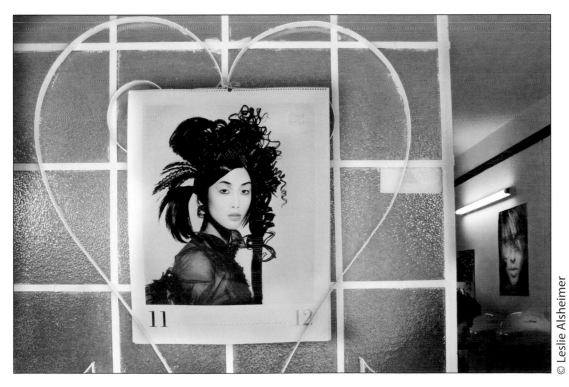

© Leslie Alsheimer

Example 3. Shadow Preference

Exposure for the barbershop scene as pictured below requires some preferential treatment for the shadow information. Notice the lost highlight detail indicated by the slam of information to the right of the histogram (Fig. 3). This lost information falls in the bright sky outside the shop and the florescent tube light over the mirror in the image below. This detail information is not as critical as the detail inside the shop. The exposure, weighting the shadow information, (Fig. 3) will ultimately produce a better overall print.

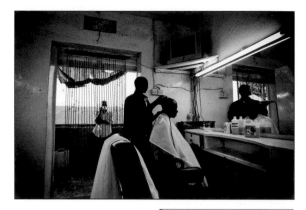

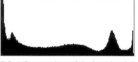

FIG. 4: Extreme loss of shadow detail as pictured above

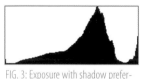

FIG. 3: Exposure with shadow preference, allowing brightest highlights to blow out

If the initial exposure for the same scene presented a histogram such as Fig. 4, the resulting image would be far too underexposed as pictured above with excessive loss in the shadow information.

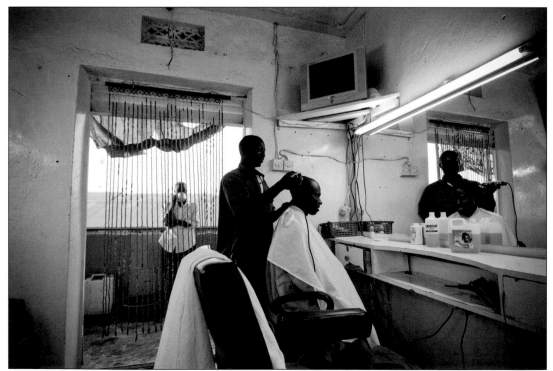

© Leslie Alsheimer

Reading the histogram accurately in the field directs us to readjust exposure and reshoot until we produce an exposure that maintains good shadow detail, such as the histogram illustrated in Fig. 3.

FIG. 5: Extreme loss of shadow and highlight detail as pictured above

Example 4. Extreme Lighting Conditions
The image of the bar interior and television is a difficult lighting situation. To expose to preserve both highlight and shadow information in such extreme lighting conditions would be impossible, as the brightness of light and the dim room light exceed the dynamic range of the camera's sensor. The corresponding histogram displayed for this scene indicates loss of detail in both the highlight and the shadow information. There is enough detail in the overall scene however to make the image visually "work" despite extreme loss of detail at both ends of the scale. The histogram for this scene therefore actually indicates a relatively good exposure for these conditions and overall mood of the image.

Example 5. Extreme Lighting Conditions 2

The sand dune image below is another example of extreme lighting conditions exposed with highlight preference and lost information in the shadows (indicated by the thin line up the left side of the histogram.) Although another scene may fall apart with this exposure, the mood and lighting effects in this scene make the exposure work well for the image overall.

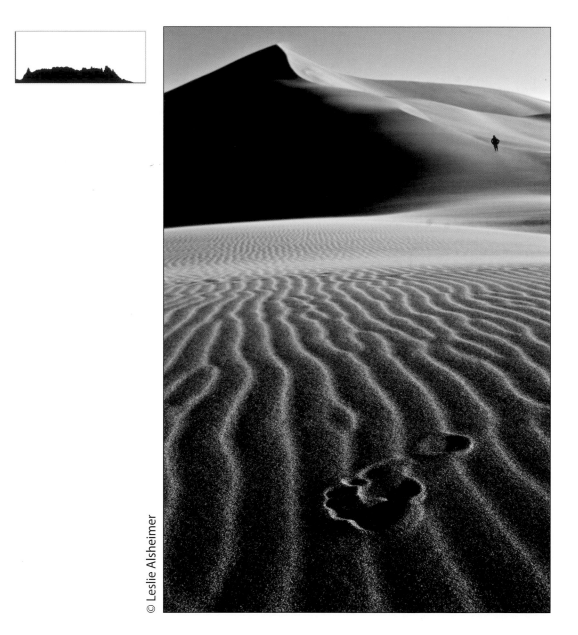

© Leslie Alsheimer

Example 6. Low Key Images Exposed with Highlight Preference
The image below of Agenina Nakanyike, a Ugandan bean farmer and mother
of four, is an excellent example of a low key image, whereby almost all of
the data in the image falls within the darkest values of the data chart. The
image maintains a small amount of information towards the highlight values
preserving the light and detail on the woman's face. The corresponding
histogram for both exposures indicates major loss in shadow information,
as illustrated by the slam of data to the left side of the histogram indicating
much information falls to black. As no image detail extends beyond the right
side of the scale, the exposure captures all the important details contained in
highlight information in this scene.

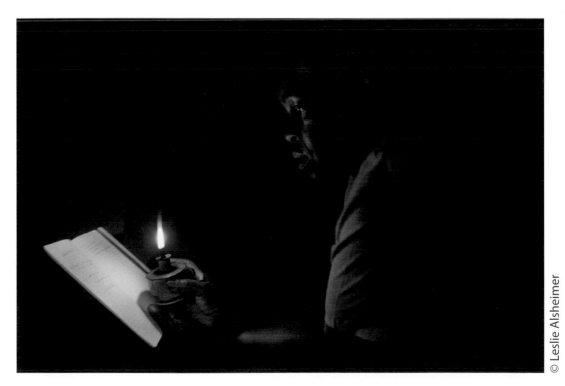

© Leslie Alsheimer

Example 7. High Key Image with Highlight Preference
The image of the white dress is an excellent example of a "high key" image, where almost every value of data is plotted toward the right side of the histogram. This histogram tells us many things about the exposure for this image. Most importantly, we can see immediately that highlight information has been preserved in the exposure, as the stack of data does not exceed the right side of the histogram chart. There is a long thin trace of information across the bottom to the left side, indicating that there are few pixels with darker brightness values. The information does not slam to the left, indicating that we have maintained the shadow detail (although there is very little) without clipping.

© Leslie Alsheimer

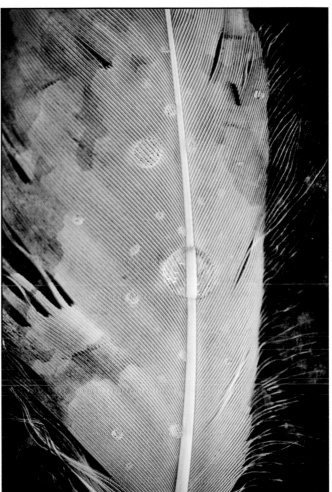

© Leslie Alsheimer

Exposed to preserve highlight detail

Example 8. Preserved Highlight and Shadow Information
The feather image above illustrates a scene where the best exposure is achieved by maintaining both shadow and highlight information and detail.

Notice the histogram data above for preserved highlight detail. There is not a slam of information, as the data cleanly ends before either end of the chart. This image captures and preserves both highlight and shadow information.

In determining exposure for this image, it is best to keep the highlights close to the clipping point; the closer the highlights are to clipping, the less sensor noise will be visible in the image. Ideal exposure with a digital camera (capturing the greatest possible dynamic range with the lowest possible level of noise and other undesirable digital artifacts at a given ISO setting) is always to bring the raw data as close as possible without reaching the clipping point for non-specular highlights.

Overexposure

Example 9. Overexposed

If the same feather image on the previous page were overexposed, the corresponding histogram would indicate the blown out highlight information with a slam on the right edge of the histogram. As the highlight information is more valuable in this feather image, it would be best to decrease exposure via a faster shutter speed, narrower aperture, or lower ISO setting, and re-expose.

In contrast, the exposure for the image below of the bird and woman has a histogram looking almost identical to the previous overexposed feather image; however, this image was exposed for the subject, allowing much of

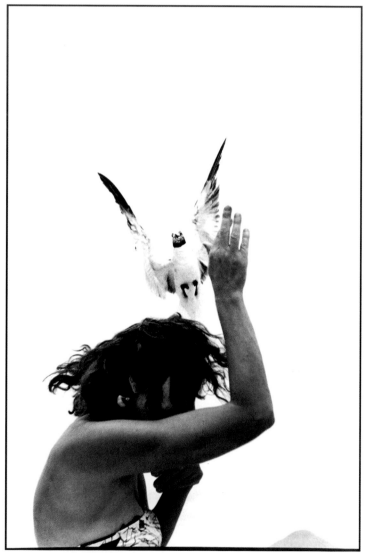

© Leslie Alsheimer

the background to fall off. The slam to the right indicates lost detail in the sky, suggesting that it is important to allow creative interpretation along with technical information to play a role in the elusive exposure decision-making process.

Example 10. Midtone Values with Contrast
This image has no white values, the extreme shadows have no detail, and the majority of the data is stacked in the center.

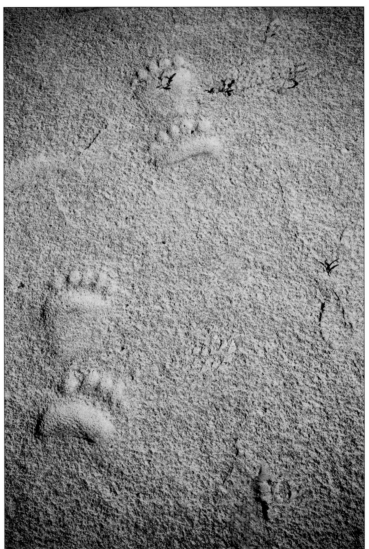

© Leslie Alsheimer

Example 11. Highlight Preference
This image and exposure histogram indicate preserved highlight information in the bright curtain with some data loss in the shadow information. As the detail in the highlights was my main concern with this image, I scrutinized the data on the right.

If the image were not exposed to preserve the highlight information and were overexposed, as the histogram to the left indicates, we would see a slam of information on the right side of the chart.

Once again, if we notice a histogram indicating loss of highlight information with an image such as the tent (below) or the woman by the window (right), we would want to reshoot, stopping down or speeding up the shutter speed to achieve an exposure that maintains highlight information.

Preserved highlights

Overexposed highlights

© Leslie Alsheimer

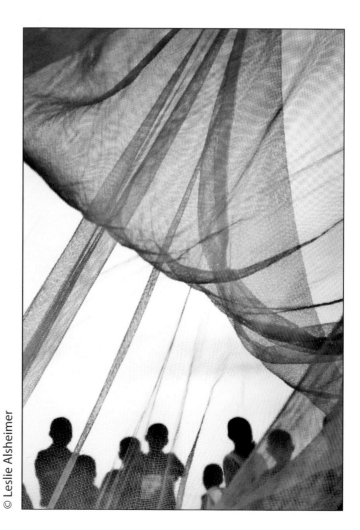

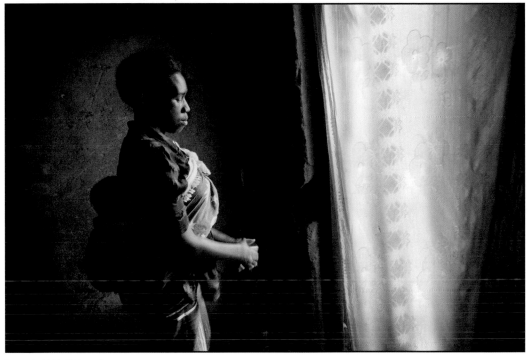

Exposed with highlight preference

© Leslie Alsheimer

Creatively speaking however, another photographer may have been in this same scene and been more interested in the baby in the shadows. A better exposure for the baby would have been to expose for the shadow detail and let the highlights blow out.

Summary of Histograms and Exposure Evaluation

Although it is important to learn to read histograms, it is also important not to get too overly obsessive about them. The truth is that a good histogram does not always equate to a good image and a bad histogram does not always dictate failure. Sometimes loss of detail works, sometimes it does not. Knowing in the field when you have exposed well for the important information as creatively interpreted for a given scene, and when you need to reshoot, is the most valuable advantage digital capture has to offer the photographer.

When shooting raw, it is important to know that there is a difference between the clipping point indicated by the camera histogram and the clipping point of the corresponding raw data. This disparity occurs because the camera histogram is created from the in-camera JPEG conversion of the original raw data. In-camera JPEG conversions typically discard 1–2 stops of the sensor's dynamic range, (another reason to shoot raw), which means that there is usually about a stop of extra leeway in the highlights information to play with in raw capture data. The

exposure intervals between the clip points indicated by the camera histogram and the actual raw data, however, will vary from camera to camera.

Once you understand exactly what information the histogram can provide for you, determining the desired exposure in the field becomes relatively simple. For standard exposure techniques bias your exposures so that the histogram data is pushed up to the right side of the chart, while making sure that the highlights are not blown out. The ultimate indication of best exposure is the histogram coupled with artistic interpretation. Learn to read histograms and you can nail desired exposures in any situation! Depending on the subject reflectance and the camera meter's characteristics, the ideal exposure could actually be more than a stop below or above what the meter reads. We recommend using the camera meter as a guide to get initial exposure settings, and then fine-tune the camera exposure settings based on the histogram data.

VII. Exposure Evaluation: Monitor Highlights Utilizing the Blinking Highlight Indicator

Another very useful feature with digital capture is the camera's LCD blinking highlights display indicator, which displays the blown out highlights within an image. This indicator illustrates blown out highlights by blinking the corresponding image components on the camera LCD image display immediately after capture. Between the histograms and the blinking highlight indicator, we now have more information about our exposure than we ever had with film!

When activated in the camera menu, this indicator can be extremely valuable in displaying exactly where we are losing information in the highlights of the image when they do blow out with undesired exposure mistakes. Utilizing such important feedback, we can then make important decisions in the field about the importance of the lost highlight information in relationship to the shadow information and desired interpretation, and re-expose if necessary.

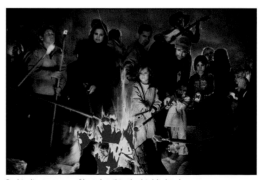

Red indicates areas of lost detail in the highlighted areas

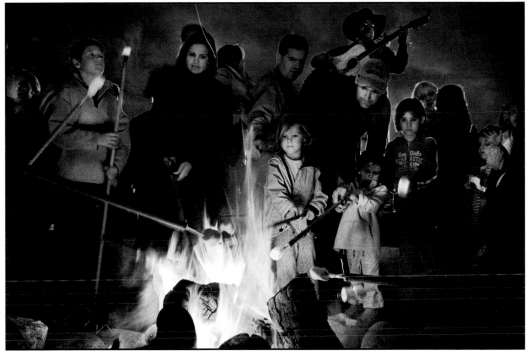

© Leslie Alsheimer

VIII. Histograms in the Digital Darkroom

Monitoring Image Detail with Image Adjustments for Highest Quality Editing Practice

Maintaining image detail throughout the editing process is absolutely integral for a high quality print. Once you are sure that you have exposed for the highest quality capture in-camera by evaluating histograms in the field, careful attention must be applied throughout the editing process ensuring your image adjustments are not detrimental to the quality of the image data. Since we already know how to read a histogram, we can use the information they provide to monitor image data during each major adjustment and conversion in Photoshop. We can also determine whether image corrections have been too dramatic, possibly leading to clipping, loss of digital data including highlight and shadow detail, as well as posterization (see definitions below). As with any and all major editing within the digital darkroom, it is essential to monitor the histogram during each major adjustment and conversion. Once again, and it is worth repeating, always start with high bit capture for the highest quality, especially if you know you are going to have a heavy hand in image editing. (See "JPEG vs. Raw Capture", page 30.)

IX. Digital Darkroom Editing Dangers

Posterization aka Banding

Posterization is a tonal separation that occurs when an image has been edited or manipulated to extremes, or if the bit depth of an image has been decreased so much that it has a visual impact on the image quality. Posterization is the loss of tones within an image that results in abrupt transitions between tones that appear as stripes or "banding" in areas which should have smooth gradations between tones. Typically extremely visible in skies, posterization

POSTERIZATION

Posterization occurs when a drastic contrast or color correction is made

Posterization is the loss of tones which result in transitions that are abrupt

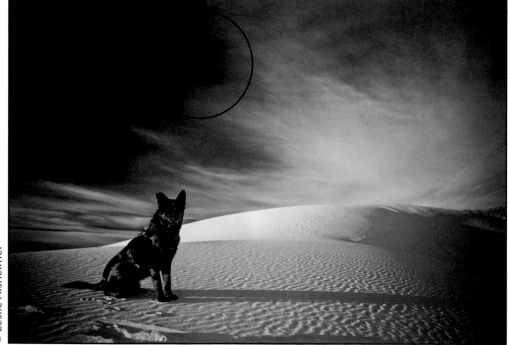

© Leslie Alsheimer

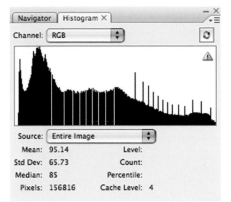

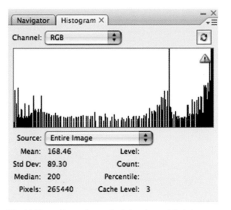

After an image is edited, it is natural to see some gaps and spikes. It will depend on the image and the amount if the loss of information will be discernible in the print

Yikes! A bit too far on the manipulation. Loss of digital information and posterization

would cause the otherwise smooth transition in tonality from light to deeper shades of blue to print with various blue stripes as the tones deepened.

The term "posterization" is used because the effect looks similar to how the colors look in a mass-produced poster where the print process uses a limited number of color inks. This effect ranges from subtle to extreme, and whether this is discernible in the print depends on the level and location of the posterization within an image.

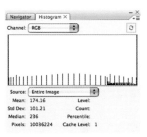

Posterization aka. stair stepping or banding is an indication of extreme loss of many brightness and tonal values within an image

Any process which "stretches" the image data and histogram has the potential to cause posterization. Stretching can be caused by improper exposure, low bit capture image editing techniques such as levels and curves in Photoshop, or even by converting an 8-bit image into Grayscale. The best way to avoid posterization is to work with high-bit files and monitor the histogram throughout the editing process, keeping image manipulation within quality controlled limits. Above are histogram examples in a side by side comparison that show results from common digital darkroom manipulation as compared with potentially problematic edited data.

Cache Warning

Inside the Histogram palette, a small triangle with an exclamation point inside appears as an indication that the histogram has not yet been accurately rendered by the software. The histogram is created from the image cache, which is a scaled down 8-bit version of the image file. Photoshop uses cached images in order to update the histogram dynamically as you make adjustments to the image. To create a more accurate histogram, click on the exclamation symbol and Photoshop will refresh the histogram and display a fully rendered histogram.

X. Scanning Capture: an Overview

Scanners have truly become an indispensable bridge between the traditional photographic medium and the new digital world, making it possible to convert our film, slides, and fine art prints into the digital format. Scanning devices have become far more enticing with the astounding technological advancements achieved over the last few years, which have made scanners more affordable and available to the average photographer. Just like a digital camera, most scanners rely on charge-coupling devices (CCDs) to capture and translate images from film, slides, or prints into the digital format.

How to Set Up for Optimal Scanning

While there are far too many scanners and software packages on the market to go any great detail with specific products, there are a few basic rules on how to achieve the highest quality black and white output with whatever hardware you prefer.

Types of scanners

Drum Scanners

These scanning devices produce the highest quality capture and conversion, but are still rarely found outside of service bureaus because they can cost tens of thousands of dollars and are very labor-intensive to use. A drum scanner uses a photo multiplier tube to capture images instead of a CCD as most other scanners use. Prints or film are placed inside a rotating glass drum where a bright light is reflected off prints – or illuminated through slides – recording the light through a photo multiplier tube. Drum scanners offer the highest resolution, best color, can digitize very large size prints, and have a far greater capacity for capturing finer detail in shadow and highlight regions than any other type of scanner. Most service bureaus charge per scan according to the scan size dimensions, which can become fairly costly for a large quantity of originals.

Film Scanners

Film scanners are designed specifically to scan film from 35 mm, 2 1/4 to 4x5 depending on the type of scanner and how much you want to spend. Film scanners offer the next best quality digital capture to a drum scanner, and are a good investment if you need to do a high volume of scanning. Film scanners typically offer very high resolutions because negatives/film have a much higher dynamic range than prints and have to be enlarged substantially, much like a negative enlarger.

Flatbed Scanners

These scanning devices are much like Xerox copy machines in that you lay the print or negative down on a sheet of glass and close the cover. The scanner illuminates the print or negative from under the glass allowing the CCD to capture the image line by line. Flatbed scanners can scan prints and film (using optional transparency adaptors).

Print/Sheet Fed Scanners

These scanners were originally designed for snapshots, although some can also scan slides and film. They are similar to flatbed scanners, however the image is fed into a slot instead of laying flat. The CCD reads the image line by line as the image is drawn past a stationary CCD. Sheet fed scanners take up mush less space than flatbeds, however you will not be able to scan images from books or magazines.

Resolution: optical vs. interpolated

Resolution describes how well a scanner can capture image detail. For the technically adept, a scanner's resolution is determined by how many pixels per square inch the scanner can read in each direction. By dividing the scanner's surface into square inches, a typical scanner might sample 300 pixels vertically and 300 pixels horizontally for a resolution of 300x300 ppi (pixels per inch) producing 90,000 readings per square inch. Higher resolutions would produce higher readings per square inch, and therefore capture greater detail. Many desktop scanners can produce scans up to 4600 pixels per inch optically.

Optical resolution is the true measure of a scanner's quality and therefore produce the purest data. Interpolated resolution is the higher resolution a scanner achieves by adding made up data and pixel information to the optical resolution, by guessing with advanced algorithms using photo editing software.

Bit depth

While resolution measures how many pixels per inch a scanner captures, bit depth refers to how much information the scanner records for each pixel, that is, the number of bits used to represent each pixel. Greater bit depth allows more shades of gray and colors (see "Bit Depth", page 34 for more information).

Most scanners on the market can scan up to 24-bit, but more and more are appearing that have even greater bit depth. Though not many systems can represent all the color possibilities such scanners provide, the greater bit depth does allow the scanner to pick up more detail in dark areas of an image, and it can help reduce noise in the final image.

Dynamic range

Dynamic range refers to the tonal range of the scanner from light to dark extremes. A scanner's dynamic range measures how effectively the scanner

Note:
Many scanners have an optical resolution (true resolution) and an interpolated resolution where image data is resampled (or made up) to create larger files. Be sure to research your scanner specifications to find the optimal resolution of your scanner.

can capture detail in shadow values and highlight areas, as well as how well it records the transitions between brightness levels within an image.

On a scale from 0.0 (absolute white) to 5.0 (absolute black) the range of a device is defined numerically as the difference between the extreme values of light and dark the scanner can manage. The higher the value, the greater the scanner's ability to distinguish information in the shadow and highlight regions. A dynamic range of 2.0 is of lower quality, while high quality drum scanners can reach up to 4.6. Most flatbed color scanners have a dynamic range between 2.4 and 3.2. The quality of a scanner's optics, in combination with its bit depth, contribute to the dynamic range.

Scanning black and white film

Most scanners have a difficult time scanning black and white negatives because black and white film has a very small density range, typically less than 2.0. Most scanners are designed to handle the 3.0 to 4.0 density range of transparencies and therefore have to spread the range over 256 levels, resulting in scans with poor separation in the shadows and poor gradation.

For optimal results, and for the very same reasons it is best to capture in color for digital BW conversions (see Chapter 4), it is also best to scan B&W negatives using color positive settings. You will get far more information out of the negative by using the four channels of capture with color settings than you can using a scanner's B&W setting alone. Better results can also be achieved by scanning the negative as a positive and inverting the negative in Photoshop. A side by side comparison of two scans of the same image, one scanned in RGB and the other grayscale, will show you that the individual

Tri-X 400 scanned with grayscale

Tri-X scanned in RGB as a positive exhibiting far more detail in the wrinkles of the socks than the previous scan in grayscale

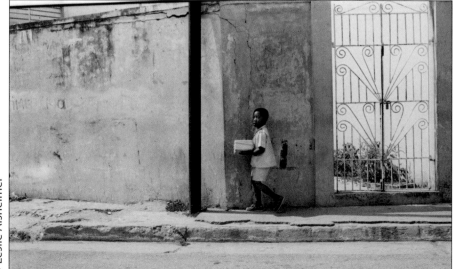

© Leslie Alsheimer

channels that comprise a color scan effectively produce sharper images and exhibit more detail than the black and white scans.

Be sure to use the highest bit settings your scanner can provide and turn off all clipping of the shadows and highlights with auto expoure settings. The scan will look low in contrast after scanning, but can be improved using simple editing in Photoshop and/or Lightroom. Turn off dust removal features because they will blur and sharpen the image. Just like we used to spot tone each print individually to remove dust and artifacts, scanned images sometimes require a fair bit of time-consuming gunk removal. This process is best approached with the Clone Stamp and Healing Brush tools in Photoshop (see point 5 below). The good news is that once a digital file is corrected, it should stay corrected forever.

Scanning essentials

1. **Set the scan resolution** to the maximum optical resolution of the scanner in order to capture the highest quality image data for the largest possible output. 4000 ppi is roughly equivalent to film grain for 35 mm and 6000 ppi for medium format.

 **If file size and storage is an issue, set the scanner resolution instead according to the number of megabytes necessary for the desired output size. (See "Resolution/Print Size Reference Chart", page 68.)

2. **Set the scanning mode to high bit.** A high-bit scan will give you exponentially more image data … 65,536 as compared to 256 in an 8-bit image file, which translates to less destructive editing. There are more points and more pixel information to effect change in a high-bit file, therefore creating smoother gradations and less destructive editing.

3. **For black and white negatives set film type to positive.** Although I have not experimented with every scanner on the market, typically black and white negatives scan best if scanned as a positive (or at least tell the scanner it is) and invert the negative to a positive once it's in Photoshop. Image > Adjustments > Invert

4. **Using the histograms,** set the highlight and shadow points ONLY. Use the scanner histogram tools to set the highlight and shadow input values to scan for the information in the image. Usually a flat scan is the most useful in Photoshop. (See "So what is a histogram?", page 42 for more information.)

5. **Make correction in Photoshop.** Even the fanciest scanners and scanning software are not as sophisticated as Photoshop. Regardless of what you paid for your scanner, it is usually best to make adjustments to the image in Photoshop. Turn off all corrections in the scanning software whenever possible, including dust and scratch removal features!

Note:
Be aware that any dust and scratch removal feature in the scanner software blurs the image and applies sharpening to correct for the blurring.

Although more time-consuming, it is often best for image quality to remove dust and artifacts by hand in Photoshop with the clone and healing tools.

Note:
Create presets that can be saved and applied to many images. For bringing scans into Photoshop see Chapter 5, pages 170–171.

6. **Turn off sharpening.** This is essential! You will have much more sophisticated control over sharpening in Photoshop.

7. **Embed the scanners profile.** Photoshop needs to know where (or from what device) your image is coming from in order to make accurate color conversions. Embedding the scanners profile gives Photoshop crucial information in describing color. (See Chapter 1, "Color Management for Black and White", page 22 for more information).

8. **Scan grayscale images and negatives in RGB mode.**

Resolution/Print Size Reference Chart

Resolution and image size are interdependent, and combine together to generate a total file size. This can get particularly confusing in the scanning process – especially with 35 mm negatives – as their size dimensions are very small – requiring much higher scanning resolutions to produce high quality prints. Scanning for the total file size necessary for the desired output size is therefore the easiest way to translate resolution for scanning purposes.

If, for example, you wish to make a 13 × 19 inch print from your inkjet printer at 240 ppi, choose a scanning resolution that creates a file size of 164.4 MB for a color or toned high-bit image print.

File sizes refer to high-bit file size

Print Size in Inches	PPI @ 300 MB Size	PPI @ 240 MB Size	PPI @ 180 MB Size
5 × 7	18.04 MB	11.54 MB	8.66 MB
8 × 10	40.12 MB	26.4 MB	19.78 MB
13 × 19	127.4 MB	81.6 MB	61 MB
16 × 20	164.4 MB	105.6 MB	79.2 MB
24 × 36	445 MB	284.8 MB	213.6 MB

PPI 300 = Necessary for prepress and dye sublimation printers
PPI 240–300 = Perfect resolution for inkjet printers
PPI 180 = Lowest resolution recommendation for inkjet printers

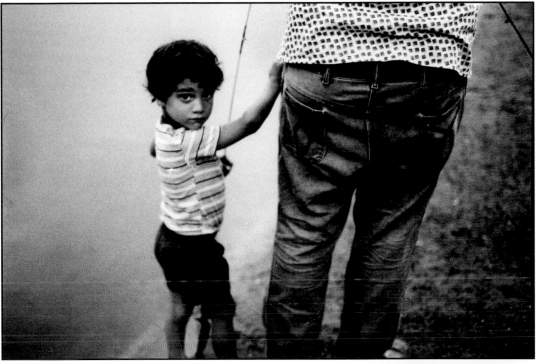

© Leslie Alsheimer

XI. Noise and Interference in Digital Capture

AKA Grain in the Film World

In order to optimize image data for the highest quality digital capture, monitoring and controlling the desired effects of noise produced is another important component of the capture workflow. Although many of the latest high-end DSLR camera systems have evolved to bring us significant new advances in noise reduction, offering a sensitivity to light far surpassing the grain equivalent of film, noise can still be an issue for the digital photographer.

Digital noise is created by randomly scattered pixels across a digital image. The effect is similar to the grain we traditionally see in film photography. Noise is usually most visible in images captured in very low light, and with slow shutter speeds or higher ISO sensitivity modes. It also appears in areas that are underexposed.

Film grain

Digital noise

69

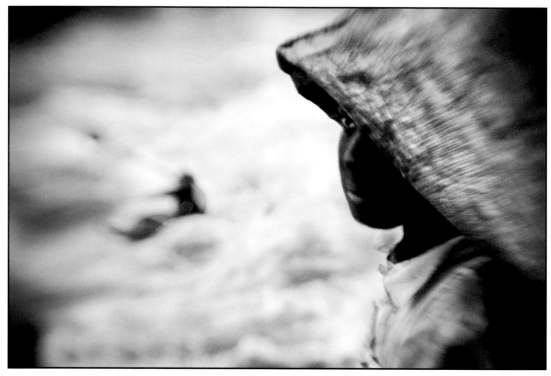

© Leslie Alsheimer

Digital color noise

The image on the previous page was captured on film in a low light situation with 400 ISO film pushed to 1600. The grainy structure of the image illustrates a quality of film that often added to the mood and feel of a print.

The image of the boys running (right) was digitally captured at 1/10 of a second with an ISO setting of 400. With digital capture, noise and grain appear very similar, although shadow areas tend to have a more blotchy look with digital noise. Noise in color images tends to have a more magenta-green look. (See image above.)

The digital camera's sensor measures light for each pixel and creates a matrix of pixels that represent the image. The sensor itself carries a certain amount of noise inherently; however, in most lighting conditions, the light is significantly stronger than the inherent camera noise. In more extreme conditions where the light is low, or when a higher ISO setting is needed, the noise levels typically increase and produce more abrupt and jagged pixels with a Christmas-colored pattern of red and green. This occurs because there is more noise data than light data available to the sensor.

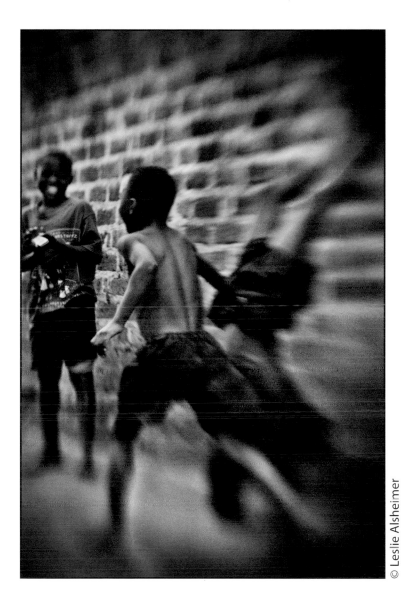

© Leslie Alsheimer

Types of Noise

Luminance noise

This type of noise will make an image look grainy on screen, but will not necessarily have much of an impact when printed, unless it is incredibly severe. Luminance noise is much like the "snow" on your television after most stations stop broadcasting. The causes of luminance noise are typically due to static and other forms of interference and imperfections of the camera.

Blue channel noise or chroma noise

This type of noise will appear as blue and red dots in an image and is especially visible in images captured in low light with a high ISO setting. If there is not enough light for a proper exposure, the longer we allow the image sensor to collect the weaker light signals, the more background electrical noise it will collect. Similarly, when we use a higher ISO setting, we are also amplifying the signal we receive from the light photons. Unfortunately, as we amplify the signal, we also amplify the background electrical noise. The prevalence of noise is especially prominent at ISO ratings of 800 or higher. It is called Blue channel noise because more noise will appear in the Blue channel of an image than in the other two channels. This type of noise is most like the grain structure of a high ISO-rated film.

Thermal noise

Higher temperatures also increase Blue channel noise. The hotter the sensor becomes, the more noise will appear. Heat can free electrons from the image sensor and contaminate the photoelectrons present. These "thermal electrons" generate a form of noise called thermal noise. More noise can actually appear at the end of a shooting session than at the beginning as the sensor heats up the longer it is in use.

JPEG artifacts

When an image is captured as a JPEG in-camera, the JPEG format compresses the image to reduce its size so that you can get more images on your card. This compression, however, typically introduces a chunky pattern to the edges and flat aspects of an image. The higher the compression ratio, the greater the damage will be to the image. All the more reason to capture in raw format!

Noise Controlling Factors

Knowing how noise is produced can help you make important decisions in the field to control some of the unwanted effects of digital noise. The following issues outline a few contributors to increased noise.

- Low light capture.
- High ISO settings: the higher the ISO setting, the greater the noise produced. This is the exact equivalent to the differences between higher ISO films which produced increased grain.
- Underexposure can greatly increase noise. Watch your histograms in the field!
- Slow shutter speeds: when the shutter is kept open for a long time, more noise will be introduced to the image data.
- Sensor size and resolution: larger digital camera sensors generally have less noise because each pixel can also be larger and each photosite can be a bit further away from its neighbor. This extra distance is often enough

to prevent signal leakage from one photosite onto another whereby creating much less noise! Smaller sensors with a higher mega pixel count unfortunately also equate to more noise in the resulting image data.

- Physical size of the pixels on the sensor: bigger pixels in general translate to less noise in resulting image data.
- Temperature of the sensor: higher temperatures generate more noise on the sensor.
- In-camera processing of the signal: camera manufacturer's processing software can affect the appearance of noise in an image.

While it is impossible to completely prevent digital noise from happening, there are a few options that allow you to decrease it significantly.

In low light scenes, ISO ratings and shutter speed are the two main variables to pay attention to. Increasing the ISO creates more internal noise, and slowing down the shutter allows for more noise to integrate onto the CCD. The amount of noise each action generates is different for each camera make and model. Experiment by setting your camera to manual mode and playing with different shutter speed and ISO combinations to find which generates the least amount of noise for a given situation.

Some camera manufacturers include a built-in feature called noise reduction which generates and applies specific algorithms when a slow shutter speed and/or high ISO setting is used to reduce the amount of noise produced in the process. Although these algorithms cannot completely remove all noise altogether, substantial reduction can occur depending on the quality of the algorithm. The noise is typically removed by an interpolation method that creates a replacement pixel based on an evaluation of its neighboring pixels. This, however, typically produces a smoothing effect which comes at the expense of losing fine image detail.

For most photographers, digital noise can be significantly reduced by turning on your camera's Noise Reduction feature, optimizing the camera settings and removing noise with some simple techniques. Be warned that many noise reduction techniques can have the effect of blurring or flattening the image. There is trade-off between losing image detail and decreasing the effects of noise within an image. Keep in mind if you have ever shot a high ISO film, the grain often times offered the image a wonderful quality that many try to emulate digitally. Grain can be beautiful, and so too can noise if the image permits. (See "Reducing Noise with Photoshop", page 228.)

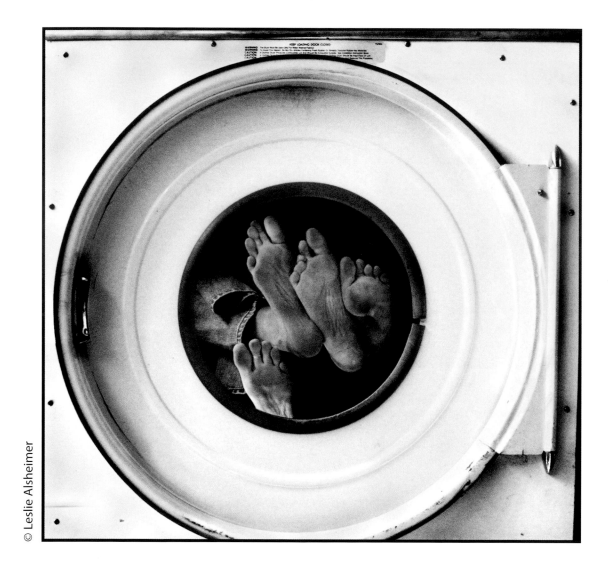

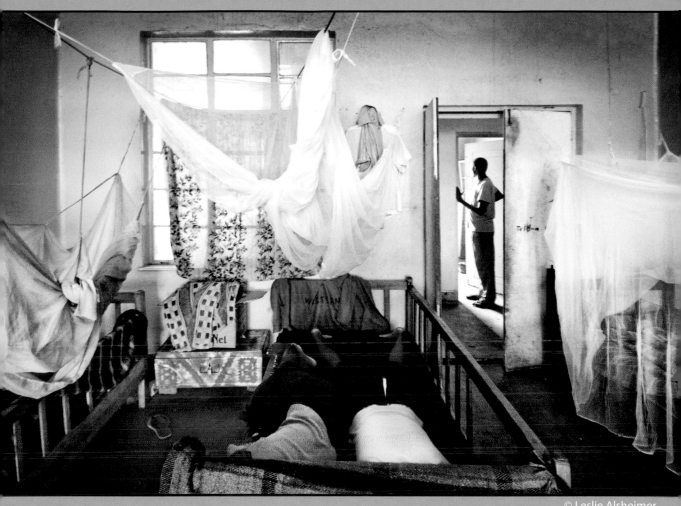

© Leslie Alsheimer

Lightroom Integrated: Workflow Phase II *by Leslie Alsheimer and Bryan O'Neil Hughes*

Integrating Workflow Practices

One of the most frequent requests I get from my beginner and advanced workshop students alike is for step-by-step tutorials through Photoshop, Bridge and Lightroom detailing the digital workflow process. Lightroom and Photoshop can now be used together in an integrated workflow, or each can be used indepently to accomplish the same tasks. Therefore, the confusing truth for many students to learn is that with so many variables from start to finish, so many photographic styles, and so many different ways to handle images, there really is no single "right" way to manage workflow. There are as many different successful methodologies as

there are industry experts and practioners to champion them. As Lightroom has streamlined many digital darkroom techniques, I have created an integrated hybrid workflow using both Photoshop and Lightroom – from capture to print – outlining a methodology I have found successful for myself in practice. Follow these workflow guidelines as a road map, appropriate what works for you and discard what does not. I hope that once you jump in, you will find the confidence and creativity to experiment and play with techniques you never dreamed possible!

Workflow is Dynamic: Go with the Flow!

Workflow is not only user defined, but also an incredibly dynamic process. The images themselves, together with your photographic style, should ultimately dictate the editing workflow. Images are each uniquely created, and therefore every image will not require the exact same set of approaches and tools. As a kayak paddler, I have spent a great deal of time on rivers, and the concept of a dynamic workflow is much like the river experience. As rivers ebb and flow, there are rapids, eddies, rocks, and holes. There is a time to float, a time to eddy out, a time to paddle hard and a time to tuck and roll. One must first learn the skills of the river, and only through experience will one gain the wisdom to know when and how to use those skills in action – and still, even the experienced paddler will sometimes hit rocks. Similarly, workflow is an active

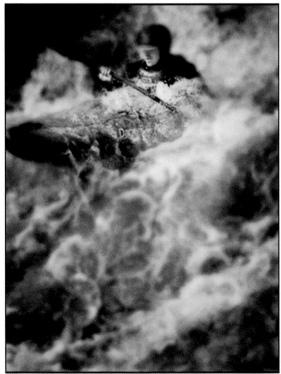

© Leslie Alsheimer

process requiring learned skills to accomplish your creative vision, as well as the experience to know which techniques to apply and when to use them. When paddling a river, the flow of the water guides you, just as the images themselves should guide you in the digital workflow process. As no book can outline the best approach for all readers, use this integrated workflow as a guide to get you started. Try new things, experiment with different methods, and save multiple versions of an image while you play and have fun. Remember the words of Scott Adams who said, "Creativity is allowing yourself to make mistakes; art is knowing which ones to keep". And, of course, go with the flow!

Lightroom Unleashed: The Editing Accelerator

Whether you are new to the digital domain or have significant experience, the release of Photoshop CS4 and Lightroom has truly revolutionized the digital workflow, making the process faster, more intuitive and user-friendly than ever before! As a powerful accelerator for the editing process, Lightroom has become an indispensable component of the integrated workflow and proves its value in the streamlined interface it offers to both the professional and recreational user. The interface lays out the editing workflow structure in an intuitive and logical manner, allowing you to process and edit images in a non-destructive, straightforward manner with exceptional speed and control. Photoshop plays a powerful role in the integrated system, especially for detail and selective adjustment editing – Phase 4 of this workflow. I think of Lightroom as a funnel for ingesting, sorting, applying initial edits and then spring-boarding into Photoshop for more detailed edits.

History

The coupling of Camera Raw, and what was then known as the File Browser in Photoshop 7.0.1, provided the first hints of an abbreviated, subtractive workflow for photographers. As the proliferation of digital cameras grew at an amazing rate, more and more people were using a somewhat limited feature set in Photoshop to satisfy their basic photographic needs. A tailor-made workflow tool was just what professional photographers needed and, in 2006, Adobe made a very unusual move and released Lightroom as a free, downloadable public beta.

Throughout the course of multiple beta updates, more features, functionality and polish was added than anyone expected. By the time that Adobe Photoshop Lightroom 1.0 hit the shelves, it had, indeed, become a full-featured workflow tool for photographers.

A Stepped Approach through Lightroom

Respecting that Adobe updated Lightroom to a full version 2 with a myriad of new features to better integrate with Photoshop and offer even more power for the high volume workflow of the professional photographer, we want to take you through an easy, stepped approach, highlighting notable features within

the software interface. Although workflows do vary, our approach is easy to follow and remember, as it steps through the tools and controls in the same order that Lightroom presents them.

While you may notice that Camera Raw and Lightroom's Develop module share the same features (see Chapter 5, "Black and White in Adobe Camera Raw 5.0", page 156), there are many differences when it comes to how these settings are presented, applied to the image, shared with other images, retained and displayed. The feature parity that the two applications share is particularly convenient when it comes to consistency across platforms as with opening a previously adjusted Camera Raw file in Lightroom (or vice versa).

Lightroom Module Overview

Library | Develop | Slideshow | Print | Web

Library: For import, export, organizing, flagging, sorting, ranking, and key wording of thousands of images. Useful for simple image processing or to apply a custom preset to an entire batch of selected images at one time.

- Library: Cmd + Opt + 1 (Ctrl + Alt + 1)
- Develop: Cmd + Opt + 2 (Ctrl + Alt + 2)
- Slideshow: Cmd + Opt + 3 (Ctrl + Alt + 3)
- Print: Cmd + Opt + 4 (Ctrl + Alt + 4)
- Web: Cmd + Opt + 5 (Ctrl + Alt + 5)

Develop: For the many facets of image adjustment, this is where you'll find some of the most powerful features of Lightroom. It provides a non-destructive raw converter with controls that work equally well on JPEG or TIFF images.

Slideshow: For professional quality PDF presentations. This module offers controls for nearly every variable for a visual presentation including the incorporation of MP3 files.

Print: For easy, and yet very powerful, control of print output. Lightroom, true to its nature, presents printing in familiar terms and a friendly interface, while still delivering professional results.

Web: For the creation, customizability and even upload (Lightroom supports direct FTP) of imagery to the web. Lightroom offers a dizzying array of Flash and HTML templates which can easily be custom tailored to the user's specific needs.

For the sake of this text, we address Lightroom in the modules most pertinent to black and white processes: the Library Module, Develop Module and on Printing from Lightroom.

The Library Module

Library

The Library Module in Lightroom has been streamlined for easier organization and workflow, providing a more intuitive image organization experience. The left-hand panel of the interface will clearly define the source location of images after they have been imported and collections of images that the photographer creates.

Grid View

View modes

1. Grid View

The Grid View in the Library module serves as a basic image browser. Use this interface to navigate files and folders, create Collections or image groupings, and sort images. To access the Grid View, click on the main window icon number 1, and select Grid from the drop-down menu, or go to View > Grid.

Filter Bar: The top of the Grid View provides a panel that can now filter image content. The '\' key will hide or reveal the filter functionality, and the filtering components can be expanded one section at a time to filter content more specifically.

Each of the categories outlined below can be toggled on or off by clicking on the name. Multiple filter categories can be shift-selected to provide additional control.

Text: This feature allows you to search across your image library using text search fields.

Attribute: The Grid View can now be filtered with flags, star ratings, color labels and the type of file, Master or Virtual

Metadata: A wide range of metadata is now presented in easy to browse filter columns that can be added, removed and customized for your specific workflow considerations. Choose the field to filter by clicking on the column header and select a metadata attribute to filter. Click the drop-down menu at the top right of each column to add or remove columns. The column arrangement and selection can be stored as a preset that is defined in the upper right-hand corner of the filter bar.

2. Loupe View

The Loupe View in the Library Module displays a single large image in the preview window. A single click on the image will instantly zoom the preview window to 100%. The Loupe View is fabulous for quickly evaluating image sharpness. You can enter the Loupe View in both the Library Module and the Develop Module just by clicking on the image. It can also be accessed by clicking on Loupe View from the drop-down menu under the 1 icon. Once you have entered into Loupe view, click on the 2 icon for the new second monitor feature and the Lightroom secondary display window will appear. In this window, you will find features that allow you to modify the enlargement factor with fit, fill, 1:1, 1:4, and the drop-down from 1:4 up to 11:1 in the lower right corner.

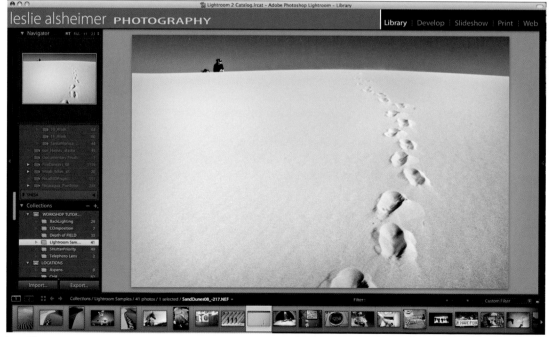

Loupe View

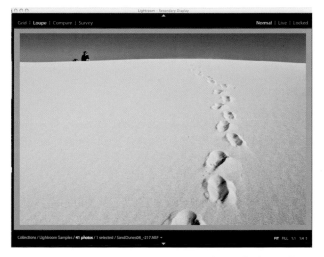

This new second monitor feature is the new dual monitor solution Lightroom 2.0 introduced that can adjust to fit your particular monitor set-up. The main Lightroom window that includes the Module picker can be positioned on either monitor and several different views, as outlined below, can be activated on an additional monitor. To activate a multiple monitor environment, choose the monitor icon in the lower right-hand side of Lightroom, just above the filmstrip. If a second monitor is not attached, a second window will appear on a single display.

Grid: Place the grid on a secondary monitor for quick image selection while the Develop Module is displayed on the other monitor. Or use the grid to reorder images while creating slideshow, print or web output.

Loupe: Allows an image at a preferred zoom level display on an alternate monitor.

- In Normal mode, the image on the alternate monitor is changed when the selection is changed in the primary Lightroom window.

- Live mode is continually updated based on the image and area of an image the mouse is currently hovering or passing over. Zooming to a 1:1 view allows for quick focus checking across a number of images displayed in a Grid View on the primary monitor.

- Locked mode fixes the image displayed on the alternate monitor until you wish to change the selection by selecting Alt/option-Enter to make the current selection visible.

Compare: Offers the same powerful compare functionality previously in the Library but can now be used to compare images while selections are made in the Grid View in the Library, or while adjustments are made in the Develop Module.

Survey: View multiple images at once while organizing or adjusting in another display.

81

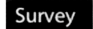

3. Survey View

The Survey View in the Library Module allows you to compare any number of images side by side in the Library Module. This is a great way to compare the overall composition of images shot in a series. First select the images you wish to survey and then click on the main window icon number 1, and select Survey from the drop-down menu, or go to View > Survey.

Survey mode can also be accessed from the Lightroom secondary display window by clicking on the 2 icon or, if you are already in the secondary display window, click the survey icon at the top left.

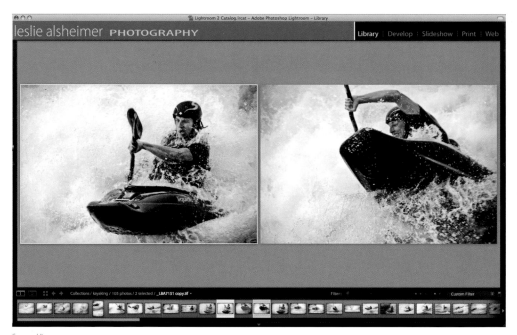

Survey View

4. Compare View

The Compare View allows you to quickly sort through a sequence of similar images to find the sharpest and best composition, and rank the images accordingly. I usually move images into the Compare View after I have made an initial edit. The Compare View places one image as a selected image and the other as the candidate. You can zoom into both images simultaneously, to the exact same location or separate locations on each image.

Access the Compare View by clicking on the 1 icon and choosing Compare, or click the 2 icon and choose "Compare".

The lock feature icon will keep them together when locked and allow separate view zooms when unlocked.

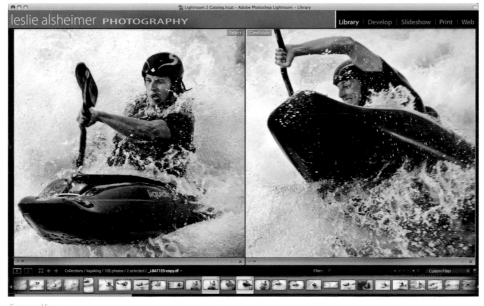

Compare View

You can use the arrow keys to scroll through the candidate images, the swap icon to exchange the candidate image with the select image, and the select icon to designate the candidate image as the select image. When you are finished comparing images, click the Done button to exit the Compare View.

Note:
Most of these steps can also be accomplished using the Photo Downloader in Bridge. The advantage of using Bridge is that it is a browser and does not does require importing. See page 109.

I. Import: Includes Download, Backup, Rename, Keyword, and Copyright

There are many ways of downloading images to your computer. Lightroom innovations have streamlined the downloading process and integrated many practical features into one simple and amazing dialog box. The Import Photos box in Lightroom allows us the benefit of file renaming, keywording, backing up, and inserting copyright and metadata in a single dialog box interface.

Step 1: Launch Lightroom and Set Preferences
Lightroom can automatically launch the Import Photos dialog when you attach your camera or plug in your card reader and insert a memory card. To enable this automatic feature, however, you need to set the preference for it in Lightroom. Open the Preferences panel: Lightroom > Preferences. Then go to "Import" and click the checkbox next to "Show import

dialog when a memory card is detected". It is a good idea to rename camera file folders. You might also want to check the "Ignore camera-generated folder names when naming folders" box as well.

Step 2: Connect Digital Media

Place your media card into the card reader or attach your camera with its supplied cables. Lightroom will automatically recognize the input image data and launch the Import Photos window for you. If, for some reason, the import window does not appear, the Import Photos dialog box can also be accessed by choosing the File Menu > Import Photos from Disk, or by simply clicking the Import button at the lower left corner of the Lightroom interface and choosing either your card or device. From this dialog box you can also import images from other drives or folders on your hard drive.

Step 3: File Handling

Next, the Import Photos dialog box will appear. It is always best to work top down within dialog boxes, so we will start with the first drop-down menu at the top of the Import Photos box, "File Handling". This drop-down menu offers a few choices to import your images into Lightroom. The first choice is to import images from their current location. This would be an excellent choice if you had already copied the image files onto the computer or an external drive. If you want to copy images directly from your compact flash card or SD card, you will want to copy the image files to the hard drive first. I am going to bypass this choice. The next choices are to "copy or move the photos to a new location and import", or to "convert to DNG and import". As an advocate of the DNG methodology for raw image storage, this workflow protocol highly recommends the "convert to DNG" option for import.

The name of the folder you choose will automatically be used as the import name in Lightroom. Lightroom 2.0 now allows you to access and view folders on your hard drive and external drives as imported. This list can also show you what files and folders are no longer accessible to Lightroom, such as those that may be on an external drive that have been unmounted. These folders will be grayed out. You can create a new folder in Lightroom with a specific name either before or after you import by clicking the plus icon next to the "Folders" list on the left interface panel in Lightroom.

Step 4: Copy To

The next step, moving down the Import dialog box interface, will be to choose the destination for the images to be copied. Navigate to your hard drive or external drive and create a new folder to copy the images into. It is good practice to create a logical naming system that works for you. I typically name by location first and by date secondary, as this is how I can best remember and retrieve my images. When finished, click "Choose".

Step 5: Organize

Next, you will choose how you would like Lightroom to "Organize" the images. You can do so by date in several ways, by original folders or into one folder. If you have multiple sub-folders of images, you can choose exactly which images to import and which to exclude, or you can combine all the images into one single folder for the shoot. I usually choose to organize into one folder because I like to see all the images from a shoot in a single unified location.

Step 6: Create Backup

Lightroom can also search for duplicate images during the import process, which can be helpful in keeping the cache from getting larger than it needs

to be. However, I usually check "Ignore Suspected Duplicates" just in case I may have different files with the same name. Next, check the "Backup To" checkbox and click "Choose" to navigate to an alternate storage device and create a folder for placement.

Backing up images onto multiple hard drives and/or CDs and DVDs is an absolutely essential practice within the workflow process. Best practice would be to always have the images in three locations at all times. Typically it is a good idea to have at least one copy in a different location than the rest, just in case of fire or other disaster. It really is not a matter of "if" a hard drive crashes or "if" other image disasters will happen to you, but more a question of "when" it will happen to you. Therefore, the best practice is to err on the side of caution and always be prepared.

Step 7: File Naming

I do not know who can make sense of the camera automatic file numbering systems with digital capture images. With so many digital images over the years, I cannot remember which image corresponds with which number, so I rename my images according to shooting location and date. Multiple files from a particular shoot can be renamed quickly and easily into a system that makes sense to you with the file naming feature in Lightroom. We can now rename all our files with one simple batch command as we import the images into Lightroom. Move down the Import Photos box to the "File Naming" portion and click on the drop-down menu next to "Template". There are many naming convention options to choose from here; I prefer "Custom Name – Sequence" and choose "Edit" so that I can type in specific information according to the shoot.

Create a name that you wish to give the files you are about to import. It is a good idea to use naming conventions that keep files universally compatible across operating systems; that is, try not to make the names too long, and use underscores – not spaces – to separate words.

File Naming: Lightroom_Samples-1.dng
Template: Custom Name – Sequence
Custom Text: Lightroom_Samples Start Number: 001

Next I choose to insert a sequence number and I usually choose three digits to allow for lots of images in a single folder. My titling system includes the location

and the date in non-numeric form so I do not end up with more of a number mess than I started with. Example: Custom text: Uganda07_SoftPower_001. Lightroom will show you an example of your choice at the top of the box so that you can make sure you are doing what you had intended.

Step 8: Information to Apply

Next choose a preset for developing the images as either Antique Grayscale, Cyanotype, Direct Positive, Grayscale conversion, Sepia Tone, Tone Curve, or Zero'd. I typically choose "Zero'd" to remove any additional data added to my raw files. You may, however, find a reason for any number of the other choices at different times. Remember, as Lightroom is non-destructive, anything you choose to do can easily be undone as no data is applied directly to your files!

✓ None
Creative – Aged Photo
Creative – Antique Grayscale
Creative – Antique Light
Creative – BW High Contrast
Creative – BW Low Contrast
Creative – Cold Tone
Creative – Cyanotype
Creative – Direct Positive
Creative – Selenium Tone
Creative – Sepia
General – Auto Tone
General – Grayscale
General – Punch
General – Zeroed
Sharpen – Landscapes
Sharpen – Portraits
Tone Curve – Flat
Tone Curve – Strong Contrast

Information to Apply

Develop Settings: None

Continuing downwards in the dialog box, we come to the metadata and keywords insertion area. These fields work together and allow an amazing degree of control for customizing and inserting metadata during the import process.

Metadata:

Step 9: Embed Copyright Info with Metadata Template

Metadata is information embedded into the image file that describes the image in any number of ways. Digital cameras attach metadata that describe the camera make and model, the ISO, aperture, shutter speed and flash settings. Within the metadata panels, we can attach our own personalized information like copyright information and descriptions about the image location and subject matter for search engines to find.

Embedding your copyright information into the image files attaches your name and contact information to the image wherever the file travels. Last summer, I photographed some friends on a kayaking trip on the Rio Grande

River in New Mexico. I emailed some of the images from the shoot to several friends, sharing the memories of the trip. Those friends subsequently forwarded the images via email to other people, one of whom happened to be a magazine editor, and I was subsequently contacted to publish some of the images. If it were not for my copyright metadata tags embedded in the image files, that art director would not have been able to contact me.

In order to apply your copyright information to your image files, you will first need to create a template. Once you have created a template, it will live in this drop-down menu for you to choose as a preset with a single click. The following steps will guide you in creating a personalized copyright template.

Click on the Metadata drop-down menu and choose "New".

Move down the box and enter information into the fields that would be pertinent to all images you shoot. Make sure to enter a title in the "Preset Name" field so that you can access it again in the future.

Step 10: Keywords
Keywords are text information that describes the important contents of an image. Embedded into the image files in the form of metadata, keywords are extremely helpful in identifying, sorting and finding images in library and database searches. Whether for stock submissions or just your own personal library, use keywords to start cataloging your image database. Move down to "Keywords" and type the words you wish to apply to all of the images for this import. These keywords will be added to every image so that it is best to keep them fairly general. Leave specific image information to selective

image keywording in the library Keyword tags panel. I am importing images shot in Uganda while working with an NGO called Soft Power Health, so I have added the appropriate general keywords for that folder of images. I will later go in and add more specific keywords if needed. Once finished, click "Create", and select the preset name you just created in the Metadata drop-down menu.

Lightroom 2.0 now offers a new Keyword Set called Suggested Keywords. This new feature makes keywording far easier as Lightroom can now suggest keywords for the current image based on existing keywords applied to that image, and offer other keyword suggestions that are close neighbors in terms of capture time. For example, if a number of images in a catalog contain the keywords "Santa Fe" and terracotta, an image assigned the keyword "Santa Fe" will cause the suggested keyword panel to automatically update to show "terracotta" as a suggested keyword.

Step 11: "Render Standard-Sized Previews"

It is a good idea to check "Render Standard-Sized Previews" so that Lightroom can build the 1:1 previews of the images being imported. This is an important step in the import process for viewing and evaluating full image detail and sharpness, but unfortunately this process is also rather time-consuming. The editing process will go much smoother and faster if you do allow the software enough time to build previews but if you need to speed up the process and choose not to render previews, you can always render the previews in Lightroom later by going to the Library Module > Previews > Render Standard-Sized Previews.

Step 12: You are now ready to Import!

Lightroom will import the images, build the previews for your thumbnails, back up your files, rename them, and apply your copyright and keywording to the metadata in one incredibly smooth moving interface! Kick back and let it all happen for you!

II. Lightroom Basic Editing

Step 1: Actual Editing: Sort, Rotate and Evaluate

Lightroom has created a streamlined interface that dictates workflow with a top down approach, but any way you wish to structure the process within your own workflow is right if it works for you. I usually move from the Grid View to the Loupe View and move through my images with the full size preview to sort, edit and rank the images. Lightroom also provides a great deal of customizable attributes to the browser windows, allowing the user to edit panels in many ways. You can click the large arrows on the side of the interface to collapse the panels and provide more screen real estate for image evaluation. I usually leave the left panel open so that I can view the Navigator and see what part of the image I am looking at when I zoom into it.

Note:
You may want to burn another backup at this stage with all your raw files to yet another device. At this point, I usually immediately stop and burn a DVD of the raw files I just imported and backed up. This way I have multiple copies of the raw files before I ever start the editing process.

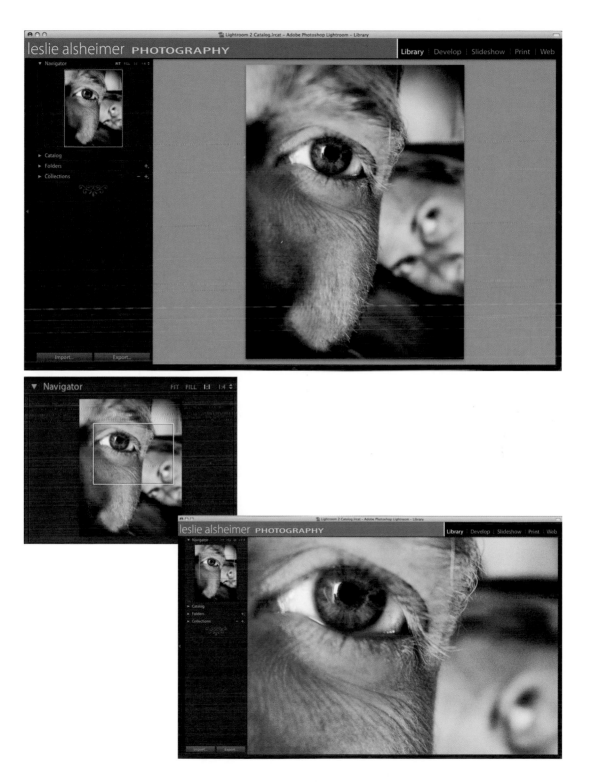

You can also compare any number of images side by side by selecting more than one image either in the Library mode or using the filmstrip and moving into Survey View. The following is an example of a customized window display.

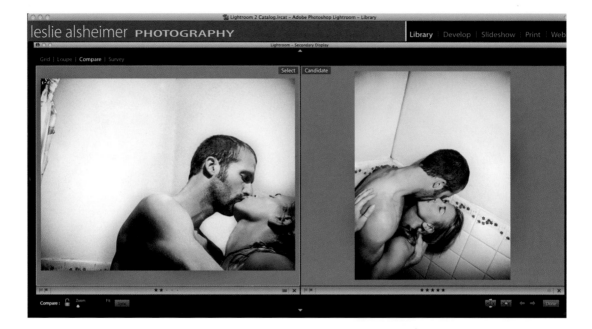

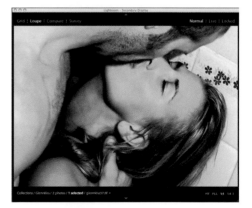

Check the sharpness of each image quickly by clicking the mouse on the image preview, which will automatically zoom the image to a 1:1 preview. Click, hold and drag the mouse to scroll the image for detail views.

Step 2: Photo Menu: Label and Rank

Set ratings, color labels and flags to label and rank your images on the fly using the Photo Menu. Use the icons at the bottom of the interface, or tap the number keys from 1 to 5 to rank the images with the numbers assigned. Learning these and other keyboard shortcuts for these features will speed up your process exponentially! Flags and color labels can also be applied for categorizing, filtering and sorting images. I typically start my editing process by giving one star to each image that gives me even the slightest pause, and nothing to images I do not like. I usually make two or three passes and narrow the edit with two stars on the second pass, three on the third and so on.

Step 3: Deleting Images

Hitting the Delete key on your keyboard will bring up Lightroom's safety dialog box, asking you whether you really want to delete the file or just remove it from Lightroom. This protects you from deleting files accidentally. Selecting "Delete" will move the files to your trash or recycle bin but will not actually delete them until you empty the trash, allowing you to retrieve the images if necessary.

III. Basic Image Processing: an Overview of the Lightroom Develop Module

First, let's select an image for development and click into the Develop Module. Of course, not every image will require the same adjustments. The following will take you step by step through a streamlined workflow for the Develop Module, highlighting all of the basic features and specific tool functions.

Note:
As with all aspects of Lightroom, crops are completely non-destructive and can be undone or modified simply by reselecting the Crop (C) tool

Step 1: Crop

1. Select the Crop Overlay (R) from Lightroom's tool bar beneath the image

2. Simply draw, drag or pull corner points to set crop guidelines.

3. To straighten a skewed image, select the Straighten tool (Shift+Command) and define a start and end point on a level axis.

4. Now double-click upon the image to apply the crop.

Step 2: White Balance: LR_WhiteBalanceTool

1. Select the White Balance tool (I). The White Balance Tool is used to approximate the true color temperature of your image. To do so, click on a tone likely to be a true neutral.

2. If your image needs further adjustment, either the Temperature slider or White Balance drop-downs are good places to start.

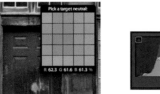

Step 3: Tone/Basic

1. By clicking on Lightroom's histogram arrows, we remind the application to show us regions of the highlights or shadows that will be clipped so that we can be certain to preserve all of our image's details. To do so, click each arrow icon at the far left and right of the histogram.

2. Move the Exposure slider until red overlays (clipped highlights) begin to appear.

3. Now select the new Recovery slider, and move it to the right until the red portions disappear.

4. Next, move the Fill Light slider to the right – this will "dodge" the shadows. Continue adjusting until you have your desired effect. If the image does not have enough contrast, do not worry, we will get there.

5. We will now carefully move the Black slider to add true blacks back to the image; move the slider until the blue overlay is just barely visible (too much blue indicates clipped shadow regions).

 If you would like yet more contrast, the appropriately marked Contrast and Brightness sliders offer a good way to massage the details – remember to be mindful of the red and blue overlays.

Step 4: Tone Curve

Everyone has heard of curves: the feature that is as intimidating as the cockpit of a jumbo jet, and promises to be just as powerful. Any Photoshop power user will tell you that magic is in Curves; this gets troubling when you try to put the gospel into practice. Something about trying to wrangle an s-shaped line to deliver a good exposure just does not seem intuitive.

Luckily, there is not a curves control more powerful or more intuitive than the one found in Lightroom. Let us look at the parts of the Parametric Curves control in Lightroom.

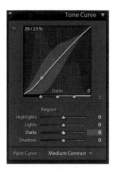

Tip:
Did you know that you can click and drag the base of the histogram to change the range of the four sliders?

Note:
See Chapter 6, "Black and White & Creative Image Editing in Lightroom" for more in-depth conversion options.

Histogram:
Behind the curve itself, Lightroom shows a large, clear histogram. Corresponding quadrants at the base of the Curve show which slider controls which region of the curve. As you mouse over the curve, the histogram shows which slider controls which region. Say you wanted to only adjust the deepest, darkest black tones in an image with the Shadow slider. Just pull the left most tab to the desired location – now Shadow maps only a small subset of the histogram.

Highlights: This control maps the quadrant from the brightest tones; adjusting this is a great way to pull down specular highlights in an image.

Lights: These are the areas that detail often hides, and where the bright side of contrast can often be found.

Darks: Conversely, this is a region where light shadow detail is hiding or mid-contrast can be improved.

Shadows: This is the darkest portion of the image, and this slider can be used to have rich blacks or detailed shadows.

This is all fine and good and, like Camera Raw, it is an enormous step forward for Curves; Lightroom takes it somewhere completely unique, though. Note the tiny round button to the left of the Curve; the tool tip reads "Adjust Tone Curve by dragging in the photo" and that is exactly what this does! With this button enabled, a user needs only to find the region on the image that they want to adjust, and simply mouse down upon it and drag upwards or downwards. This is by far the most powerful and intuitive way to make adjustments.

Step 5: Convert to Grayscale: Basic Conversion

Like Camera Raw, "Grayscale" refers not to an image mode, but to the black and white conversion feature in Lightroom.

1. Within the HSL/Color/Grayscale palette, simply select "Grayscale".

 By design, this adjustment leverages the same "Auto" setting as Camera Raw. "Auto-Adjust" maps the color tones in the image to present the user with a nice, well-contrasted conversion.

2. As with Camera Raw, each individual slider can control a given region of the monochromatic image. You may have noticed that familiar button from Curves; yes, you can interact directly with your black and white adjustment by first pressing this button!

Step 6: Split Toning

Lightroom features a very easy and powerful ability to split tone, which is to apply two separate hues – one to the highlights and the other to the shadow regions.

1. Within the Split Toning palette, grab the Highlight Hue slider and pull slowly to the right.

2. Once you have decided upon a highlight tone, repeat Step 1 with the Shadow tone.

3. Simply slide the Balance control back or forth to equalize the image to suit your taste.

Tip:
While moving the Hue slider, hold the Option key. This gives a preview of all hues at 100% saturation and saves a ton of time.

Step 7: Detail

All images benefit from some form of sharpening and many, even this one shot at 100 ISO, enjoy a bit of noise reduction. As with all of Lightroom, the controls are simple and very powerful. The best methods for user controlled sharpening are still in Photoshop; however Lightroom can be useful for speed and ease.

1. Before touching either slider, click with the (default) Hand tool to zoom in to 100%, or you can use Lightroom's new 100% preview window to enjoy "multiple views".

2. Within the Detail palette, under "Sharpening" move the Amount slider to the right until you see the results you like.

3. Now do the same with the Noise Reduction slider.

*Remember, for both controls these are only settings and can be adjusted at any time for printing, exporting or previewing. Lightroom now has variable output sharpening too, so you always have the right sharpening for preview, print or web.

Step 8: Lens Correction

Vignetting is a way to dodge or burn just the corners of an image; doing so correctly brings the center of the image into even more prominent focus. (See Chapter 6 for a more detailed description.)

1. Within the Lens Corrections palette, under "Lens Vignetting" move the Amount slider to the left (watch out for shadow clipping).

2. To control the range of the vignette, move the Midpoint slider.

3. Lightroom 2.0 brings more flexibility to vignetting with control over feathering and roundness, and a truly re-editable feature via post-crop vignette.

Step 9: Before and After

Lightroom offers a variety of ways to see "before" images beside, above or split with "after" images. You can see by the below example how far I've come in a few short steps.

1. Toggle the Before and After button to get different views.

2. Click upon the Loupe View icon to revert to full screen.

Lastly, pressing "L" once shows us our finished product in a semi lights-out mode. Ta-da! Image development and processing can be done extensively and uniquely one image at a time or, for incredibly fast batch processing, Lightroom allows you to apply all the same adjustments to multiple images at once. You must first develop one image entirely the way you like it and then select any number of images you wish to process with the same adjustments and click the SYNC icon at the bottom of the Develop Module. A dialog box will appear allowing you to choose which of the previous adjustments to sync. Uncheck the adjustments you feel should not be applied.

Step 10: Photoshop

Lightroom is extremely powerful and we have rendered a very nice split toned image in a relatively short amount of time. If your particular image needs more detailed edits, continue to Photoshop by menu, Ctrl + Clicking on the image or by clicking Command + E (with Photoshop set as an external editor). (See "Integration: Lightroom to Photoshop" on page 103.)

IV. Export: Archive, Contact

Export DNG and burn another backup

After all the image processing, file naming, keywording, copyright embedding, sorting, ranking and global adjusting has been applied to your satisfaction, the best practice would be to burn another backup onto disk. Lightroom offers the option of burning large JPEGs to disk with one quick and easy step (great for registering copyright of your images). Since the raw files are your "digital negatives" containing the highest quality versions of information, the best practice will always be to do everything you can to save them. I first export all the images as DNG files with all my latest editing and adjustments to a separate folder as "selects" for backup and burn that file to DVD.

Step 1: In Lightroom, click the big Export button at the bottom left panel of the interface window, or go to the File Menu > Export. The Export dialog box will appear. As always, the top down approach is the most logical and effective way to address dialog boxes within both Photoshop and Lightroom.

Export...

Step 2: Start with the "Preset" drop-down menu. Here you can create your own templates catered to your specific output goals, or use one of the Lightroom templates. You can create as many different presets as you have destination output goals for your images. Lightroom already includes presets for exporting for email purposes, as well as burning JPEGs to disk. We choose the ready-made template for converting to DNG. WAY COOL. Choose Export to DNG.

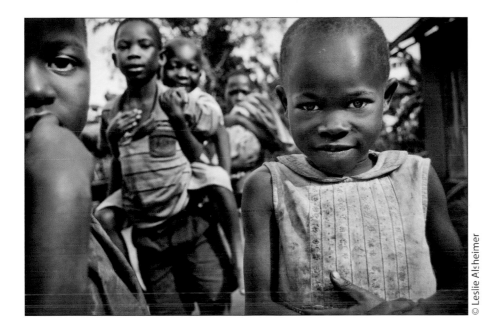

© Leslie Alsheimer

Step 3: Choose a destination folder. For organizational purposes, I have a permanent Lightroom export folder on my hard drive marked with the year. For each export, I check the "Put in Subfolder" box and title according to the shoot.

Step 4: I choose a file name that keeps the current file names attached to the images. You may want to create a custom name here to differentiate between the raw files and the processed DNGs. Either approach is good workflow practice.

Step 5: Now click on the drop down menu at the top and choose "Files on CD/DVD" instead of "Files on Disk".

Step 6: Click "Export". The CD drive of your computer will magically open and a dialog box will appear prompting you to insert a blank disk. Insert a blank disk and burn!

Print a contact sheet

At this point in the workflow, you may want to print contact sheets of the images that can give you a visual reference to the images and where they live. Move to the Print Module and choose one of the easy templates 4×5, 5×8, or 4×4., or have fun customizing a contact sheet style of your own with the options available in the right hand panel of the Print module.

Note:
See Chapter 6, "Printing," page 204 for more details.

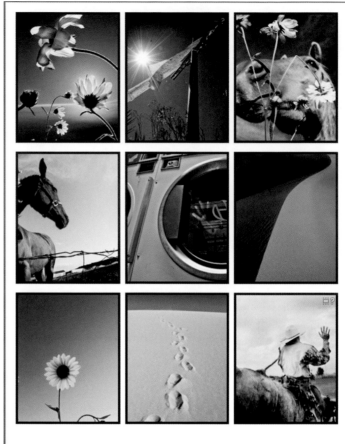

© Leslie Alsheimer

Customized Contact Sheet

Special Note: Lightroom Color Management

Lightroom is extremely color savvy and, up until the point of Export, Lightroom has done all the color management behind the scenes. Lightroom works with all images in the ProPhoto RGB color working space and combines that space with a special tone curve developed from the sRGB working space. Remember, ProPhoto RGB is the largest working space, allowing for the greatest amount of color possible; however, it is also so large that as of yet, there are no monitors nor printers that can reproduce all of the colors it can produce. The added tone curve allows Lightroom to create a realistic working space for image editing. The export process is where color management, and your decisions about how you wish to handle color, will come into play with your Photoshop color management policies. (See Chapter 1, "Color Management for Black and White", page 23 for details in setting up Photoshop to manage color properly.)

Integration: Lightroom to Photoshop

Once you have processed your images with all the global adjustments possible in Lightroom, and safely archived your images in at least three locations, you will want to work more extensively with some choice images for the more powerful selective adjustment phase of the workflow. Photoshop is the next step for more complex selective editing and conversion options, as well as for applying more advanced sharpening techniques for your desired output in prepping images for print.

There are a few options at this point to move images from Lightroom through to Photoshop.

Lightroom to Photoshop: Direct Edit

To move directly from Lightroom into Photoshop, select one or several images in Lightroom that you wish to edit in Photoshop. You can do this either one at a time as you are ready for them, or in a group with as many images as you can take on at once. Use the Shift key to select multiple images at once.

Go the Photo Menu > Edit in > Photoshop CS4 or Control-click (Right-click PC) on the selected images and choose "Edit in Photoshop CS4", or use Command+E. Choose "Edit a copy with Lightroom adjustments".

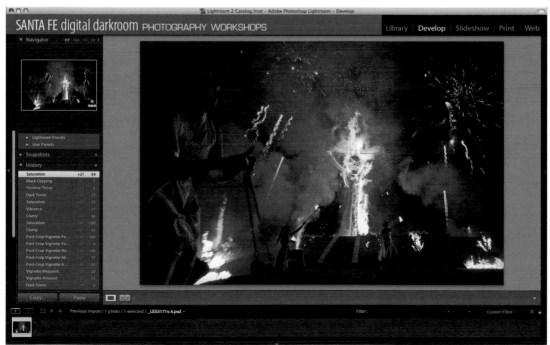

© Leslie Alsheimer

Lightroom to Photoshop: More Features

To invoke these features, Control-click upon one or more of your images in the library, you will then be presented with this dialog:

Open as Smart Object in Photoshop

A Smart Object is a non-destructive way of referencing a file's original. This means that once in Photoshop we can resize, rescale, apply filters, etc. and can always revert back to our original. So imagine an image sent from Lightroom to Photoshop is downsized for web use and sharpened, but then later you need to send that same file out of Photoshop as a full res CMYK with different sharpening. This is no problem! Smart Objects embrace Lightroom's live, re-editable workflow.

Merge to HDR in Photoshop

Bracketed shots can quickly and easily be sent to Photoshop where they're merged and converted to 32-bit HDR High Dynamic Range to extend the visible information throughout the spectrum.

Open as Layers in Photoshop

Whether you want to do something really tricky like create a time-lapse video, use CS4's newfound ability to add depth of field in auto-blend, or just composite various images into one, Lightroom now works closely with Photoshop to allow you to bring a series of images into one Photoshop file as Layers to be merged in Lightroom – that way all the data looks as consistent as possible.

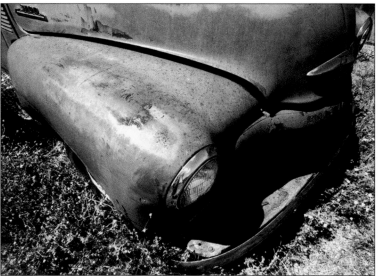

© Bryan O'Neil Hughes

Merge to Panorama in Photoshop

Talk about a time-saver, not only can you send multiple images over to Photoshop to leverage its incredibly powerful alignment engine, but you can also blend, remove vignetting and correct for geometric distortion (all new in CS4). Another great and unknown feature in CS4 is that the "Auto layout" knows best: you don't have to choose which sort of composite your merge looks the most like, though I should mention you have more choices there too. Once you've selected this option (only available with two or more images) you will be presented with the dialog (right). Photoshop takes care of the rest. Saving the new image file will place the merged composite back in the Lightroom's Library Module alongside the original!

A tip for getting better panoramas is to lock exposures when you originally record them and synch settings amongst the files to be merged in Lightroom – that way all of the data looks as consistent as possible.

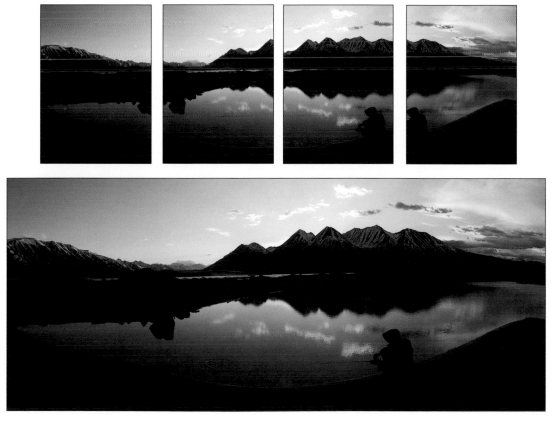

Note:
Bridge can also preview
and play video which
some new SLRs record!

Adobe Bridge: Overview

Adobe Bridge CS4 is a powerful and easy-to-use visually-oriented media
manager, organizer, file browser, and navigational tool. Bridge offers much of
the same functionality as the Lightroom Library Module, however Bridge does
not require the importing or exporting of data in order to use it. Bridge can
be used to visually browse all the images on your computer and external hard
drives instantly. For this reason alone, Bridge remains an essential component
of the integrated workflow process. If you work with images frequently in
Photoshop, Bridge can be invaluable in expediting workflow. Additionally, if
you know both Bridge and Lightroom, you can use Bridge to process a batch
of raw images in the background, which frees up Lightroom for other tasks.

Use Lightroom as an image database and primary digital darkroom in the
integrated workflow. Use Bridge as your image navigational tool for locating
images with any format visually and for launching them into Photoshop when
you are not working in Lightroom, and for background batch processing. As
Bridge and Lightroom share the same camera raw engine, and Bridge has the
capability to do many of the same workflow tasks we outlined in Lightroom
(although not as efficient and with fewer features,) for the specific focus of this
text we have bypassed the redundancy and outlined an overview of Bridge
for its usefulness in the integrated workflow process.

Default Thumbnail View

Bridge allows you to easily organize, browse, locate, and view all your creative assets providing centralized access to image files and XMP metadata with a multitude of tagging and searching capabilities. As a stand-alone application, Bridge synchronizes files for the entire Adobe Creative Suite, and allows you to see larger thumbnails of files, and even video, with a plethora of options. In previous versions, Bridge was sometimes painfully slow but CS4 has updated Bridge with a speed boost, a new exciting Review Mode, and many other cool features.

Interface

Use the Folders panel to navigate through your computer's internal and external hard drives, as well as to view images visually as scalable thumbnails. To see larger previews, click an image and it will appear in the Preview panel (or press the keyboard spacebar to see a full-screen preview. Press the spacebar again to return to the thumbnail).

Vertical Filmstrip View

Export from Lightroom

Use the Bridge to navigate to and select images exported from Lightroom, such as the DNG files previously exported for the burned backup.

Automatically Launch Bridge

Bridge can now be set to automatically launch in the background during system login so that it is instantly available when needed. To set this preference, go to Bridge > Preferences > Advanced and check "Start Bridge at Login".

Advanced

☑ Start Bridge At Login
During system login launch Bridge in the background so that it is instantly available when needed.

Essentials View: Metadata Focus

LESLIE1　VERTICAL　**ESSENTIALS**　FILMSTRIP ▼

View Controls

Workspaces got top billing in the new Bridge CS4 window, making them much easier to find and use. These were previously tucked at the bottom right of the CS3 window with the mysterious 1, 2, 3 labels. Use the quick icons in the upper right corner of the browser window to see different views of the thumbnails, and use the slider to change thumbnail size on the fly!

Custom Workspaces

The interface design allows you to move through your hard drive quickly and easily affording you much faster access to workspaces. If the pre-configured workspaces don't suit your needs, you can also create some of your own. Arrange and resize panels and eliminate unnecessary panels to maximize your screen real estate. After you've arranged and resized the panels the way you want them, save and name the workspace so you can access it quickly. Create several workspaces for different image tasks, Window Menu > Workspace > New Workspace.

Navigation

At the top of the Bridge interface window are several navigational tools including Forward and Back arrow buttons that let you move through recently viewed folders, a "Go to parent or Favorites" menu (the down arrow icon) which lets you move up a folder in your directory or access folders you have added as Favorites,

and the "Go to recent file" menu that allows you to see all the files and folders you have recently visited.

One of the most useful additions is the Path Bar, which serves as a trail for helping you maintain a spatial orientation to your file system. If you do not see it, choose Window > Path Bar.

Spotlight Integration

New to Bridge CS4 is a search bar with Spotlight integration. If you do not know where an image file lives, type its name, the first few letters, or keywords into the search field and press Return. Bridge will instantly launch a search throughout your hard drive to locate the file. However Spotlight is specific to OSX on the Mac, otherwise Bridge will search by default through file metadata.

Downloading Images

Using Bridge to download your photos instead of Lightroom can now be done seamlessly through a separate application called Adobe Photo Downloader. This allows you to accomplish almost all the same workflow chores outlined in Lightroom, such as automatically rename images, add keywords, descriptions, and copyright info. It can perform a backup as part of the import process and burn a DVD for off-site storage in a single user-friendly dialog box. (See I. Import: Includes Download, Backup, Rename, Keyword, and Copyright, pages 84-90.)

Automation Tools

If you are shooting for HDR (High Dynamic Range) or for panoramas, there are a few new automation tools that will help speed up your workflow. By evaluating metadata, Bridge can now collect your panorama or HDR images for you by choosing Stacks > Auto-Stack Panorama/HDR. Images can be moved directly to Photoshop to create, save, and preview the finished panorama or HDR file by choosing Tools > Process Collections. If you want to open several images in a multi-layered document, choose Bridge > Tools > Load Files. However, small quantities of images seem to work better than large quantities at one time.

Create Collections

Open the Collections Panel, Window Menu > Collections. Expanding on the previously existing collections feature, Bridge now offers a new Collections panel allowing you the ability to group your images into virtual albums just like Lightroom. You can build collections manually or have Bridge do it for you by selecting certain criteria like star-rating, name, or keywords for Smart Collections that will grow over time as new photos with matching criteria are added to the collection automatically. Collections now afford Bridge some powerful library functionality, accelerating its usefulness well beyond the mere browser it once was.

Camera Raw Integration

One of the many benefits of organizing and browsing images in Bridge is its integration with the Lightroom Develop Module and the Camera Raw plug-in – as they share the same engine the feature parity is synonomous. There are many ways to open your images in Camera Raw from within Bridge, with the simplest being to just double-click the file, or Control-click it and choose "Open in Camera Raw".

Batch processing

If you have several images that need the same processing edits, you can copy the settings from one image and apply them to other images right in Bridge. Control-click the image in the Content panel and choose Develop Settings > Copy Settings from the resulting shortcut menu. Then, multiple select the images you want to apply the settings to with the CMD and/or shift key and Control-click to access the shortcut menu again and choose Develop Settings > Paste Settings. You can also access these menus from the Edit menu in Bridge.

Adobe Output Module: Slideshows, PDF, and Web Galleries

Bridge can also create an instant slideshow of your images, and generate PDFs or a Web gallery. The new Adobe Output Module offers an interface very similar to the Print and Web Modules in Lightroom. It is extremely intuitive and easy to use. Select the images you want to export and click the Output workspace button at the top of the Bridge window. In the Output panel a Template pop-up offers some preset options that can be customized. Click the Output Preview tab

in order to see a preview. Although you cannot save any of the settings created, Bridge will remember the last settings applied.

Review Mode

After downloading your images, the new Review mode lets you see them in a full-screen floating carousel. It's a quick and easy way to view your images full-screen, mark rejections, create collections, and apply a star-rating system. To use Review mode, select a folder or multiple images, click the refine icon at the top of the Bridge window and choose Review mode (or press Command+B). By using the left and right arrow keys, you can sift through your images very quickly. To exit Review mode, click the "X" at the bottom right corner or press "Escape".

To take a closer look at part of your image, click the Loupe button at the bottom right or click the image itself. You can also rotate your images in Review mode.

Sorting and Filtering

Bridge offers a lot of flexibility for viewing and sorting your image collection. The Sort menu feature at the top of the window can be used to arrange images by name, date modified, size, etc.

The Filter panel allows you to weed out images by displaying those that match a certain criteria, like star-rating, or rejections. If you have rated your images, you can quickly view your top edits on the fly.

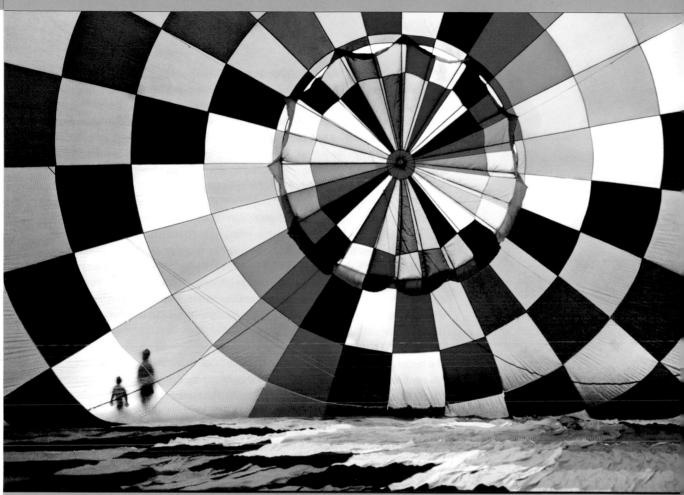

© Leslie Alsheimer

Black and White in Photoshop I
by Leslie Alsheimer

Black and White Conversion Techniques in Photoshop

The selective image adjustment and conversion process from this point on is based entirely on aesthetic judgment. There is unfortunately not a step-by-step formula applicable to all images. Content, time and creative preference must guide you through the rest of the workflow. This chapter will outline some simple and advanced conversion options available in Photoshop, as well as their founding theories and methodologies, followed by step-by-step techniques outlining each option. Experiment with the differences. Create several different versions before you move on to more advanced selective image editing and the printing workflow.

113

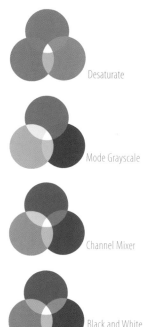

Desaturate

Mode Grayscale

Channel Mixer

Black and White
stand-alone

negative required a bit of testing to determine its unique best exposure and development technique including chemical dilution, agitation and temperature. Similarly to the digital domain, the reality in the chemical darkroom was that one could produce a beautiful print using any number of dilutions, exposure combinations and temperatures (within a certain range). Although the tools and the methods have changed significantly over the years, the methodology is really remarkably similar. Throughout this chapter, we return to the traditional darkroom methods and how to bring those principles back into the new technology. For those who have never experienced the traditional darkroom, my best alternative analogy would be cooking. Many recipes for green chili stew (a local New Mexico favorite of mine) can make a great meal, but the best recipe probably involves a few adaptations of one's own to suit preferences and taste.

The advantages and possibilities in the conversion process become more fun and dynamic as we explore the various options and tools at our disposal. The more of these techniques you have in your repertoire, the more adept you will become at optimizing your images with the most effective grayscale conversions. Notice in the images (below) how each conversion method offers a slightly different result. With some images, this difference will be subtle and with others the differences can be absolutely stunning.

Desaturate

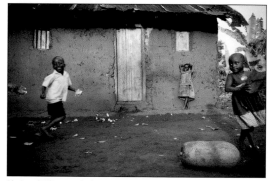

Mode > Grayscale

Channel Mixer

Black and White stand-alone

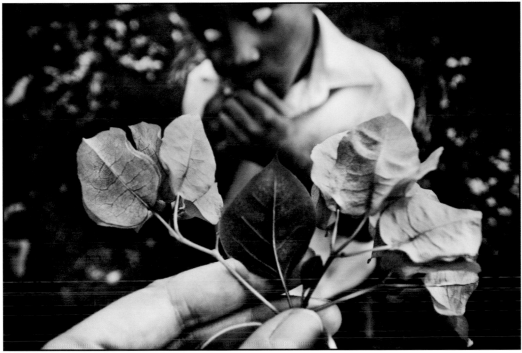

Advanced conversion

© Leslie Alsheimer

I. Simple Methods

Grayscale Mode Change

This method is by far the easiest, fastest and most straightforward approach to converting color to black and white. It creates a nicely balanced conversion with distinct separation in tonal values and serves as a great method for reducing file size, if necessary. Although this approach may be fast and easy, it does not, however, always produce the best possible results.

1. Open an image you wish to convert to black and white.

2. Choose from the Image Menu > Mode > Grayscale.

3. A dialog box may appear asking whether to "discard color information?"

4. Click "Discard".

![Discard]

Color

Grayscale

Photoshop will throw away the RGB (Red, Green, Blue) or CMYK (cyan, magenta, yellow, black) color channel information, creating a much smaller file, and convert the image colors into black, white and 256 values of gray tones. Photoshop determines the tonalities each color will render with a pre-calculated formula (algorithm) in order to create the resulting grayscale image. This method of conversion attempts to simulate the look and feel of Kodak Plus-X film. While this method is exceptionally fast and easy to use, the photographer loses color information that cannot be recreated, as well as control and input in the conversion process. The results are usually relatively pleasing for many images, but rarely produce the optimal image the fine art photographer will be looking for. One can, of course, greatly improve the conversion by adjusting tone and contrast, as well as shadows and highlight information with adjustment layers and digital darkroom editing.

Advantages:
1. Fast
2. Moderately effective
3. Creates smaller files

Disadvantages:
1. Loss of control
2. Moderately effective
3. Discards color channels
4. Discards image data
5. Limits post-processing, filtration, gamut, etc.

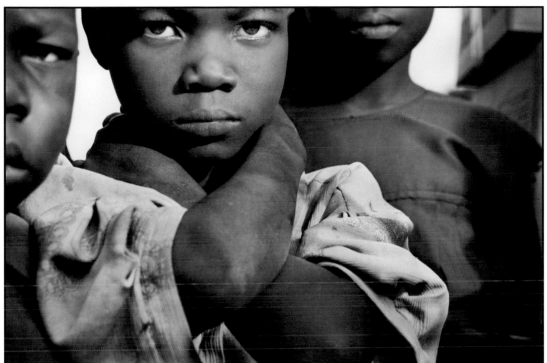

Advanced conversion

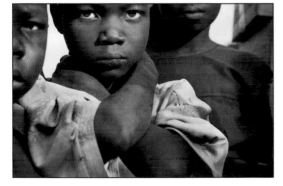

Color

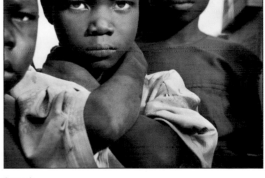

Grayscale

As with all the conversion techniques, some images will convert beautifully to black and white with simple methods, while other images will require more complex techniques. Notice how the grayscale mode change method results are not much different from the advanced methods for the image pictured above. The differences are much more noticeable between conversion methods in the image on the previous page.

Desaturate

The second fast and easy option is desaturation. While desaturation results in an image that appears to be grayscale, it is actually not. Desaturating removes the color from each of the RGB channels by equalizing the color pixel information to equivalent values. As this method does not actually discard the color information, the resulting image remains in the RGB color space. This method can be created as an adjustment layer, introducing many additional advantages for the creative user. As with any adjustment layer, it is non-destructive and offers the many cool features adjustment layers have to offer, such as variable opacity and masking. This technique, though more advantageous, still tends to produce an image that needs more work. It will be fairly limited in range of gray detail and does not produce deep blacks. You will find that each conversion method will sometimes produce noticeably different results, and sometimes the differences will be hard to decipher.

There is more than one way to desaturate an image in Photoshop, believe it or not.

1. Choose Image Menu > Adjustments > Desaturate
2. Choose Image Menu > Adjustments > Hue Saturation

3. Layer Menu > New Adjustment Layer > Hue Saturation
4. New CS4 Adjustments Panel > Hue / Saturation

 All these access methods will get you to the same dialog box. The difference between them is that numbers 3 and 4 allow you the flexibility of an adjustment layer. We recommend you follow a non-destructive workflow and choose an adjustment layer whenever possible!

5. Open the Hue/Saturation dialog box and slide the Saturation slider all the way to the left.

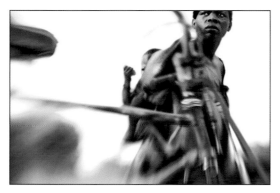

Color

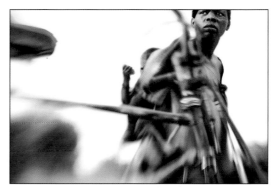

Desaturated

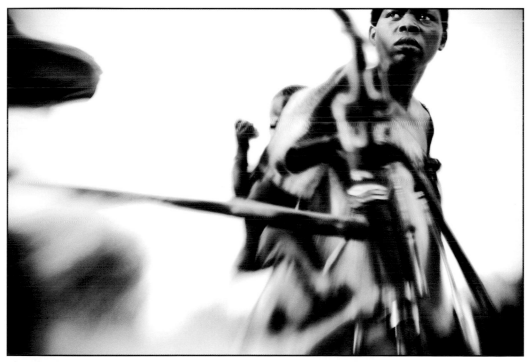

Advanced methods

© Leslie Alsheimer

Advantages:

1. Fast and easy
2. Moderately effective
3. Adds all benefits of adjustment layers (i.e. variable opacity and masking capabilities)
4. Non-destructive
5. Maintains RGB color mode and all color information

Disadvantages:

1. Loss of control
2. Moderately effective
3. Limited range in gray detail
4. Does not produce deep blacks

Selective desaturation

With an adjustment layer you can play with layer opacity and masking for fun and creative effects. Try the fabulous "Ben Holland Technique", in memory of a well-loved Nile River photographer in Uganda, who frequently removed all colors but one. In this example I desaturated all the colors but red and magenta.

CS4 also provides a cool new On-image Control feature. Click on the pointed finger icon in the upper left portion of the Hue/Saturation box and allow Photoshop to choose the colors to desaturate by clicking and dragging in the image area. With the On-image Control feature active, click in the image area directly onto the colors you wish to change, and drag towards the left to deasturate and back to the right to increase saturation.

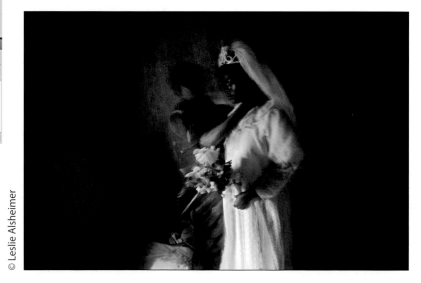

© Leslie Alsheimer

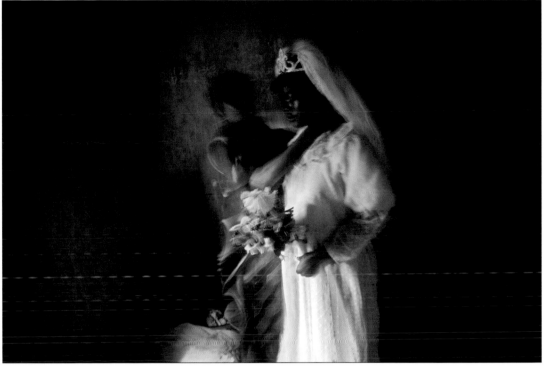

© Leslie Alsheimer

Lab Color Mode

Another simple and relatively quick conversion method is to convert the image to Lab Color mode and use the Lightness channel for the conversion. You will need to delete the two channels that contain the color information, labeled as "a" and "b". As you delete the first color channel, however, the others will automatically become renamed in the process. The Lightness channel should remain fairly obvious, as the other remaining channel will appear quite dark.

1. Choose Image > Mode > Lab Color
2. Open the Channels palette
3. Drag the "a" & "b" channels to the adjustment layer trash can. (The Lightness channel will automatically rename to "Alpha 1".)

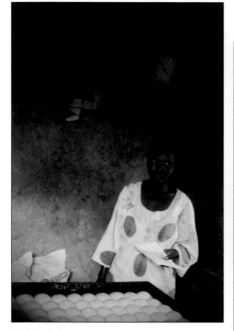

Original color image

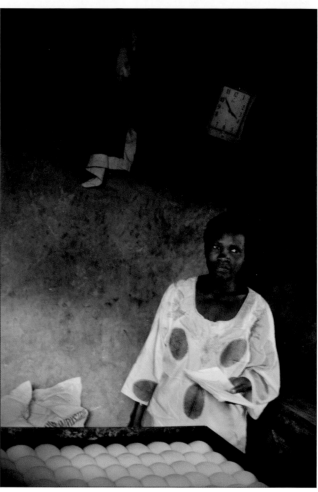

Advanced methods

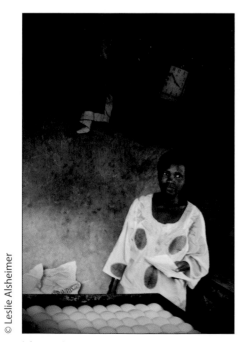

© Leslie Alsheimer

Lab conversion

Advantages:

1. Fast
2. Conversions are fairly pleasing for the speed
3. Creates smaller files
4. More control

Disadvantages:

1. Some loss of control
2. Moderately effective
3. Discards color channels
4. Discards image data

II. Advanced Black and White Conversion: Foundation and Theory Overview

The methods of conversion available today range from simple one-step conversions to more complex multi-step processes. Unless time and simplicity are of the utmost importance, converting a digital color image into black and white typically requires going beyond simply desaturating the colors or converting to grayscale. As we increase the complexity of the conversion method, we generally gain more control and variation over

FIG 1

FIG 2: Simple conversion

FIG 3: More complex conversion

© Leslie Alsheimer

what is available with the more straightforward methods. Understanding the foundations and principles behind the more complex techniques as well as the advantages they provide will serve you well in putting these methods into practice.

First, however, let us look at an image with two striking contrasting colors like green and orange (see chameleon below). Sometimes the conversion method causes the contrasting colors to become a similar shade of middle gray, and the contrast and visual impact becomes lost in the translation as pictured below.

It is possible, however, to use conversion methods that can map specific colors separately from one another and translate the differences into contrasting tones of gray. Notice the green color of the chameleon next to the orange color of the kayak in the image background. The pizzazz of the original color image and the spectral relationships between colors maintain integrity in the more complex black and white conversion (previous page), and that image now holds some of the same impact in black and white as it did in color.

Red Filter

Green Filter

Blue Filter

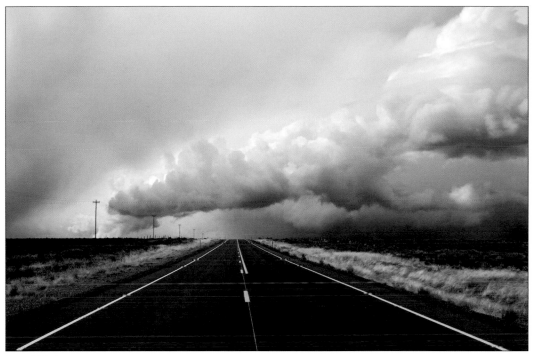

Original Color Image

© Leslie Alsheimer

Foundation & Theory: Color Filters and Black and White Film

Since photography began in black and white, it is impossible to truly understand any of its newer forms without at least a passing knowledge of its beginning. Traditional black and white photographers have always needed to be attentive to the type and distribution of color within their images. Just as with color photography, black and white photography can use the spectral relationships between colors and tonality to make a subject stand out. In order to maximize this principle, black and white photographers traditionally used color filters to manipulate how the spectral relationship between colors was translated into black and white. Colored filters such as blue, red, yellow and orange were used to selectively affect the gradient and contrast in the tonality of colors as they recorded onto film. By allowing colors that are similar to their own color to pass through and expose onto the film, while simultaneously blocking colors that are of opposite wavelengths to the filter color, colors were effectively lightened and darkened as they recorded on the film. Therefore, a strong red filter will lighten reds and darken blues, a green filter will lighten greens and darken reds, etc. For example, landscape

Red Filter

Orange Filter

Blue Filter

127

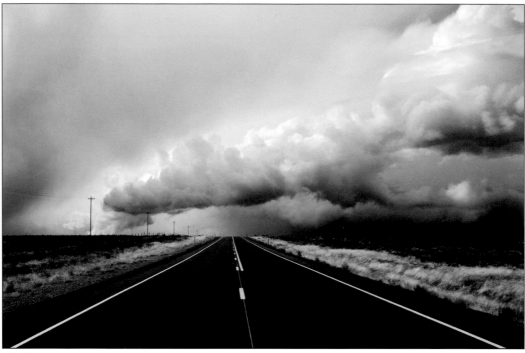

© Leslie Alsheimer

Mixed Filters

photographers often use orange and red filters to cancel blue and green, making skies dark and foliage rich in tone. Careful selection of these color filters allows the photographer to decide which colors in the image will produce the brightest or darkest tones.

How color filters in black and white make color film

Even when photography was only black and white, visionaries were already laying the foundations to move photography into color. In the 1860s, less than 30 years after the introduction of Daguerreotype, the method of using color filters with black and white film was utilized by James Clerk Maxwell, who experimented with a three-image projection process to create a color image from black and white film. He presumed that a color image could be created by exposing three monochrome images of the same subject, exposing each using a different color filter before the lens. Each of the red, blue and green filtered exposures was then projected using three lanterns, each equipped with the corresponding colored filter. The red and green filter together created a yellow image, and all the three colors together created a white image. The final image, although far from perfect, included all of the original colors in the subject. This experimentation laid the foundation for not only color photography but also the Technicolor process used well into the 21st century to create movies in color.

Well so what, you might be thinking: how does this help me with black and white conversions? Actually, understanding this concept and its development is the foundation for the concept of color channels in Photoshop, and the subsequent features software now provides for black and white conversions. If you can wrap your head around this concept, you will be very close to grasping the fundamental essence of the advantages digital photography has to offer the black and white photographer.

Channels in Photoshop

Just as James Clerk Maxwell's experiment in the 1860s created color, so too does a digital camera. However, instead of three separate images, we now have separate channels within the same image file composited together to create the full color spectrum of an image. Separated, they are the individual color "plates" that make up the image's color. A color image typically contains four color channels: a Red channel, Green channel and Blue channel, creating the "RGB" composite, and a fourth channel composite of all three. This composite channel allows you to view any one of the individual colors independently, or any combination of all three. There are five color channels within a CMYK image (cyan, magenta, yellow, black and the combo of all four). These channels store all the color information for each individual pixel within an image and are generated automatically by Photoshop.

In addition to the standard four channels RGB or five channels CMYK, Photoshop will also support images with up to 20 more channels. These additional channels are called Alpha channels, where selections created

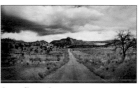

Red Channel

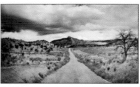

Green Channel

Blue Channel

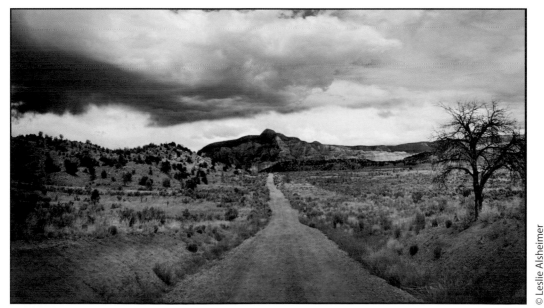

RGB Composite

© Leslie Alsheimer

129

Note:
Generally, under default program settings, Photoshop is set up to reveal channels in grayscale. This can be changed in Photoshop CS4 Preferences > Interface > Show Channels in Color

FIG 1

in Photoshop are stored and edited within a working document. The example below (Fig. 1) illustrates an Alpha channel storing a selection of the horses.

Digital RGB capture is actually grayscale first!

This may be surprising, but digital cameras do not actually capture in color at all. Camera imaging sensors have the capacity to capture luminance values or brightness alone, not color. All digital images, therefore, are fundamentally grayscale at the time of capture and then converted to color. How this works is a little complex but, basically, colored filters cover each photosite on a digital camera's imaging sensor. These filters capture the brightness of the light that passes through them. With the filters in place, each pixel can record only the brightness of the light that matches its filter and passes through it, while other colors are blocked.

The grayscale in digital terms is a series of 256 increasingly darker tones ranging from pure white to pure black. 0 represents pure white, 255 represents pure black with the other 254 brightness values being varying shades of gray that increasingly darken from pure white to pure black.

How the digital camera creates a color image from this brightness scale recorded on the sensor is much like Maxwell's 1860 experiment as well. Since daylight is made up of red, green and blue light, placing red, green and blue

0 255

filters over individual pixels on the image sensor can create color images just as they did for Maxwell in 1860. For example, a pixel with a green filter knows only the brightness of the green light that strikes it. A process called interpolation then determines the actual color of a pixel, which uses the colors of neighboring pixels to calculate the two colors that the pixel did not record directly. By combining these two interpolated colors with the directly measured colors, the full color of the pixel can be calculated and then recorded. Interestingly, the human eye is more sensitive to green than it is to red or blue, so most digital camera sensors have twice as many green filters as red or blue filters to accommodate this preference.

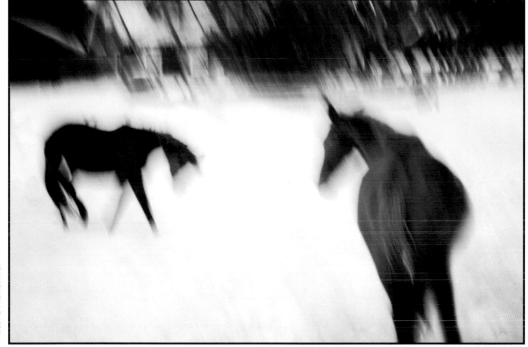

© Leslie Alsheimer

CMYK Composite

Cyan Channel

Magenta Channel

Yellow Channel

Black Channel

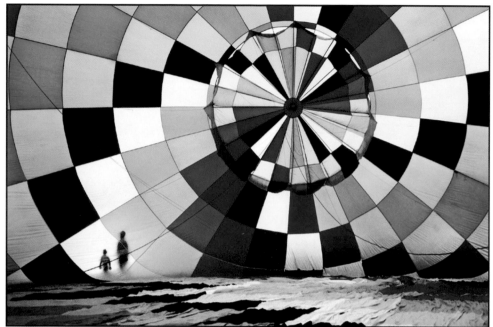

© Leslie Alsheimer

III. Advanced Conversion Techniques

Channel Mixer

Utilizing these founding color principles, the channel mixer puts theory into action. With the same effect color filters produced, you can dynamically interact with the translation of the spectral relationships between colors in the conversion process by mixing the individual channels within a document. The Channel Mixer tool allows you to control how much each of the three color channels (Red, Green and Blue) contributes to the final grayscale brightness. This method, therefore, has the ability to act as a digital set of black and white filters, all in a single interface allowing you the flexibility and power of having the whole color filter pack in post production.

The channel mixer has been traditionally and undoubtedly one of the most powerful black and white conversion methods; however, it may take some time to master since there are many parameters which require simultaneous adjustment.

There are many ways to mix the channels in this process, and the "right" mix will vary on a per image basis. Photoshop CS4 provides a few great presets to start with (in fact you can save your own) but it is important to play with the mix until you find a pleasing effect.

Pre-Channel Mixing:

Step 1: Open an image that is in RGB color mode.

Step 2: Analyze the channels (Note: this step is for viewing purposes only). Open your Channels palette and click on the individual channels by clicking on the **words** "Red," "Green" and "Blue". These different views will provide a guide for how to customize the black and white conversion.

You will select the channel with the most detail and tonality to be the dominant channel for the channel mixer on an image by image basis. The Red channel

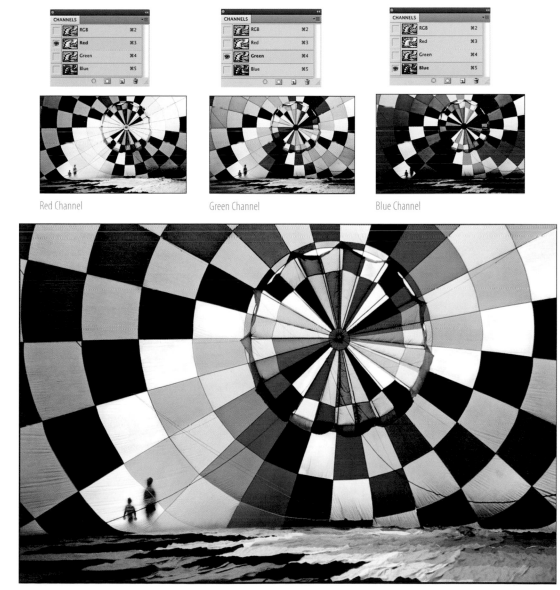

Red Channel Green Channel Blue Channel

© Leslie Alsheimer

133

typically contains most of the detail in the image. The Blue channel typically contains the luminosity, skin tones and contrast but also frequently the most noise. For this image, the Green channel was selected.

Be sure you **click back on the RGB letters at the top of the Channels palette to return the image to color before moving to the next step.

Channel Mixer: The Method

Step 1: Choose Channel Mixer from the Adjustment panel, or from the Layers palette, by clicking on the adjustment layer icon at the bottom of the Layers palette.

Step 2: Check Monochrome
Check the box next to the word "Monochrome" in the lower left-hand side of the Channel Mixer box. The image will immediately turn to grayscale.

The initial mixture predetermined by default, as of Photoshop CS3, opens with Red 40%, Green 40% and Blue 20%. These better default values are actually another cool new feature as of CS3, as CS2 used to just map to 100% Red. Photoshop lessens the amount assigned to the Blue channel because the Blue channel typically holds more noise than the other two channels of Red and Green.

Note:
Be careful of the Blue channel as it typically holds more noise than the other two channels of Red or Green. Unless the goal is to create a grainy-looking image or some exaggerated effect, it is best to steer clear of using too much Blue channel in the mixture.

The advanced user may wish to monitor the Histogram palette in this process. (See Chapter 2, "Highest Quality Capture", page 29, for more information.)

Step 3: Make Custom Changes
Adjust the Red, Green and Blue sliders to add and subtract amounts or percentages of each channel to produce an image to your liking. The choices made are purely aesthetic. The user has complete control of how each channel will be represented in the final image outcome.

For an even more pronounced effect, some colors can even have negative percentages.

It is advised that the percentage totals should not exceed 100%, when all three channels are added, in order to maintain the density or overall brightness of the image, although creative interpretation should always take precedence over numbers. Experimenting with different color settings will enable you to find the combinations that your prefer. Be mindful though, if the number totals do equate to over 100% there is a risk of losing highlight information. Notice how cool Photoshop is to provide us with a Calculation Total feature at the bottom of the channel sliders! So fabulous not to have to do all that math on the fly!

Note:
Curiously, the image will not return to Color if the Monochrome button is unchecked. To reset, hold down the Option key and the Cancel button will turn to reset.

Other cool new Channel Mixer features in Photoshop include the ability to save, load and share settings and presets.

Step 4: Click OK when finished.

Step 7: Play!

There are as many interpretations of how an image can be conveyed as there are number combinations within the tool. Create several different interpretations and decide which one you prefer the best!

Digital like film

For some digital photographers, the ultimate goal is to create black and white digital images that look as if they were captured on film. The gritty quality that came from pushed Kodak Tri-X film sometimes seems aesthetically so far removed from the crisp digital files we see with today's high resolution cameras. There is a unique elegance in film's simple grain and mysterious qualities. For the film photographer, certain specialized looks have always been achieved by choices in chemistry, paper and technique coupled with the type of film or emulsion chosen. The varying differences in the consistency of light sensitivity in emulsions typically give each type of film its unique aesthetic. With many films being taken off the market today, it is still incredibly useful to keep those traditional names and what they meant to the film photographer alive, and use them as points of reference. For the black and white photographer, whether traditional or digital, using black and white effectively is about choosing a "look" that matches your image and intention.

Film stocks replicated from the Channel Mixer!

Of course, you will still have to add noise and grain to achieve the "look" of some films.

> **Note:**
> A close approximation to the luminosity perceived by the human eye would be settings of red = 30%, green = 59% and blue = 11%. An approximation to the default grayscale mode change might be red = 60%, green = 30% and blue = 0%, and a mix of red = 34%, green = 33% and blue = 33% is the approximate equivalent to desaturation.

Film Type	Red values	Green values	Blue values
Agfa 200X	18	41	41
Agfapan 25	25	39	36
Agfapan 100	21	40	39
Agfapan 400	20	41	39
Ilford Delta 100	21	42	37
Ilford Delta 400	22	42	36
Ilford Delta 400 Pro & 3200	31	36	33
Ilford FP4	28	41	31
Ilford HP5	23	37	40
Ilford Pan F	3	36	31
Ilford SFX	36	31	33
Ilford XP2 Super	21	42	37
Kodak Tmax 100	24	37	39
Kodak Tmax 400	27	36	37
Kodak Tri-X	25	35	40

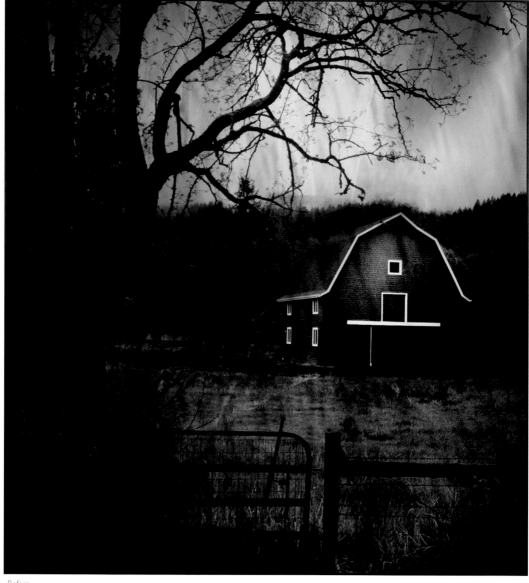

© Leslie Alsheimer

Before

Hue/Saturation Technique

This method, patented as "The Russell Brown Tonal Conversion Technique", lays the foundation for Photoshop's latest Black and White stand-alone feature. This method uses two Hue/Saturation adjustment layers to make the initial conversion and creates a customized set of color mapping options at the same time! How does it work?

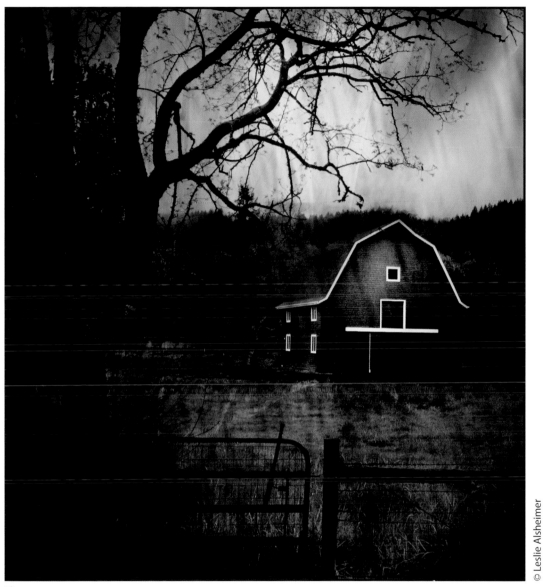

After

© Leslie Alsheimer

Step 1: Open an image you wish to convert, and click the Adjustment panel and choose Hue/Saturation. You can also choose the Hue/Saturation adjustment layer icon at the bottom of the Layers palette, or go to the Layer Menu > New Adjustment Layer > Hue/Saturation. We are going to work with this layer later. So when the dialog box comes up, do not make any adjustments. Just click OK.

137

Hint:
It is always a good idea to name your layers! Double-click on the letters in the Layers palette that spell out "Hue/Saturation" and type in a name like "Color Mapping". This will help make it easy to remember what each layer does when you come back to the image later.

Step 2: Change the Blend mode of this new adjustment layer from Normal to Color. This option is one of 20 or so available blend modes from the drop-down menu in the Layers palette. This blend mode will allow us to adjust the hue and saturation simultaneously. (If we think about this technique in photographic terms, this layer will act as our Filter layer, or the Remapping color layer.)

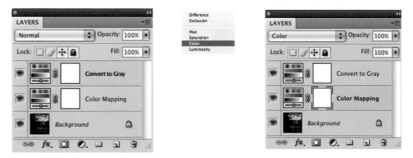

Step 3: Make another Hue/Saturation adjustment layer by clicking on the Adjustments panel, or adjustment layer icon at the bottom of the Layers palette and choosing Hue/Saturation a second time. This time, however, we will pull the saturation slider all the way to the left, reducing the saturation to –100 (in photographic terms again, this will be the "Film" layer, or simply "convert to gray").

Step 4: Now we are ready to create the black and white conversion dynamically by playing with the individual color channels within the Hue/Saturation dialog box's drop-down menu. Here's how …

Step 5: Double-click the adjustment layer thumbnail icon on the middle layer in the stack, which is the "Filter" layer, or the first layer you created and set to color. This will reopen the Hue/Saturation dialog box. Adjust the Hue slider and notice how you are interactively changing the spectral relationships between the colors as they translate into black and white. Isn't that cool?

Step 6: You can also play with the Saturation slider and make further adjustments to give more emphasis to tonal values within the image.

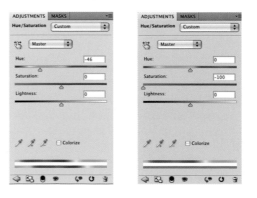

Step 7: This process actually gets better, believe it or not. If you go to the Edit Menu in the very same dialog box and click on the drop-down menu, you can change the "Master" composite to isolate each color separately. Pull both the Hue and Saturation sliders for each color independently. Watch out for unwanted posterization effects as this can happen fairly easily if you are not paying attention.

Extra Bonus Tip!
You can also expand the color range of the sliders by using the eyedroppers. If you have some red in the image and you wish to add yellow and green to that adjustment area, select the "Add" sample eyedropper tool and simply click on the colors you wish to add, such as blue and green. The tool will expand the range of colors and result in better blending values.

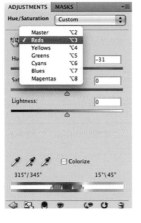

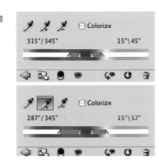

© Leslie Alsheimer

Turn Up the Volume! This One Goes to 11

Coined by Nigel from the film *This is Spinal Tap*, this pop culture phrase commonly refers to anything capable of being exploited to its utmost abilities, and to exceed them. In other words, it is the act of taking something to an extreme. Coincidentilly Photoshop CS4, code name "Stonehenge", also pays homage to Spinal Tap. So this technique is an 11: The ADVANCED Maximize Detail Combo Conversion Technique! To the MAX!

Once you have explored the fundamental conversion methods, you may be ready to delve deeper into the conversion process. If you have not noticed yet, converting to monochrome is most notably about re-establishing the spectral relationships between color and tone within an image. The advanced printer will know that image detail plays an integral role in successful black and white fine art print making. Be warned this fancy technique takes a fair bit of time, is not simple and can be incredibly confusing. It does, however, maximize your control over the conversion process, whereby allowing the user to selectively maximize detail and tonality in the conversion process. Althought there are a few variations on this technique, no other method quite matches its power, as this one really does go to 11!

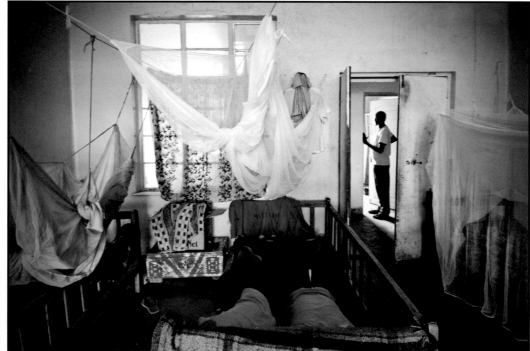

© Leslie Alsheimer

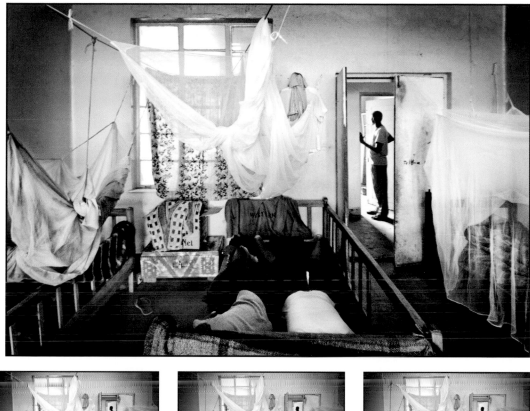

© Leslie Alsheimer

Blue Channel Green Channel Red Channel

Step 1: Begin with an RGB image file processed optimally for color. Duplicate your image. Image Menu > Duplicate. Open the channels palette and analyze the channels by clicking on each of the individual channels in the Channels palette. Do this several times and make notes on the differences in how each channel translates the information and detail. (See "Channel Mixer", page 132 for more information on how to analyze the channels.) For this image, I noticed that there was more detail in the doorway (where the man is standing) in the Blue channel, as well as in the top of the window. In the Green channel, there was more information in the flowered curtains, the girl's feet on the bed, and the skirts they are wearing, as well as with the flip-flop on the floor. The Red channel holds more detail in the empty beds.

141

Step 2: Convert the Duplicate Image to Lab mode.

Step 3: Go to the Channels palette and click on the Lightness Channel. Select All > Edit Copy.

Step 4: Reactivate the original color image and create a new layer. Layer > New Layer, or click on the new layer icon.

Step 5: Edit > Paste the Lightness channel into the new layer and rename the layer "Lightness".

Step 6: Create three more empty layers and rename them "Red," "Green" and "Blue." You are going to copy and paste each of the Red, Green and Blue channels into these layers.

Note:
You will need to retarget the Background layer and the corresponding channel each time you want to copy a channel.

Step 7: Turn the visibility off on the Lightness channel by clicking on the eyeball next to it in the Layers palette. This will ensure that the Lightness

channel will not affect your channels. Copy and paste each channel into the appropriate new layers you have just created.

You can make excellent conversions by simply lowering the opacity of the different layers at this point. But who is stopping there? I said this one goes to 11!

Step 8: Add a "Hide All" layer mask to each of the Red, Green and Blue channels. Do this by holding the Option key as you click the "Add Layer Mask" icon in the Layers palette, or simply use the Layer Menu > Add Layer Mask > Hide All.

Step 9: Use a paintbrush, set to the default colors of black and white at various opacities, and hide or reveal the different aspects in which you noted. I revealed the doorway on the Blue channel, the curtains, feet and skirt on the green channel layer and the empty bed detail on the red channel layer.

Try this technique with images shot in low light. The blue channel is great for bringing out lost shadow detail. But be careful, as it also holds the most noise!

If you love this method, you may want to create a customized action in Photoshop that sets up the layers for you to make the process a bit faster. Visit the Santa Fe Digital Darkroom website for downloadable actions coming soon: www.santafedigitaldarkroom.com.

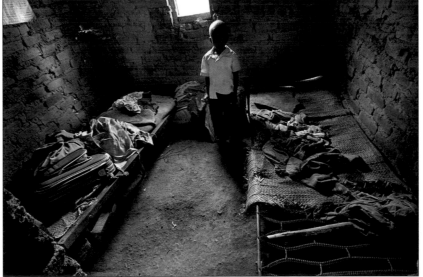

© Leslie Alsheimer

143

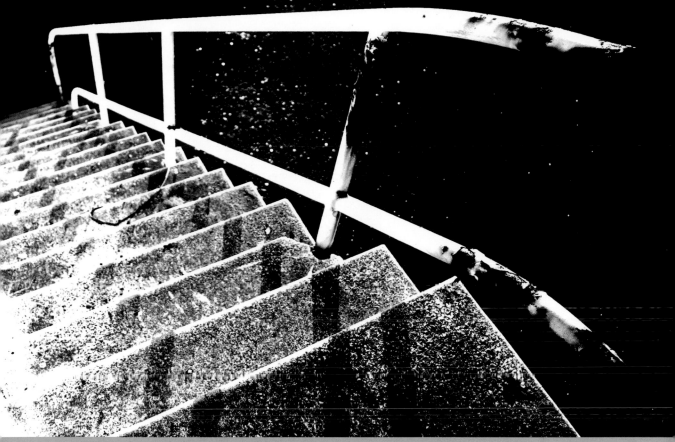

© Bryan O' Neil Hughes

Black and White in Photoshop II

by Bryan O'Neil Hughes

Black and White from Black and White

How many times have you had an image that you wanted to replicate or be consistent with when it came to look and tone? Have you ever spent hours on a high contrast black and white conversion only to choose another image and wish all that hard work could carry over? This first trick isn't a magic bullet, and its nowhere near as flexible as raw editing or layers, but it can be a great launch pad to nice, monochromatic images in just a few steps.

First open an image that you like, be it a high or low contrast, or black and white; ideally with similar subject matter. Now open a color image. Here you see two similar subjects, the one of Alex in color and Dominic in black and white.

© Bryan O'Neil Hughes

With the color image targeted, navigate to Image/Adjustments/Match Color. With just a couple of clicks you can choose the target and even adjust parameters such as Luminance, Color Intensity (in this case you can work with either the default or even dial in a bit of color cast) and Fade.

© Bryan O'Neil Hughes

Black and White Stand-alone Feature

Photoshop has always offered many ways to convert color images to black and white, each having its own unique advantages and quirks. However, none has ever been particularly intuitive.

Photoshop offers a great deal for black and white photographers: recent changes to the power and usability of selective editing (and previewing via the refine edge controls); a myriad of changes to camera raw, new ways to dodge, burn and saturate; curves and the incredible advent of smart filters. Specific to black and white, CS3 improved greatly on the popular channel mixer method of converting to monochrome. In Photoshop the experience is simple, easier and faster.

For readers of this book, however, nothing is likely to be more exciting, useful, easy or powerful as the features and functionality found in the Stand-alone Black and White feature introduced in Photoshop CS3. When the Photoshop team looked at making a black and white feature, they surveyed the landscape, listened to user requests and threw in a bonus on-image control compliments of the family's newest application, Adobe Photoshop Lightroom.

The feature exists as both a regular (pixel-based) image adjustment and as a new addition to a growing list of non-destructive adjustment layers (now readily available in the default interface, LIVE!)

Let us step through a common conversion:

1. In the interest of best practices, we will use an adjustment layer: using either the new Adjustment panel in CS4 > Black & White, or by using the fly-out menu from the Layers palette.

2. By default, Photoshop gives a nice set of fixed conversion numbers.

3. At this point, you can choose to use the Auto button to map contrast amongst various tones. The effects of "auto" will vary from image to image, but, in essence, Photoshop is adjusting sliders to give a well-contrasted adjustment.

4. For further control, each of the individual sliders can be moved to control the tonal value of that region.

5. The best control is the ability to interact directly with the document. In this feature, you need only to click upon any region of the image and then move right or left to lighten or darken it! You will notice that whichever region you click upon maps to the appropriate slider in the black and white control.

> **Note:**
> First, it is always a good idea to get a good, working exposure before applying any sort of black and white conversion. See "Chapter 2: Capture in color" page 29 for tips.

Note:
Keep a keen eye out
for posterization when
pulling colors to extreme.

Black and White

Preset:	None			OK
Reds:	■	40	%	Cancel
				Auto
Yellows:		60	%	☑ Preview
Greens:	■	40	%	
Cyans:	■	60	%	
Blues:	■	20	%	
Magentas:	■	80	%	

☐ Tint
Hue °
Saturation %

6. Now that you have spent a couple of minutes setting a nice conversion, let us save your hard work. Just to the left of the OK button is a preset options toggle – click it to "save settings". These "BLW" settings reside in the presets directory of the application folder – because they are small files and can easily be emailed or posted on the web for others to use.

7. The same Preset button allows you to load other settings, or access one of the many presets that ship with CS4. Let us take a look at what they do.

© Bryan O'Neil Hughes

Green filter: By adding more lightness to the green and yellow regions, this filter brightens foliage and leaves skies and other areas fairly neutral

© Bryan O'Neil Hughes

Blue filter: By adding more lightness to the blue, cyan and magenta regions, this filter dramatically lightens sky and water while darkening leaves and foliage

High contrast red filter: Always popular in landscape photography because of its ability to make the sky dark and bold, while preserving the luminosity of shadows and foliage, the high contrast red filter boosts reds, yellows and magentas, while slightly darkening the others

High contrast blue filter: A more extreme version of the blue filter, this magnifies the differences between the blue, cyan, magenta regions and others, creating a very high contrast image with a dark ground and light sky

© Bryan O'Neil Hughes

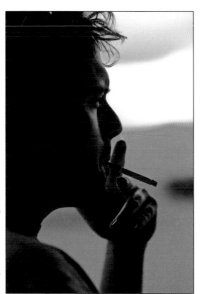

© Bryan O'Neil Hughes

Infrared: This filter emulates the popular and surreal effect of using infrared film — that which measures reflective infrared light outside of normal measurement or perception. Infrared film shows greens and yellows in an ethereal glow

Maximum black: Just as it sounds, this filter darkens all sliders — 50%

© Bryan C'Neil Hughes

© Bryan O'Neil Hughes

Maximum white: The opposite of the last mentioned filter, maximum white brightens all sliders to 150%

© Bryan O'Neil Hughes

Neutral density: Another popular filter in conventional photography, this filter often exists in various degrees of lightening and darkening

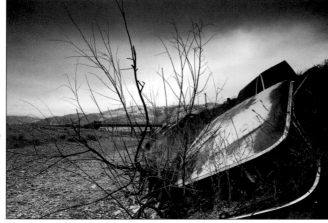

© Bryan O'Neil Hughes

Red filter: The most used filter in black and white photography, the red filter adds contrast by darkening blues and brightening reds and yellows

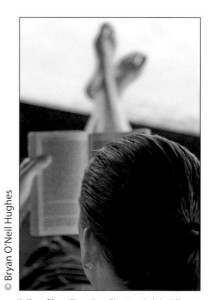

© Bryan O'Neil Hughes

Yellow filter: The yellow filter is a slightly different take on adding contrast

Photoshop's Black and White Stand-alone feature is very powerful and, between the auto function and a series of presets, you can accomplish a great deal in a couple of clicks. Beyond just those, here are a few others to experiment with:

High Contrast Landscape

First click "Auto"

Increase Greens to 150

Decrease Blues to −75

Better Overall Landscapes

First click "Auto"

Increase Yellows to 125

Change Greens to 75

Change Blues to 25

Better Portraits

First click "Auto"

Increase Reds to 50

Increase Yellows to 100

Mixed Light, with focus on the people

First click "Auto"

Increase Reds to 200

Increase Yellows to 85

Decrease Greens to −85

Decrease Cyans to −20

Blues at 0

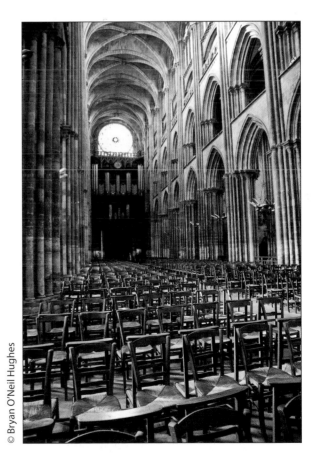

© Bryan O'Neil Hughes

As with anything subjective, these are "season to taste", so use those to experiment, but enjoy creative freedom!

Samples:

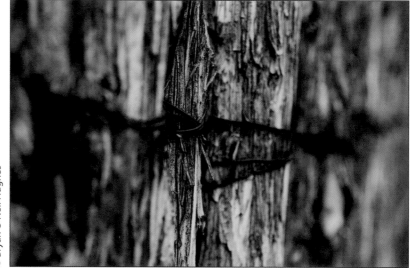

© Bryan O'Neil Hughes

B&W stand-alone with on-image adjustments made

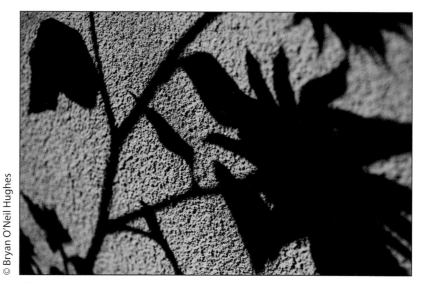

© Bryan O'Neil Hughes

B&W stand-alone adjustments with tinting

Tinting

Tinting very often goes hand in hand with black and white conversion. A sepia or selenium tone can make a drab black and white image pop. Toning a monochromatic image gives it mood and personality. Unlike some of Photoshop's less discoverable other methods, tinting in the new Black and White feature is as simple as pulling two sliders.

1. First check the "tint" checkbox.

2. Then slide the Hue slider to the desired effect. Here are two popular ones:
 Sepia – hue 42 degrees, saturation 20%
 Cyanotype – hue 200 degrees, saturation 10%.

3. To further adjust your toning, pull the Saturation slider in either direction.

4. You can also click upon the color picker to the Tint control's right to select your own custom color.

© Bryan O'Neil Hughes

Sharing saved settings: remember that saved settings can also be shared with others, here is how:

1. Navigate to the Photoshop application folder/presets/black and white.

2. Select the files that you want to share; copy (do not move) them to another location, and simply attach those to an email, post them to a website or burn them to the media of your choice.

 To load settings from another user, move their .BLW files to that same directory, or select "load" from the preset drop-down and target the directory of your choice.

In addition to the non-destructive benefits of using this new tool as an adjustment layer, you will recall that doing so gives you a host of blend modes. As with everywhere in Photoshop, experimentation is a great door to discovery, so do not stop with your conversion – consider what the many blending modes and selective edits can bring to your image.

Blend Modes

An often unrealized, but very powerful method of extending the creative powers of Layers is leveraging one or more of the 25 Blend modes. Blend modes govern the relationship between the layers and can be used to blend color and monochrome, add or remove contrast and quickly realize unique changes to an otherwise drab conversion. Looking closer, here are a couple of fun methods to try.

With an existing monochromatic conversion, from, say, the auto results of the B&W feature in Photoshop, duplicate the layer.

Now simply change the blend mode to any of the below to realize new and dramatic results.

Change the opacity of that layer and/or mask to get more refined results.

Multiply

This is a great way to introduce punch and contrast to an otherwise flat image; I really enjoy this particular blend coming from a nice B&W conversion in Lightroom.

Liner Burn or Color Burn

These offers great ways to realize immediate and very strong contrast. The effects of these adjustment layer blend modes on a somewhat flat monochrome image are reminiscent of Kodak's Tech-pan film (which was unique in its almost black or white tonal range, or lack thereof). Of course, this too can be minimized with opacity and masking controls.

Color Dodge and Linear Dodge

These can be a lot of fun as they essentially wash your image with light. This is almost like a bleached image or an infrared minus the specific softening of the Green channel. Harsh images are softened considerably by the use of either of these.

Hard Mix

This extremely heavy-handed blend mode offers a shortcut to half-toning and is great for dramatically simplifying the range of tones.

So, you see that the Stand-alone Black and White adjustment control gives you the conversion, but the blend modes really give you the spirit of the image.

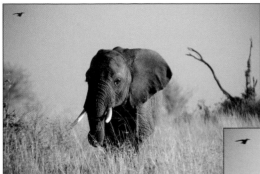

Before Hard LIght

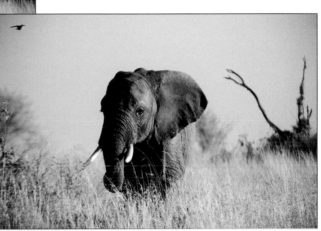

© Bryan O'Neil Hughes

After Hard Light

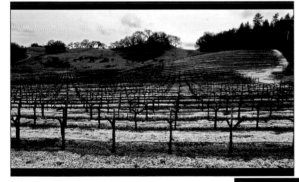

Before Linear Dodge

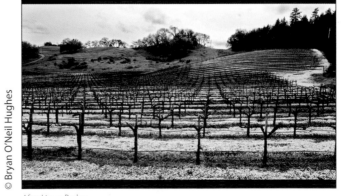

© Bryan O'Neil Hughes

After Linear Dodge

Black and White in Adobe Camera Raw 5.0

A very brief background

The Adobe Camera Raw (or "ACR" for short) plug-in became available shortly after the release of Photoshop 7.0. What is now taken for granted as a self-loading portal into Photoshop was at inception a very new, forward-thinking, powerful and flexible alternative to each individual camera company's proprietary methods for raw file conversion. From the initial version 1.0 of the plug-in, Adobe provided a quick, consistent and intuitive interface for photographers who preferred the high image quality and non-destructive nature of the raw format. I don't think that anyone then knew how much ACR would catch on; but with an easy-to-learn stepped interface, terms familiar to photographers like "temperature", "exposure" and "white balance" coupled with a layout that was both familiar to legacy users and approachable by those new to the application – it really couldn't lose.

Why use Adobe Camera Raw?

The most powerful aspect of shooting in raw, and subsequently using ACR, is not perhaps immediately obvious – it is entirely non-destructive. "Non-destructive" is a term that gets used a lot these days, but what does it mean? In the case of ACR, any adjustment applied in the plug-in, from tonal adjustments to sharpening, are all a system of settings associated with each file – each list of adjustments is simply a set of instructions to be applied to the original. For those converts from a film-based workflow, think of a raw file as your negative – pure, pristine, and unaltered.

Beyond giving the user an easy way to constantly make changes to a file, settings also have an incredibly powerful advantage – they can be shared! This means that when you give five or ten of your precious minutes to massaging the tonal adjustments in ACR, you can subsequently share any of those adjustments with other files with the mere seconds it takes to make a mouse click or two. So, reading between the above lines, this equates to a harmless system of adjustments that are entirely extensible – essentially, the preservational benefits of adjustment layers and the power of batch conversions without any requisite knowledge of either.

Why a plug-in?

ACR was lauded as brilliant when it came out, and raw shooters the world over welcomed it with open arms – after all, it supported nearly every major camera capable of shooting a raw format at that time. Unfortunately, getting ACR to work on the proprietary formats of so many cameras was only part of the problem. Change is inevitable, and change in digital photography, especially hardware, is constant! ACR thus needed to be flexible. Luckily, Photoshop has always been built upon an architecture which supports the extensibility of, literally, thousands of plug-ins.

Plug-ins are basically applications within an application: they can range from the simplest of file readers (which, first and foremost ACR is) to the full-featured adjustment tools (which, as it happens ACR also is) and filters. Plug-ins constitute many of Photoshop's abilities to read, write and filter images and are developed by Adobe as well as a dizzying network of hundreds of third-party developers.

Advantages of shooting raw:
1. Flexibility
2. Extensibility
3. Preservation
4. Ease-of-use
5. Constant updates

Disadvantages of shooting raw:
1. Large files (raw files can be 3X the size of JPEGS!)
2. Limited hardware (only DSLRs and a small subset of pro-sumer point-and-shoots support the format)
3. Updates

Version 5.0, Adobe Camera Raw offers even more control!

Photoshop CS4 ships with version 5.0 of ACR; this revolutionary release maintains feature parity with Lightroom 2.0, and that means selective edits in a raw workflow! Think of this not as a replacement for Photoshop's incredibly powerful paint and selection engine, but rather a high-volume solution for common, minor edits. Of course, by integrating with Lightroom, that which you see in Bridge and ACR looks and works the same as it did in Lightroom (and vice versa).

More specifically, ACR now has two incredibly powerful new tools (neither is available in Photoshop):

Graduated Filter (G)

Beyond just neutral density (exposure and brightness), we can now have multiple graduated controls of things like color, saturation, clarity, sharpness and tone! Of course, like everything in Camera Raw, these are live and re-editable and they can be shared and synced amongst other files or saved as presets.

Adjustment Brush (K)

All of the controls of the Graduated filter wired to a brush! This is metadata-based editing taken to a whole new, selective, paint-driven level. As with

Graduated Filters, you can add, edit, delete, share. With brushed regions, you can even auto-mask and save multiple brush parameters!

ACR 5.0 has a few new controls too

Post-crop Vignetting

Yes, your vignette removal (or addition as we see more and more people doing) will now follow the guidelines of your crop – when you change your mind about cropping, the vignette intelligently follows. The other real power here is found in two new sliders: Roundness, which affects the width of the vignette and Feathering, which softens the Vignette edge. The flexibility and controls combine to take Vignetting removal or addition to an entirely new (and more believable) level.

As a refresher, CS3 gave us:

1. "Recovery" (think of this as the "Highlight" control in Photoshop's Shadow/Highlight)

2. "Fill Light" (think of this as the "Shadow" portion of that same Shadow/Highlight feature)

3. "Vibrance" (a less heavy-handed Saturation control mindful of skin tones)

4. "Parametric Tone Curve" (the powerful but daunting Curves control, now hooked-up to intuitively marked sliders! Don't worry, there's a standard point curve for you old-schoolers)

5. "Convert to Grayscale" (yes, you read that right – ACR has a Black and White conversion feature! No more modifications of the calibration controls or extensive methods of desaturation – we now have a powerful and intuitive method of making gorgeous monochromatic images!)

6. "Split Toning" (it's now incredibly easy to make gorgeous multi-toned "black and white" images)

To those of you using the exciting new Adobe Photoshop Lightroom 2.0 (see Chapter 3 for an in-depth look), you're probably thinking that all of the new features in ACR look very familiar – with good reason. Not only do Lightroom and ACR share the same underlying engine, but they were designed to read each other's files and settings with complete consistency.

Lastly, Adobe Camera Raw now has the smarts to update itself; when an updated version is detected, you no longer have to install the plug-in yourself – ACR and the Adobe Updater do it for you! Now you always have the latest features and support, and never have to hassle with figuring out where to put what. Enough already, let's get our hands dirty …

A stepped approach through ACR

This being a book primarily intended for black and white conversions, we presume a certain aptitude for adjusting the tonality and composition of an image; however, ACR being a relatively concise application, and one that's certain to be new to many of you, we want to take you through an easy, stepped approach from end to end.

Although workflows vary, ACR is constructed with an array of tools that are logically ordered; our prescribed approach is easy to remember, as it steps through the tools and controls in the same order that you find them presented to you.

Opening files in ACR
One of the most common questions surrounding ACR is "How do I get there?"

From Photoshop
Photoshop will automatically open raw files in ACR, however if you'd like to use Adobe Camera Raw to open your JPEG files, you must first do the following:

1. From within Photoshop, navigate to Photoshop (Menu) . Preferences . File Handling

2. From within the Preferences dialog, check the box "Prefer Adobe Camera Raw for JPEG Files"

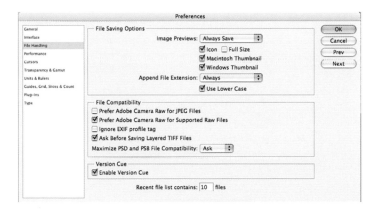

From Bridge CS4
Although Photoshop will automatically open raw files from Bridge in ACR, choosing to open JPEGs and TIFFs requires first:

1. From within Bridge CS4, navigate to Bridge (Menu) . Preferences.

2. From within the Preferences dialog, check the box "Prefer Adobe Camera Raw for JPEG and TIFF Files".

3. There's a new task-based button in Bridge CS4 that means you can have the best of both worlds: simply click upon it to open an image in Camera Raw (regardless of whether or not you've set your preferences to do so).

4. Another new trick to browse and edit photos is to select multiple images from bridge and then click Command+B – with more than four images selected you'll now enjoy a hardware-accelerated preview. Clicking Command+R from within this view will take your TIFFs, JPEGs and proprietary raw files into Adobe Camera Raw – once you click "Done", you will return to the Browse mode and see the updated changes.

From the Operating System: Apple OSX

Now that we're in ACR, let's get to work!

Step 1: Crop

1. Select the Crop tool (C) from ACR's horizontal tool bar.

2. Simply draw, drag or pull corner points to set crop guidelines.

3. Now select any other tool (in this case the White Balance tool) to apply the crop.

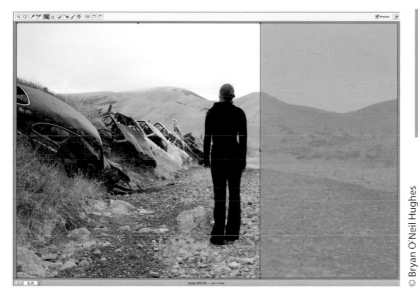

© Bryan O'Neil Hughes

Step 2: White Balance

1. Select the White Balance tool (I).

2. The White Balance tool is used to approximate the true color temperature of your image; to do so, click on a tone likely to be a true white.

If your image needs further adjustment, either the Temperature slider or White Balance drop-downs are good places to start.

As Shot
Auto
Daylight
Cloudy
Shade
Tungsten
Fluorescent
Flash
✓ Custom

Step 3: Tone

1. First, let's remind ACR to show us regions of the highlights or shadows that will be clipped, so that we can be certain to preserve all of our image's details. To do so, click each arrow icon at the far left and right of the histogram.

2. Move the Exposure slider until red overlays (clipped highlights) begin to appear.

3. Now select the Recovery slider, and move it to the right until the red portions disappear; in the case of my image, I chose to continue moving the slider to show even more highlight detail.

4. Next move the Fill Light slider to the right, this will "dodge" the shadows. Continue adjusting until you have your desired effect. If the image doesn't have enough contrast, don't worry, we'll get there next.

5. We'll now carefully move the Black slider to add true blacks back to the image; move the slider until the blue overlay is just barely visible (too much blue indicates clipped shadow regions).

 If you'd like yet more contrast, the appropriately marked "Contrast" slider is a good way to massage the details – remember to be mindful of the blue overlays.

Step 4: New in ACR 5.0 are Selective Edits

These can be applied in two ways. Let's first look at brushes (K): these require only that you paint a selected region and then adjust the parameters of that area on the right side of the screen. Brushed areas can be added to (the default behavior after one is made), created and supplemented ("New") or deleted ("Erase"). In this case I've auto-masked the figure to make it more of a dark, low contrast silhouette.

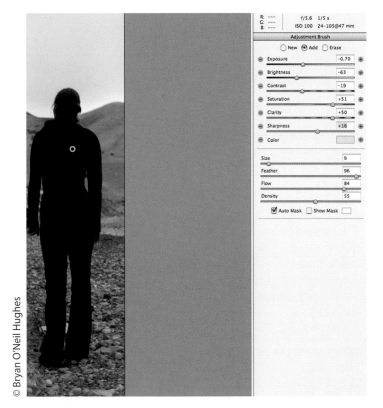

© Bryan O'Neil Hughes

Graduated Filters (G)

These work in the same way as brushed areas and with the same controls, only with Graduated Filters you are applying a dissolving effect from a start to end point. To enable these, you need only to click and drag and then adjust the settings. In this image I've applied two – one to darken the sky and bring back the cloud detail, and the other to brighten the foreground and add contrast.

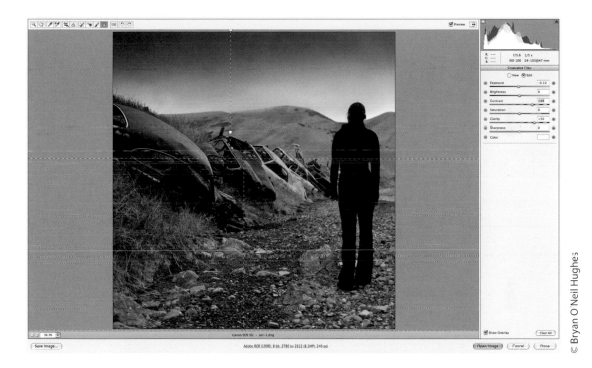

© Bryan O'Neil Hughes

Convert to Grayscale

There's reason for a bit of confusion here, isn't "Grayscale" an image mode in Photoshop? Yes, but it's also a way of describing a monochromatic image – think of this feature as it was intended: Black and White in ACR! Unlike film, shooting digitally allows a photographer to shoot in both color *and* black and white; in ACR, not only can you do that, but you can revert at any point because the conversion is only a set of instructions. If we like our conversion, those same settings can be shared with other files in the form of a preset with a single mouse click!

1. Within the HSL/Grayscale palette, simply check the box "Convert to Grayscale".

 By design this adjustment leverages ACR's "Auto" setting, "Auto" maps the color tones in the image to present you, the user, with a nice,

well-contrasted conversion. If you compare this to selecting "Default", you'll see that the image looks much flatter otherwise.

2. With a mind towards what the colors **were** (remember, you can always toggle the Preview button in the upper right of ACR to see the image without adjustments), you can now move the sliders to lighten or darken any of the listed tone values.

In my case, I found that further lightening the grass and cars (Oranges and Yellows) and further darkening the sky (Blues) presented me with an even more appealing monochromatic contrast.

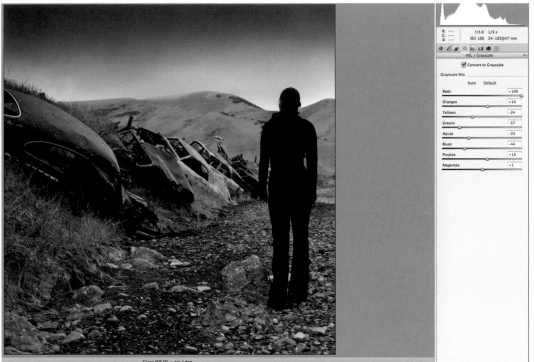

© Bryan O'Neil Hughes

Step 5: Split Toning
One of ACR's easy and powerful features not found anywhere in Photoshop is the ability to split tone, which is to apply two separate hues – one to the highlights, and the other to the shadow regions.

1. Within the Split Toning palette, grab the Highlight Hue slider and pull slowly to the right.

2. Once you've decided upon a highlight tone, repeat Step 1 with the Shadow tone.

3. Simply slide the Balance control back or forth to equalize the image to suit your taste.

Step 6: Vignetting

My image is close to where I'd like it to be, I have a clean crop, nice contrast, a sepia-toned black and white conversion that snaps – it just needs one more thing. Vignetting is a way to dodge or burn just the corners of an image, and doing so correctly brings the center of the image into even more prominent focus.

1. Within the Lens Corrections palette, under "Lens Vignetting", move the Amount slider (to the right in this case to introduce mood).

2. To control the range of the vignette, move the Midpoint slider.

3. The new post-crop vignette controls allow for the flexibility of cropping or changing a crop at any time, but they also give us feathering and roundness controls.

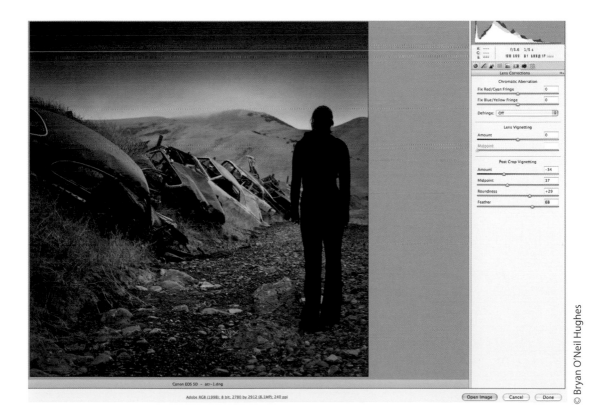

Step 7: Saving Preset

By saving our work as a preset, we can use it later to apply settings quickly to one or many images.

Step 8: Sharing Settings

Our settings can also be shared with others; to do so navigate to the appropriately named .xmp settings files in the user's Adobe/Camera Raw/ Settings folder. These small files (sets of instructions) can be passed on to others via email, etc. and loaded into camera raw. To load files, simply select the Load Settings option from the preset flyout.

Black and White Beyond

A selection of Photoshop plug-ins

Thanks to the extensibility of its plug-in architecture, Photoshop has always had tremendous powers beyond the features that it ships with. In fact, many of the features that are included in Photoshop are actually plug-ins themselves; some are built by Adobe, others licensed from outside providers.

Plug-ins are in essence programs running within a program, and they can be anything from a reader of an obscure scientific file format to a 3D manipulation tool. As digital photography has exploded in the past years, a number of third-party plug-ins have been introduced to help in color correction, lens correction, noise removal, High Dynamic Range and – you guessed it – black and white conversion!

You may ask yourself, if I have black and white conversion abilities in Photoshop, Camera Raw and Lightroom, what more do I need? Well, as you are about to see, there are some very powerful features found in some of these add-on solutions. There are dozens of products out there, and sites (like Adobe's own

Note to Intel-based Mac users:
Legacy plug-ins (those from CS2 and before) can still run in Apple's translation environment, "Rosetta". To run those older plug-ins, you must run Photoshop itself in Rosetta; to do so press Command+I on the Photoshop CS3 or CS4 application icon (in the Application folder) and select "Open using Rosetta".

http://www.adobe.com/products/plugins/photoshop/index.html) can help you find nearly all of them. For the sake of this book, we will focus on just a couple of the more current ones, offering abilities well beyond Photoshop's own.

Imagenomic's Real Grain
http://www.imagenomic.com/

Far more than just additive grain, Real Grain offers film stock and grain simulation of dozens of film stocks (both black and white and color). For those of you looking to replicate the effects of, say, TMAX 3200, not only does this plug-in help match the grain, but also the tonal aspects of the film.

Like Camera Raw and Lightroom, Real Grain offers easy controls to add split toning and balance the end result. Other features of this plug-in are black and white conversions, tinting, the ability to split previews – to have multiple "snapshot" previews in the case of the latter, each slider changes to represent the previewed effect.

✓ Fujifilm Neopan 100 Acros
Fujifilm Neopan 1600

Ilford Delta 100
Ilford Delta 100 (Pushed 1 Stop)
Ilford Delta 400
Ilford Delta 3200
Ilford FP4 Plus 125
Ilford HP5 Plus 400
Ilford XP2 Super 400

Kodak T-Max 100
Kodak T-Max 100 (Pushed 1 Stop)
Kodak T-Max 400
Kodak T-Max 400 (Pushed 1 Stop)
Kodak T-Max 400 (Pushed 2 Stops)
Kodak T-Max P3200
Kodak Tri-X 400TX
Kodak Tri-X 400TX (Pushed 1 Stop)
Kodak Tri-X 400TX (Pushed 2 Stops)
Kodak Plus-X 125PX
Kodak BW 400CN

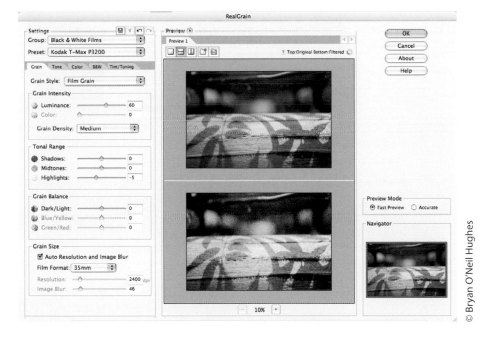

© Bryan O'Neil Hughes

Power Retouche Studio's Black and White Pro
http://powerretouche.com/

Like the others before it, Power Retouche Studio's Black and White Pro offers film stock emulation, easy and powerful conversions and photo filters; unique to this plug-in is a powerful Contrast control and a way of applying strength and opacity, which is very evocative of the power found in adjustment layers. This plug-in has a clean enough interface that you often feel as if it must have come with Photoshop.

Fred Miranda's B&W Workflow Pro 1.5
http://www.fredmiranda.com/

Fred Miranda's solution also offers additive grain, film ISO emulation, black and white conversions, tonal effects and common black and white filters, all in an easy to navigate user interface. Most unique in B&W Workflow Pro is the innovative smart channel mixer; this is a channel mixer which automatically biases channel balance in real time – it is easy and powerful, and it produces great results.

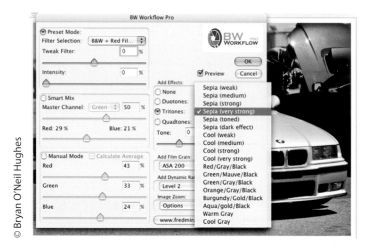

© Bryan O'Neil Hughes

Imaging Factory's Convert to Black and White Pro 2.0
http://www.theimagingfactory.com/

In addition to a clean interface in its black and white converter and a series of strong controls for toning, Image Factory has some support for 32-bit processing (aka High Dynamic Range); also unique to this group is the plug-in's ability to be scripted. Think of scripting as Actions gone wild: a user can define and call upon their own steps and procedures and vastly expand the speed and productivity of the plug-in.

© Bryan O'Neil Hughes

Power Retouche Studio's Toned Photos
http://powerretouche.com/

Power Retouche makes a separate plug-in just for toning, and it delivers on the expectations of a stand-alone. This plug-in has a wide array of presets, and features the same strength and contrast controls found in Black and White Pro.

Nik Software's Silver Efex Pro
http://nikonsoftware.com/

One of the coolest plug-ins to be released recently is this one from Nik. A sleek, polished interface with split views like Lightroom gives usability to a powerful engine. This plug-in has a myriad of presets served up in a variations-like series of thumbnails on the left side, but users can control exposure, grain, contrast, structure and much more. For those of you with a film background, Nik even offers a notion of the infamous Zone system. Very powerful and walk-up simple, there's a lot to like here. My first tests showed no problems running in CS4 (even though the installer told me otherwise).

© Bryan O'Neil Hughes

As mentioned before, there are hundreds of other plug-ins out there, and at least dozens which help when it comes to black and white conversions – what we have mentioned here are a few of our many favorites. Most plug-ins are available as limited trials, which is a great way to test what they might mean to your workflow.

Bringing scans into Photoshop

The mass proliferation of digital cameras has moved just about everyone to an almost entirely digital workflow; with it come limitless possibilities for images and an archival medium untouched by time, weather or light. What about all of those images that weren't shot with your digital SLR – you know, those shoeboxes filling the attic? Whether you've decided to enjoy the organizational powers of a good Digital Asset Management (DAM) system or you're just looking to have a desktop darkroom, you'll need to get those images into your computer.

So whether you're pulling in your film shots to have everything in one place or enjoying the nostalgia of a chemical workflow as your front-end, let's take a look at bringing those scans into Photoshop.

Different scanners bring images into Photoshop in different ways. Some will populate Photoshop's Import sub-menu (under the File menu), others will send the image from the scanner directly into Photoshop, and still others will place images in a folder where you'll then use the File menu to open them like any others. As with your camera, you'll often have a choice between a JPEG and TIFF and, as with the camera, if you have the room, use it and opt for the uncompressed (and artifact-free) TIFF.

*In these days of ever-changing operating systems and drivers, check with the manufacturer's website to assure you have the latest drivers.

If you're bringing in multiple images, follow these tips:

1. Always assure your scanner's surface is clean (treat the scanner's optical glass as you would a lens and keep it clean and clear with only approved materials).

2. Use a blank white piece of paper behind the images (this keeps the dark edges of prints from getting "lost" and helps Photoshop to define the boundaries of each image.

3. Don't worry too much about keeping the images straight – Photoshop has a wonderful tool to help. With your multiple-photo scan open in Photoshop, navigate to the File menu, Automate, Crop and Straighten. Here Photoshop will extract and straighten your photos into separate files (a **huge** time-saver for anyone who has tried the select, copy, drag, new layer, save, repeat method!) and number them based upon the original file name.

4. Before you begin to adjust your images (at least a little bit of adjustment always seems to be necessary when moving from analog to digital files), start an action. This way you can replay those setting on each image from the scanner. It's very easy, here's how:

 * With an image open, navigate to the Action panel (if it isn't yet open, go to the Window menu and select "Actions").

 * Use the turned page icon to create a new Action.

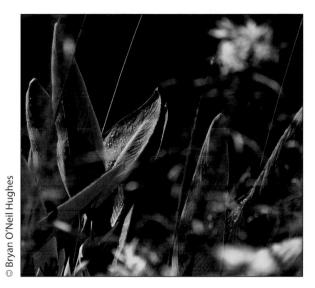

© Bryan O'Neil Hughes

- Name your Action and assign a function key if you think you'll be using it often.

- Anything (and everything – with a few exceptions like brush strokes) you do now will be recorded as evidenced by the red dot in the Action panel.

- When you're ready to stop the Action recording, just click the Stop button – just like recording a tape.

© Bryan O'Neil Hughes

© Leslie Alsheimer

Black and White & Creative Image Editing in Lightroom *by Leslie Alsheimer*

Now that we know about conversion methods and the foundation theory behind them, before we continue our Workflow into Photoshop for some more advanced editing, I want to outline a few great and easy methods for black and white conversion and creative image editing in Lightroom.

I spent many years learning, practicing and teaching Photoshop techniques alongside many of today's well-known Photoshop gurus and divas. From each of them I learned that there are many different and exciting ways to approach just about everything in the digital darkroom. Each and every artist I worked

with had very compelling reasons why their methods were superior to all others. I would be absolutely enchanted with one method one week, and be equally persuaded by another method the next. At first, I sided with the artist buying margaritas that week. Later, however, I dedicated some time testing and practicing each and every method with my own imagery and artistic goals. I determined in the process that the most dazzling techniques were not always the best for my work, nor even the most effective.

I learned that the best techniques for me are the ones that give me the results I like, with the least amount of time and frustration. And for that reason alone I have truly learned to love the ease of image handling and creative possibilities Adobe Lightroom has to offer my workflow.

Black and White Conversion Options: The Methods

Simple Grayscale

1. Select an image in Lightroom and click on the "Develop Module" for editing.

2. Check "Grayscale".

3. To optimize the conversion with further control, go the Grayscale panel and click the Auto button at the bottom of the panel. This feature automatically adjusts the Grayscale Mix sliders for an excellent grayscale conversion based on the White Balance settings of "Temperature" and "Tint" in the Basic panel.

© Leslie Alsheimer

4. Go to the Basic panel and adjust "Temperature" and "Tint", pulling each of the sliders to one extreme (left) or the other (right). You will notice significant changes in the grayscale conversion as you pull the sliders.

5. To adjust colors more specifically related to the image, you can also click on the Target Adjustment tool and adjust colors within the image without guessing as to what they are. Move your mouse into the image area, click "hold" and drag on the area you wish to adjust: drag up to lighten, drag down to darken.

6. Return to the Grayscale panel and click "Auto" again, and Lightroom will automatically readjust the Grayscale Mix sliders based on the new White Balance settings.

7. Adjust other Basic panel settings like "Exposure" and "Blacks" and fine-tune with "Contrast" and "Brightness", and anything else that seems to work.

HSL Conversion Method

This method will produce relatively the same results as the previous simple method, however the HSL method often produces less noise, particularly in skies.

1. Select an image in Lightroom and click on the "Develop Module" for editing.

2. Open the HSL/Color/Grayscale panel and click on "HSL".

Note:
This method often produces less noise, particularly in skies.

3. Pull the Saturation sliders for all the colors down to −100 to desaturate all the colors, and create another simple conversion. (You can create a preset for this in the Presets panel to quickly apply this technique to multiple images.)

4. To optimize the conversion with further control, adjust the Luminance sliders for each of the colors. I pulled the Luminance of the greens, aquas and magentas up and the Blue and Red sliders down for optimum results.

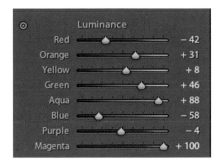

5. To adjust colors more specifically related to the image, you can also click on the Target Adjustment tool and adjust colors within the image without guessing as to what they are. Move your mouse into the image area, click "hold" and drag on the area you wish to adjust. Lightroom can move multiple sliders at different strengths in targeting an image-specific color: drag up to lighten, drag down to darken.

6. Zoom in and evaluate the results. The rendering should be a fair bit smoother with much less noise than the previous technique.

7. Adjust other Basic panel settings like "Exposure" and "Blacks", and fine-tune with "Contrast" and "Brightness", or anything else that seems to work.

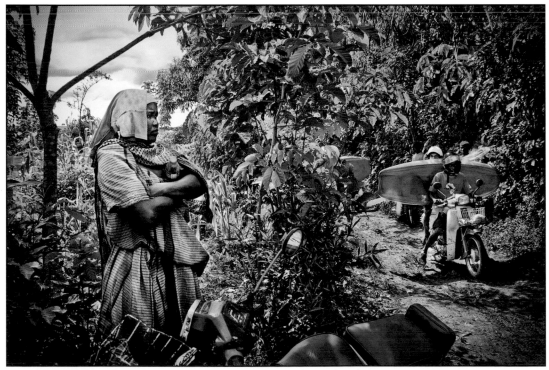

© Leslie Alsheimer

Creating a Graduated Neutral Density Filter in Lightroom

Most traditional photographers are familiar with the Graduated and Split Neutral Density filters. These filters reduce the exposure over part of the image in either a graduated or abruptly graduated manner. Often Neutral Density filters are used to equalize exposure when shooting a large amount of sky in the image. Used properly, metering and exposure can be adjusted for the foreground details, while preserving highlight detail in the sky and clouds.

1. Select an image and activate the Develop Module.

2. Activate the Neutral Density tool just under the Histogram (M) key.

3. Click on the show effect icon to activate the Exposure panel and create an Exposure Neutral Density filter.

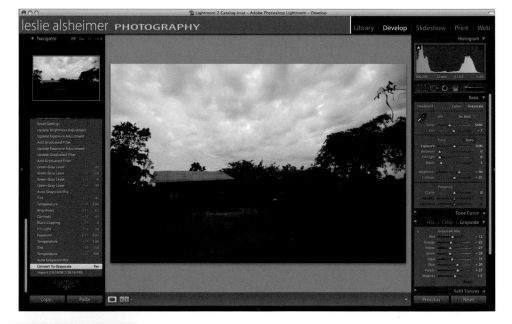

4. In this case I clicked the "+" icon to increase exposure because the house and foreground were underexposed.

5. Click inside the image area where you would like the lightening effect to begin and drag to the portion of the image where you would like the lightening to end. Lightroom will automatically graduate the transition of the effect. You can also hold the

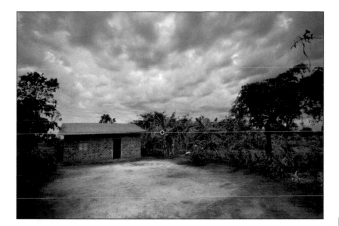

Alt/Opt key and begin dragging the Filter tool from the center point of where you would like the effect to apply.

6. Click and drag the edit dot in the center to adjust the position. Click on the center dot and hit the Delete key to remove the adjustment.

7. Return to your basic adjustments for exposure, shadows, brightness and contrast for final edits.

Note:
Neutral density filter effects are re-editable and, like anything in Lightroom, can be applied to any number of raw file types, JPEGS and TIFFS.

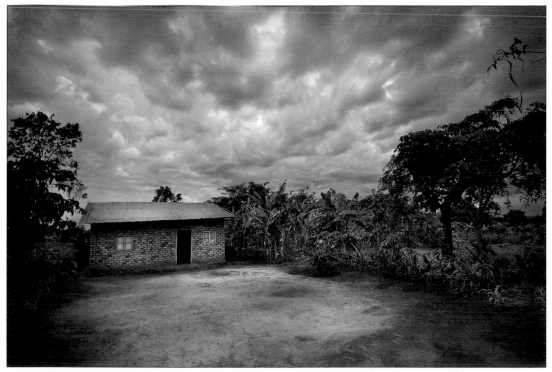

© Leslie Alsheimer

Dodging and Burning with the Adjustment Brush

"Dodging and burning are steps to take care of mistakes God made in establishing tonal relationships." ~Ansel Adams

While dodging and burning may be familiar terms to anyone brought up with traditional darkroom techniques, the ability to open shadows and burn highlights selectively and skillfully using a paintbrush tool is one of the most astounding tools Photoshop has had to offer the black and white photographer. Now, the new Adjustment Brush tool in Lightroom has become one of my absolute favorite new additions to the workflow. As Lightroom was previously limited almost entirely to global image adjustments, this new tool now affords us some ability to make technical corrections and creative enhancements more quickly with powerful selective adjustments like dodging and burning.

With this tool you can lighten and darken subtle detail work with the precision of a paintbrush. Although still not quite the same power and precision as dodging and burning in Photoshop – which is much faster and easier in my opinion – this Adjustment Brush tool does simplify much of the integrated workflow process. This new feature makes it possible to do more in Lightroom and potentially less in Photoshop (depending on your work criteria and standards). Selective adjustments are still the major advantage Photoshop has to offer the workflow, but it is pretty cool to be able to make some of these adjustments in Lightroom. This is especially true because the changes can be saved and applied to any number of image files needing similar adjustments. The adjustments are also non-destructive, meaning they can be undone at any time, and the file size does not increase as adjustments are made because no layers are created.

Note:
This technique is fairly cumbersome, a bit sluggish, and complicated in Lightroom until you get used to the way the tools function. Although it has advantages, I still personally find dodging and burning far easier and faster in Photoshop (see "Photoshop: Dodging and Burning with 'Soft Light' on page 214").

To begin, look for areas within the image that need special attention for tonal corrections and enhancements. Brightening and darkening areas is not only good for fixing exposure problems, but also essential for creating visual interest. In Lightroom, you can use the Adjustment Brush tool to dodge and burn and enhance and diversify the overall tonality within an image. This helps to serve the separation of spectral relationships that create a dynamic black and white image.

1. Select an image in Lightroom.

2. Select the "Adjustment Brush" from the tool strip in the Develop Module, or Press (K).

3. The Exposure settings control the overall image brightness, with a greater effect in the high values, while the Brightness settings adjust the image brightness, mainly affecting the midtone values.

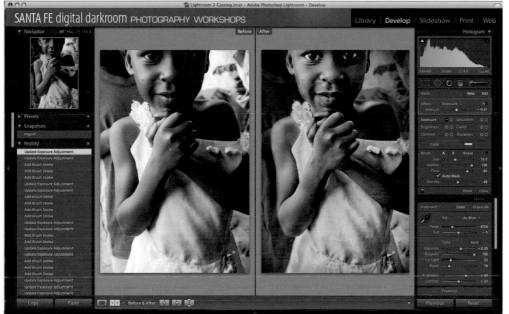

© Leslie Alsheimer

a. In order to brighten areas: increase the Exposure and Brightness amounts (I like to start with + 2.00 for Exposure, and Brightness to +50 but the specific settings will vary from image to image).

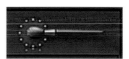

b. To darken areas: decrease the Exposure and Brightness amounts (−200 Exposure, −50 Brightness).

4. Choose the size of the brush according to the area you wish to adjust. The size specifies the diameter of the brush tip in pixels.

5. Set the Feather amount on a higher setting – this creates a soft-edged transition between the brushed area and the surrounding pixels. I usually start at +100 for a soft brush, and make the edges harder when necessary by decreasing the Feather amount. If the Feather amount is greater than zero, the brush cursor appears as two concentric circles. The distance between the inner and outer circle represents the Feather amount.

6. Choose a low Flow amount – this controls the rate of application of the adjustment so that you can build the dodging or burning incrementally with successive brush strokes. This allows you to make some areas more dense and some softer as you brush. I usually begin with a Flow of 20, although you will need to increase this amount for stronger results, and

decrease for softer results. Note that at this amount it may be hard to tell what is happening at first because the effects will be subtle.

7. You may want to increase the Contrast settings slightly to add a bit of "snap" to the areas that will be brightened, although this feature mainly affects midtone values. "Clarity" can also be added for this purpose, but do so with caution as clarity introduces sharpening, which should always be done with extreme care and critical scrutiny.

8. Select "Auto Mask" in order to affect a large area of the image. This feature confines the brush strokes to areas of similar color. (See "Auto Masking", page 184, for more details.)

9. Set "Density". This setting controls the amount of transparency in the stroke.

10a. Paint back and forth over the area within the image that needs brightening or darkening. You will need to change brush settings each time you want to switch from lightening to darkening. The plus icon (+) in the center of the circle indicates the point of application. The circle indicates the brush size.

10b. When you first release the mouse, an adjustment pin (or big dot) appears at the initial application point of the adjustment. In the Adjustment Brush tool drawer, the Mask mode changes to Edit and the Effect sliders become available to refine the adjustment. Move the pointer over the adjustment pin and drag the double-pointing arrow to the right to increase the effect, or to the left to decrease the effect.

* Press the "H" key to hide or show the adjustment pin.
* To see a mask of the adjustment, position the pointer over the adjustment pin.

11. Customize the adjustment by dragging the advanced Effect sliders in the tool drawer. Drag the Amount slider to the right to increase the strength of the selected effect, and to the left to decrease the strength of the selected effect. Or, click the plus icon (+) or (−) by the effect name to increase or decrease the effect.

12. Click "New" for each new area to adjust so that the strength of the adjustment can be refined independently.

Undo

To undo part of the adjustment, click "Erase" in the Adjustment Brush tool drawer, and paint over the adjustment. When you paint in Erase mode, the Adjustment Brush tool appears over the photo with a minus icon (−) at its center.

Press Ctrl+Z (Windows) or Command+Z (Mac OS) to undo your adjustment history.

Remove adjustments

Remove the adjustment completely by positioning the pointer over the adjustment pin and pressing "Delete".

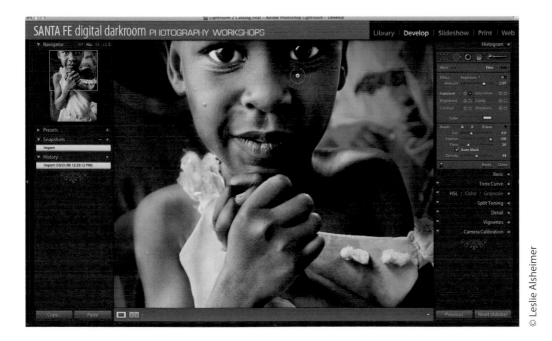

© Leslie Alsheimer

Auto Masking

The Auto Mask feature in the Adjustment Brush tool can automatically create and apply masks for the image as you paint with the Adjustment Brush tool. As you click with the Adjustment Brush on the image, the Masking feature analyzes the color and tone of the image area and applies the effect to only those areas that match the same tone and color. By finding the edges of an area, the tool essentially tries to keep the adjustment contained within the boundaries of the active painting area.

The Auto Mask feature can continuously resample image data as you paint with the brush, recalculating the mask as you work. Several brush strokes in a row will be linked into what is called a pin group, allowing the brush strokes applied to be based on varying color samples.

Although this feature works best with high contrast edges and with images that have clearly defined areas/regions, and not so well otherwise, it is pretty cool to be able to make adjustments such as dodging and burning in Lightroom. Again, Photoshop is far more powerful and effective with Masking tools and features, but I appreciate how easy this feature makes some adjustments.

The fundamental difference between Lightroom and Photoshop in this implementation is that Photoshop allows the capacity for an individual "layer" system for each adjustment, like dodge, burn, or contrast for example, while Lightroom uses "point-based regions" for each adjustment. In Lightroom, this means that every time you make a "new" adjustment it creates a "point", which is a little white dot around which that brush stroke adjustment is based. This is essentially the anchor for the adjustment region, and you simply paint on the adjustment you want.

You can also switch to the erase brush with the same controls (Feather, Softness, etc…) or simply toggle it by holding the Option/Alt key.

Each "pinned" region becomes another adjustment on the image that can be changed/refined at any point in time by selecting "edit".

When you hover the mouse over a "pin", the masked area is revealed in red, like Quick Mask in Photoshop. However, this comes up only while you are hovering over it and does not stay active for editing. Sometimes it is really essential to be able to fine-tune the edges of your adjustment area, and it is difficult to do this in Lightroom without having an Overlay View as Photoshop provides.

In the following example I was able to apply dodging and burning techniques to Jamie, the fisherman, as well as to larger areas in the background without bleeding my adjustments into the sky areas or into the fisherman. The Auto Mask feature worked remarkably well at auto-selecting areas of this image based on color and contrast, but I did still need to fine-tune the edges. This

can be done by switching back and forth with the Alt/Opt key to erase areas where the Adjustment Brush effect spills over the edges.

Lightroom makes the adjustments to the raw file, which are included in the history, allowing you to step back and forth through the edit states of an image.

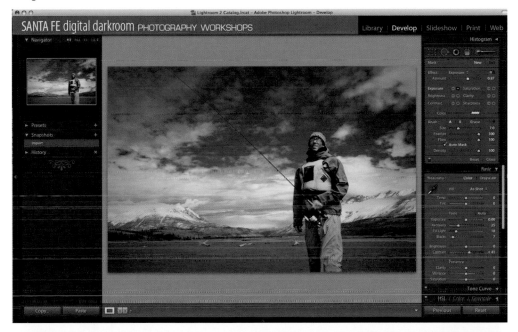

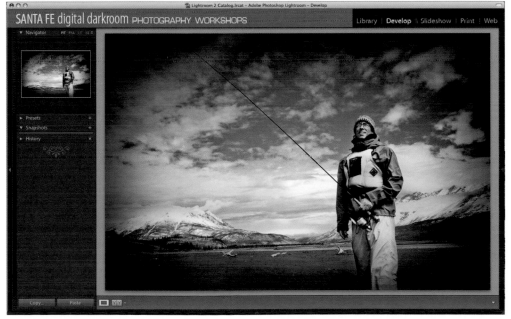

1. In the Develop Module, click on the Adjustment Brush to reveal the tool options.

2. Select Auto Mask mode. This feature confines the brush strokes to areas of similar color.

Tip:
Hold the Command key (Mac)/Control key (PC) to switch the Adjustment Brush into Auto Mask mode, or revert back to Normal mode if Auto Mask is already selected.

3. For this example, I set the adjustment to "Exposure" and made some dodging and burning adjustments as outlined in the previous exercise.

4. After painting an area, hover the cursor over the dot to reveal the mask area.

5. After finishing the main brush work, switch to Edit mode to fine-tune the settings.

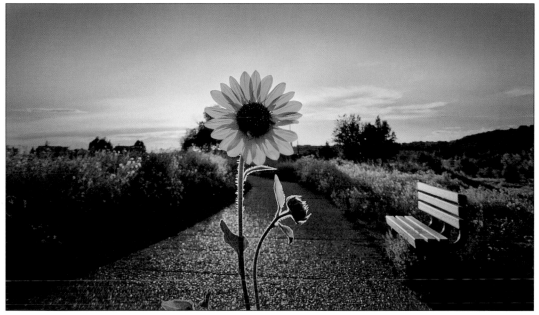

© Leslie Alsheimer

Hand Coloring with the Adjustment Brush and Masking

This technique is applied by applying a Color effect adjustment in Lightroom to an image that has been converted to monochrome in Lightroom. This process looks a little like traditional Marshall oil hand coloring techniques.

The Color effect feature of the Adjustment Brush allows you to brush with color on your images – much like using the Paintbrush tool and Color blend mode in Photoshop.

In the example shown here, I started with an image that had been converted to black and white by desaturating the colors. I used the Adjustment Brush in Color mode with "Auto Mask" selected. Although the previewed image was in black and white, it did not matter which black and white conversion method was used since Lightroom always references the underlying color data when calculating the Auto Mask. The Auto Mask feature was therefore able to detect the mask edges based on the underlying colors of the flowers and leaves.

1. Convert an image to Monochrome in Lightroom using one of the methods outlined in this chapter.

2. Select the Adjustment Brush.

3. Select the Color Effect mode from the Effect drop-down menu.

4. Click on the color swatch rectangle to open the color picker and choose a color to paint with.

5. Make sure "Auto Mask" is checked.

6. Brush along the areas of the image you wish to color. In this example, I colored the flowers, stems and leaves.

7. You can create custom settings for the "A" and "B" brushes with different custom setting features for each brush, so that you can easily switch back and forth between a brush set up for larger areas and another with custom settings to reach areas of finer detail.

8. Use the Edit sliders to modify the color and increase the saturation.

9. Click "Enter" approve the brush strokes and start a new set of paint strokes.

10. Choose another color and repeat the steps.

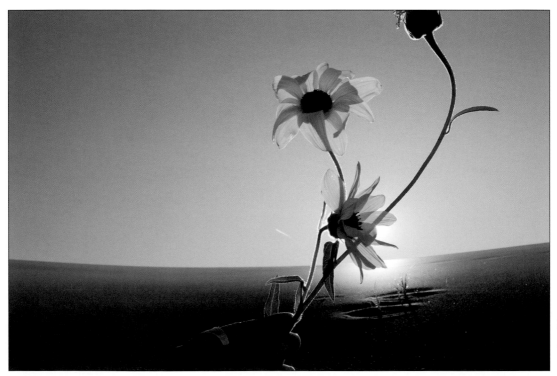

Selective Black and White

1. Open an image in Lightroom.

2. In the Develop Module, make basic exposure, tone and contrast adjustments to taste.

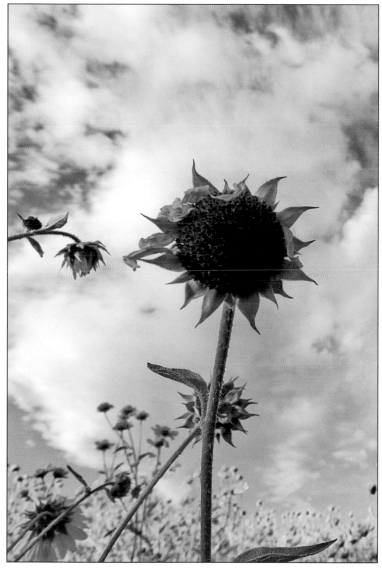

Tip:
Colors can be chosen from the ramp, preview image, or from anywhere on the Desktop. In order to select a color from somewhere else, click in the color ramp and hold the mouse depressed while dragging the cursor over any color area you wish to sample.

3. Move down to the Color/HSL/Grayscale section of the Develop Module and click the Color tab. Instead of desaturating all the colors for a full black and white conversion, desaturate only some of the colors (effectively turning them to grayscale) while leaving some colors alone. In this case, I desaturated all colors but yellow, green and orange.

4. Adjust the Luminance for each of the colors that have become black and white for tonal shifts and separation of spectral relationships.

5. Also adjust the Luminace for the colors that are still in color. In this example I adjusted the orange and green to get the results pictured.

Post-Crop Vignettes

In my work, I often use the Lens Vignetting sliders to darken edges, and also as a basic Dodge and Burn tool for the corners of images. Lightroom 2.0 now offers a Vignette panel in the Develop Module, expanding the capabilities of the two slider Vignette tools in Lightroom 1.0 – this tool was mostly created to be a correction tool for removing the slightly dark edges around an image caused by filters, lens hoods and lenses. The previous tool worked fairly well for that purpose, but it was far more useful when applied as a creative application to add a darkening (or lightening) effect to the edge of images.

The major problem with the tool in Lightroom 1.0 is that it only applies the vignette to the outer edges of the source image. This means that a cropped image would lose the vignetting effect.

Lightroom 2.0 has now attempted to remedy this issue with a new Vignette panel that adds the ability to dial in a vignette that is tied to the cropped framing. Although the new effect appears more graphical than photographic, it is a functionality offering some new creative options with much more control over features such as feathering and roundness.

There are four sliders in the Post-Crop section of the Vignette panel, offering a wide range of possible effects with various combinations of settings. Even if you have not cropped the image, the Post-Crop sliders work just as well on uncropped images as they do on cropped images.

- The Amount slider controls the amount of vignette you can apply to the image. A positive amount will lighten the vignette and a negative amount will darken it.

- The Midpoint slider controls the distance the vignette effect extends into the middle of the image. A Midpoint of 0 applies the Vignette amount as far into the middle as is possible.

- The Roundness slider controls the shape of the inside edge of the vignette. The higher the Roundness setting, the rounder the inside of the vignette effect will be. A +100 setting will create a circular vignette effect.

- The Feather slider determines how softly the vignette fades into the middle of the image. A setting of 0 will have no fading (or softening), while a +100 setting will apply the maximum amount of fading from the center, or lightest point, to the edges, or darkest points.

Note:
When editing crop settings in the Crop overlay mode, the vignette effect will be temporarily disabled.

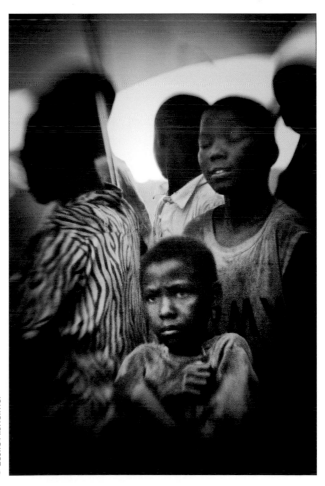

© Leslie Alsheimer

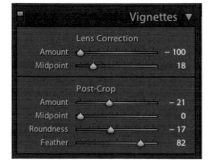

To give you some ideas I have taken the same image from the previous page and applied three more Post-Crop vignettes. Try combining a negative global vignette with a positive Post-Crop vignette to achieve both global and local vignettes in the same image.

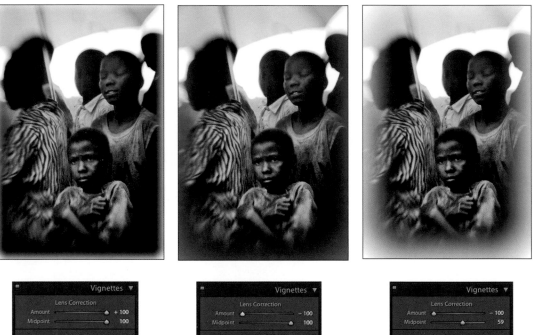

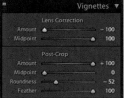
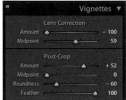

Develop Module Lightroom Presets

Lightroom ships with several presets listed in the Presets panel of the Develop Module that can be used as creative and time-saving tools. Develop presets are templates containing specific pre-made photo adjustments. There is a variety of presets available, such as photo aging, black and white conversion, sepia toning, cold toning, and sharpening.

Using Lightroom Develop Presets

Develop presets can be applied by simply clicking on the desired preset while viewing a photo in Loupe mode.

1. Pass the cursor and hover over each of the develop presets in the Presets panel. The preview pane will display the effects of each preset.

2. Choose a preset and then click on its name in the Presets panel to see its effects on the image selected.

3. Tweak the results using the Develop panel on the right, or undo the preset and choose another.

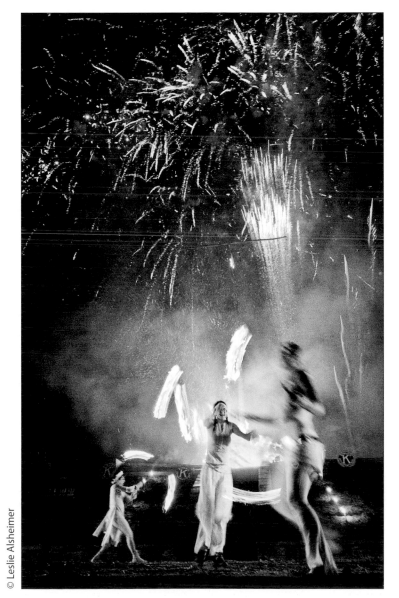

© Leslie Alsheimer

Develop Module User Presets

The presets available are organized into two folders: Lightroom Presets and User Presets. The Lightroom Presets ship with the software, while User Presets are uniquely created or installed by you. The ability to create and share User Presets is by far one of the coolest reasons to bring Lightroom into the digital darkroom workflow. Many talented photographers and Lightroom gurus have already made hundreds of presets available on the internet. A Google search of "Lightroom presets" will bring a wealth of options for free downloadable develop presets. Visit www.santafedigitaldarkroom.com for some downloadable black and white presets coming soon.

Installing Customized Lightroom Develop Presets

1. Open Adobe Photoshop Lightroom.

2. Select an image for creative adjustment.

3. Click on the Develop module at the top right.

4. In the Presets panel on the left, CTRL-click on a Mac, or right-click (PC) on the User Presets.

5. Choose "Import" from the pop-up menu.

6. Browse to the .LR template file(s) downloaded and select one or more.

7. Click "Import".

Creating Your Own Lightroom Develop Presets

Creating your own custom develop presets can really help save time and streamline workflow efficiency in the digital darkroom workflow. Any repetitive adjustments in Lightroom can be recorded to create your own custom develop presets. These are especially useful for batch processing images with exposure adjustments, white balance settings, black and white conversions and other development corrections with a single click.

1. Process an image in the Develop Module as desired.

2. In the Presets panel on the left, click the plus symbol (+).

3. Type in a descriptive name for the new preset.

4. Choose which adjustments to include in the new preset.

5. Click "Create". You now have a preset template that can be applied to any image with a single click.

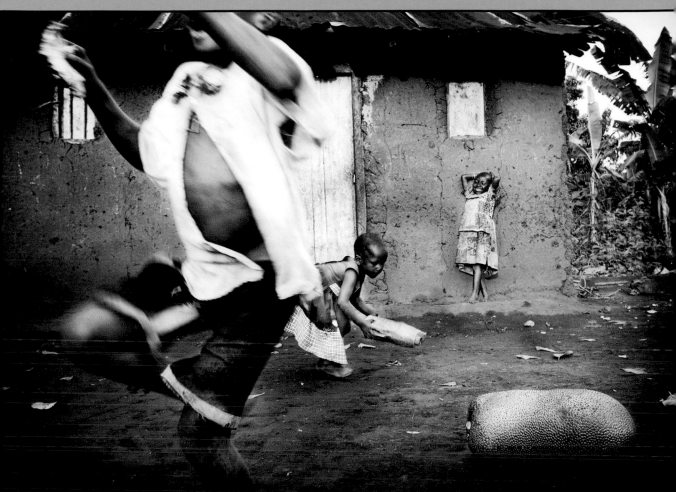

© Leslie Alsheimer

Creative Image Editing in Photoshop

by Leslie Alsheimer, with contribution by Bryan O'Neil Hughes

The Digital Darkroom

Photoshop is far too extensive to cover any and all possible adjustments and creative tricks available for a given image. There are countless books on the market today outlining the array of tools and techniques Photoshop has to offer. For the purposes of this text, we have concentrated on some of the digital darkroom processes most pertinent and most useful for the black and white photographer.

Non-Destructive Editing: an Overview of Best Practices and New Features in CS4

The notion of "non-destructive editing" has received a tremendous amount of buzz in the last couple of years, but it has actually existed in Photoshop since version 3.0 in the form of layers! Today, we think of non-destructive editing as the system of settings that accompany a raw file, but that is just the latest example.

For a digital photographer, non-destructive editing in Photoshop means adjustment layers. Adjustment layers are virtual "sheets" placed over an image background that contain the entire content of an image adjustment. Because they keep the effects of the adjustment from being applied directly to the pixels in an image, they can be adjusted infinitely and without compromising the quality of the original. Specific to the needs of digital photographers, adjustment layers are truly the digital photographer's modern darkroom. In addition to preserving the image's original detail, all layers also have the benefit of a myriad of blend modes.

Blend modes are an extremely powerful set of controls which dictate how layers "speak" to each other and to the image with which they interact. This chapter will illustrate some great techniques utilizing adjustment layers and blend modes in the step-by-step tutorials.

Another unique attribute of Photoshop is its arsenal of selective editing tools. Selections, whether made by tools, masks, channels or subsets of layers, govern which portion of a given area Photoshop focuses its powers. When the power and flexibility of layers and selections meet, it becomes very obvious why Photoshop is the world standard for image adjustments.

Remember that only a few file formats preserve Photoshop's adjustment layer capabilities. They are:

– Photoshop (.PSD and .PSB)
– PDF (.PDF or PDP)
– TIFF
– DICOM

Non-destructive editing has made incredible progress in Photoshop. Manipulations now look fresh and new because of how they are able to non-destructively "speak" to the original image through blending, opacity and masking. There are many features important to the non-destructive workflow process in Photoshop. First, Smart Objects, introduced in CS2, are references linking a file with its original. As an example, were you to take a high resolution image and scale it down or crop it, the image would only be as good as its final incarnation; with the use of Smart Objects, the image, when later up-scaled, references its original, pristine state and thus continues to assure maximum fidelity. CS3 brought us Smart Filters, which are essentially

filter layers. As with other layers, filter layers multiply the dozens and dozens of existing filters exponentially with the extensive reach, depth and breadth of complex blending modes. Now, Photoshop CS4 has added even more to the non-destructive workflow with the new Adjustment panel and Mask panel.

Lightroom and Adobe Camera Raw 5 (which ships alongside Photoshop CS4 and CS4 Extended) also benefit from non-destructive support for both TIFFs and JPEGs that translate to a preservational workflow for everyone! From a cell phone image to a burst of space-saving files off a pro SLR, anyone can now enjoy the walk-up simplicity of these application's non-destructive workflows. In the case of these two applications, image integrity is preserved not through layers, but through a system of settings applied to the original image. These settings can either be baked into the file, or sit alongside the original in what's known as a "sidecar" file, which is a ride-along file full of .XMP metadata (a set of the adjustment instructions). Further, benefits of metadata-driven adjustments are speed, intuitive controls (everything is non-destructive by nature) and sharing of effects; the one detriment is that Camera Raw and Lightroom are global editing tools, and adjustments are made to the entirety of an image – their big brother, Photoshop, is the home for selective edits.

A truly non-destructive workflow is about best practices and methodologies. Throughout this book, whenever applicable, we suggest methods which protect your valuable assets as best as possible. As stated, a non-destructive

workflow is the only workflow with Lightroom and Camera Raw; here is a set of guidelines for keeping your files pristine in Photoshop.

1. Use the highest resolution and highest bit depth file (the original) as possible.

2. Use Smart Objects (that way anything done that threatens the original can always reference the first incarnation). When using filters, use Smart Filters.

3. Use adjustment layers whenever possible.

4. When saving, always save in a format that allows for full support of all of your data.

Using Adjustment Layers for a Non-Destructive Workflow

Adjustment layers allow you to make multiple edits to your image without degrading the original image data. This is one of the components of non-destructive practice. Using adjustment layers in Photoshop will give you more freedom and flexibility in your editing process, without sacrificing valuable image data.

Creating adjustment layers

Creating adjustment layers is now easier than ever with the New Adjustment panel in CS4. There are now three ways to create adjustment layers:

1. Click on a specific adjustment in the New Adjustment panel.

2. In the Layers palette, click on the adjustment layer icon and choose the adjustment layer from the drop-down menu.

3. Go to the Layer Menu > New Adjustment Layer > and choose the adjustment you would like to perform.

Benefits of adjustment layers

1. *Non-destructive*
 Applying image adjustments and edits directly to an image (Background) is destructive because actual image data is being thrown away in the process. Once that data is gone, it is no longer available to you for re-editing or tweaking the image at any future time. Adjustment layers, however, preserve the original image data like a negative by applying the editing adjustments above the original image.

2. *Easily edited and re-edited*
 Adjustment layers document, maintain and save the exact corrections applied, so the adjustment or edit can easily be accessed and readjusted by simply clicking on the adjustment layer icon in the Layers palette.

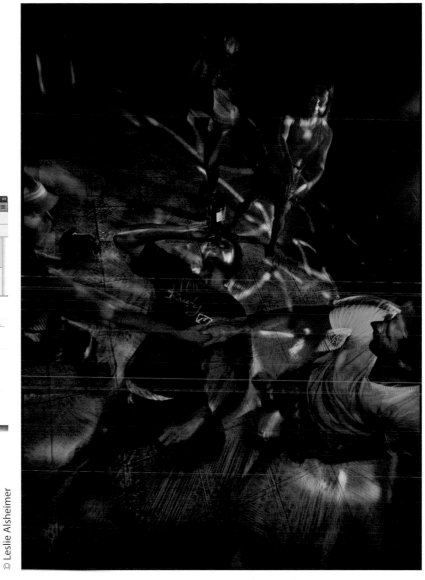

© Leslie Alsheimer

3. *Reviewing changes*
Because the adjustment layer sits above the original image, reviewing image changes in a before and after state can be easily seen. Clicking the eyeball icons next to the adjustment layer allows you to turn the visibility of each adjustment on and off and make decisions accordingly.

4. *Layer options*
Adjustment layers, as image layers, also provide layer options including opacity, blending options, masking, selective editing and the ability to transfer the adjustment layer to other documents.

Opacity: 100%

201

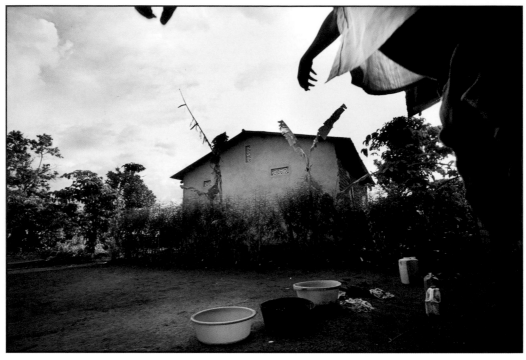

© Leslie Alsheimer

Monitoring Adjustments with the Histogram Palette

Open the Histogram and Info palettes. Choose Window Menu > Histogram. The default configurations will bring up both the Histogram and the Info palette grouped together. In order to look at both palettes simultaneously as pictured to the right, click on the tab with the word "Info", hold the mouse depressed and drag the two palettes apart.

The Histogram palette, introduced with Photoshop CS, allows the user to monitor the overall tonality and quality of an image dynamically as it is being adjusted. It is just as important to monitor loss of highlight or shadow information and detail as an image is being adjusted in the editing process, as it is in capture phase. Keep these palettes active and in view while editing and adjusting images in your digital darkroom practice. As outlined in Chapter 2, slams to the right side of the histogram indicate loss of highlight detail, while slams to the left of the histogram exhibit loss of shadow detail. (See "The Zone System Applied: Exposure Evaluation with Histograms", page 41 for a more in-depth analysis of the histogram)

The Info palette can also be useful in this process as one can mouse over the image and watch the Info palette dynamically measure image data in numerical values for each of the Red, Green and Blue channels. To ensure that

Note:
If the Info palette is not grouped with the Histogram palette, just go to the Window menu and check "Info". Be aware, clicking on a palette toggles it either into or out of view. If the menu is already in view, clicking on it in the Window menu will actually turn it off.

detail is not being lost, look at areas of concern and read the corresponding numbers as you mouse over the image, or shift-click on specific areas to set target points to monitor. Equivalent values of 255 with each of the RGB channels is by definition pure white on the brightness scale, or white without detail. Equivalent values of 0 with each of the RGB channels is by definition pure black, or black without detail. Unless an image is aiming toward some creative interpretation, we typically want highlight and shadow detail within a photographic image.

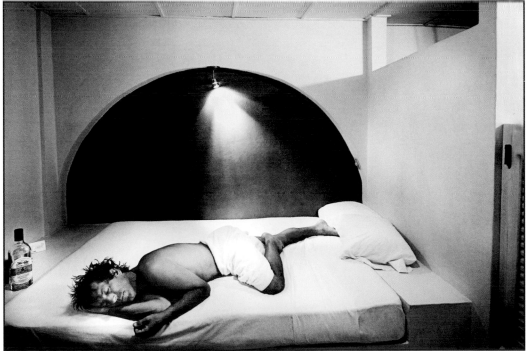

Levels and Curves Overview: Tone and Contrast Corrections

Levels and Curves are the fundamental digital darkroom tools in Photoshop for both global and selective tone and contrast adjustments. Both Levels and Curves offer a Histogram feature providing important information on shadows and highlights as tonal values are mapped within an image during the corrective process.

Levels

Input sliders

The three colored triangles just below the histogram allow you to change the black point, white point and gamma of an image in real time. As you move one of the sliders, Photoshop starts remapping pixel brightness within the image. Create contrast by bringing the white and black sliders closer together.

Moving the black point slider to the right, away from its default position at 0, will force any pixel information to the left of the slider to pure black. Moving the white point slider to the left will force any pixel information to its right to become pure white. Monitor the histogram as you pull the sliders to keep from inadvertently throwing out image data.

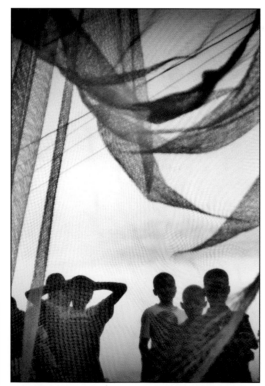

© Leslie Alsheimer

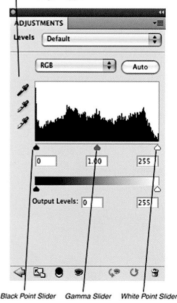

Black Eyedropper
Grey Eyedropper
White Eyedropper

Black Point Slider Gamma Slider White Point Slider

Moving Black or White Point sliders to the point where pixel information begins in the image results in added contrast and a remapping of pixel values. Pixels will be stretched to fill out the tonal range from 0 to 255.

The Gamma slider, the middle slider, allows you to change the midtone values within the image without affecting the highlight or the shadow values. Moving the Gamma slider maps where the middle gray, or 128 tonal value, will fall. Click OK, and Photoshop remaps the pixel data to your specifications.

Keep a close eye on the histogram as you make corrections in the digital darkroom to make sure that your editing is not creating significant gaps in the histogram. Too much pixel pushing can lead to posterization, which is the lack of smooth graduation between tones. (See "The Zone System Applied: Exposure Evaluation with Histograms", page 41 for a more in-depth analysis of the histogram)

Output Levels

Output Levels also affect the brightness and contrast of the image. This control slider compresses the tonal range of an image. Moving the highlight output slider to the left decreases contrast and darkens the image. Moving the shadows output slider to the right also decreases contrast, but lightens the image. This slider is most often used for graphic design purposes in screening back an image, to overlay text for example.

Preview

Turning on and off the preview checkbox allows you to view the changes you made to the image before you apply them.

☑ Preview

© Leslie Alsheimer

Curves

Curves is another editing tool providing the ability to affect tone and contrast correction within an image. Curves, however, is far more powerful. This is the digital darkroom power tool. Just as a hand-held screwdriver and a power operated drll can perform the same functionality, Levels and Curves, too, accomplish the same tasks. Levels is to the hand-held driver with three points of adjustment as Curves is to the power drill with 16 points of adjustment. The concepts are the same as in the Levels dialog box; the method however, is different. The Curves box functions as a graph that plots the relationship between input values along the bottom of the graph and the output values plotted vertically along the side.

Curves gives you far more control of the corrections you apply, due to the number of points that can be placed on the graph, but requires more skill in its application.

Levels and Curves have many similar controls. There are shadow, highlight and gray droppers that can be used to set white and black points, and a specific Curve adjustment can be saved and/or loaded.

As with any power tool, the best way to work in Curves is to make subtle gentle movements and adjustments with smooth flowing curves. Too aggressive or too many points haphazardly placed, and adjustments will be out of the photographic digital darkroom and into the "way-out art" fast. Experiment with the CS4 presets for medium contrast, linear contrast, strong contrast, and lighter and darker image adjustments to get a feel for how to apply these corrections with a free hand – subtle, gentle, and smooth.

The On-Image Adjustment tool

This new feature is available with three adjustment tools: Hue/Saturation, Black & White, and Curves. The On-Image Adjustment tool allows you to selectively modify tone, colors and luminance levels by dragging in an image. There is no need to isolate a tone, color or hue range. Just drag!

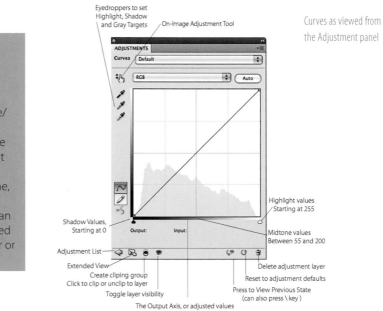

Curves as viewed from the Adjustment panel

206

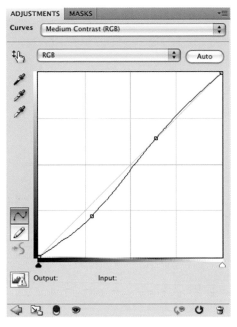

Medium Contrast Preset

Strong Contrast Preset

Lighter Preset

Darker Preset

Setting Black and White Points

If true black and crisp whites are what you are after, then setting black and white points within an image is a good place to begin your digital darkroom practice. This process will give you added tonal control, as well as eliminate unwanted color cast within an image. We will outline a few different ways to set black and white points.

Before we begin, however, we need to reset the eyedroppers tools as Photoshop installs with values for the color correction eyedroppers set to default numbers that represent a pure black and a pure white. For photographic purposes, we need the settings to represent values for both a white and black with detail.

Changing the Dropper Default settings

For photographic purposes it is necessary to first reset the black and white eyedroppers default target values
To maintain black and white with detail, first create a Levels or Curves adjustment layer. As both Levels and Curves utilize the same Eyedropper tool functions, changing the settings in either one corrects the tools universally.

Double-click on the black and white eyedroppers within the dialog box to bring up the color picker. Edit the RGB values to read as follows:

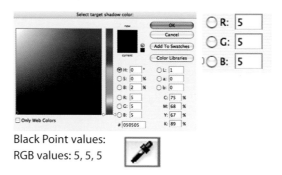

Black Point values:
RGB values: 5, 5, 5

There are a number of value settings on the market today. Those that we have outlined above are a typical stock agency requirement. Although they vary among agencies, these numbers were recommended by the Corbis stock agency, who is currently one of the leading agencies setting standards for commercial digital imaging. Look under Setting White Point in the Adobe Help menu for additional number settings as recommended by Adobe. Save these as your defaults or talk to your agency or printer/service provider for their recommendations.

Save these as your target values!!!
Click OK to the Color Picker settings, and again to the Levels box, and "Yes" to save the new values as the default settings.

Setting black and white Points using Levels

We will outline two methods to determine black and white points within an image. Method 1 is a faster and easier approach, while Method 2 will prove distinctively more accurate in determining point placement, but also a bit more complex. The process for setting black and white points for color and black and white images however is exactly the same utilizing either method.

Method 1: This Method is Easier!
After the target values for black and white are set in the Eyedropper tools. (See "Changing the Dropper Default settings", page 208.)

Step 1: Create a Levels adjustment layer

Step 2: Option key sliding

While holding down the Option key (Alt key on the PC), click on the white point slider in the Levels display box (just under the histogram). The image will turn completely black. As you pull the slider, white will eventually begin to appear within the image indicating where to find the lightest area that contains detail within the image. This is very helpful when deciding where to click the eyedropper. You will be looking for the first place white presents itself

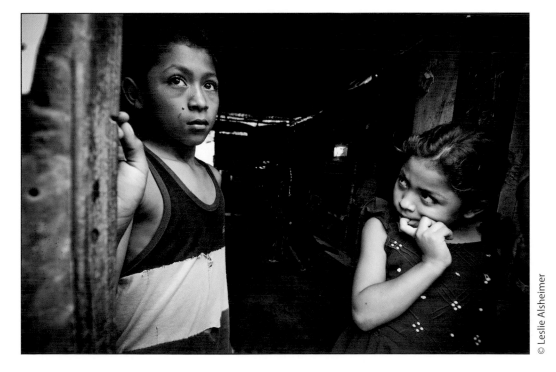

© Leslie Alsheimer

Note:
The slider method will not work for the gray dropper. It is a subjective placement. Try several different placements to see what looks to be the best to you.

Tips:
Preview turning on and off the preview check-box allows you to view the changes you made to the image before you apply them.

☑ Preview

in an area with detail (not a specular highlight). Choose the white dropper and click in exactly that spot on the image.

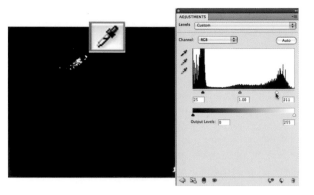

Step 3: Repeat the same process to find the black point, only this time use the black slider and the black eyedropper.

Use the middle dropper to set a neutral value, or something that should be neutral.

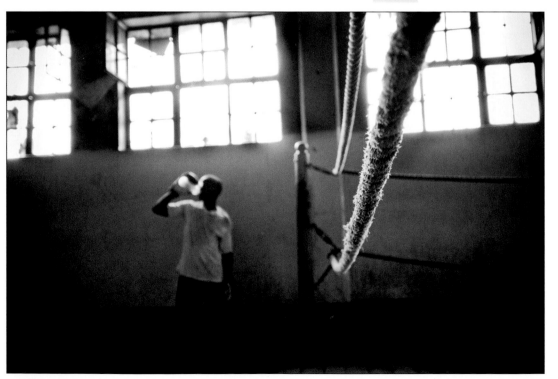

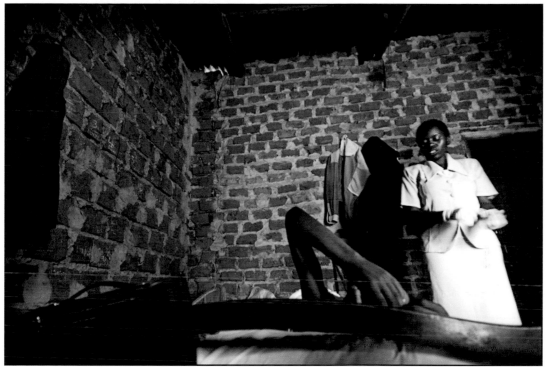

© Leslie Alsheimer

Method 2: Threshold – a More Advanced and More Accurate Method
Both Levels and Curves have the powerful eyedropper tools, and both are a
great place to start preliminary tonal and contrast corrections with black and
white point settings.

Step 1: Use Bridge to find an image that requires black and white point
corrections File > Browse.

Step 2: Find the White Point w/ Threshold. Create a new levels adjustment
layer. Choose Layer > New Adjustment Layer > Threshold, click the
adjustment layer icon in the Layers palette and choose "Threshold", or just
click on the Adjustment panel icon for Threshold to bring up the Threshold
window.

Click on the white input triangle in the center below the histogram and drag
it all the way toward the right to bring the image to all black. Slowly drag the
slider back toward the right to reveal the first white pixels. Click OK.

Step 3: Set the White Point target

Zoom into the isolated white pixels. Click and hold the mouse on your Eyedropper tool in the tool box to find the Color sampler tool nested underneath the eyedropper. Click in the white area created by the Threshold layer of the image to place a color sampler target point.

Step 4: Find the Black Point w/ Threshold

Double-click on the threshold adjustment layer icon in the Layers palette to bring back the Threshold window. This time, pull the white slider all the way to the left to bring the image to all white. Then slowly drag the slider back to the right to reveal the first black pixels. Click OK.

Step 5: Set a Black Point target

Zoom into the isolated black pixels. Click and hold the mouse on your Eyedropper tool in the tool box to find the Color sampler tool nested

underneath the eyedropper. Click in the black area created by the threshold layer to place a color sampler target black point.

Step 6: Throw away the threshold adjustment layer
Drag the threshold adjustment layer to the trash can at the bottom of the Layers palette, or just turn the visibility off in the Layers palette.

Step 7: Create a Levels adjustment layer
Go to the adjustment layer icon at the bottom of the Layers palette and choose Levels or Curves.

Step 8: Set the White Point
Single-click on the white eye dropper to select the dropper, and click on your image in the center of the color sampler target you created for the white point.

Step 9: Set the Black Point
With the Levels dialog box still open, single-click on the black eye dropper to select the dropper, and click on your image in the center of the color sampler target you created for the black point.

Hint:
Finding a neutral point in an image for color corrective purposes is often a matter of "click fishing". Try clicking on gray hair on humans or animals; shadow areas, rocks and clouds are often places that contain a good neutral.

Step 10: Set Neutral Point if there is one
Click on the gray dropper, and click on an area within the image that should be a neutral gray. It is ok to go "fishing", i.e. just clicking around the image with the gray eyedropper to get different results if you do not know where a neutral exists.

Photoshop: Dodging and Burning with "Soft Light"

While dodging and burning may be familiar terms to anyone brought up with traditional darkroom techniques, the ability to open shadows and burn highlights selectively and skillfully using a paintbrush tool is one of the most astounding tools Photoshop has to offer the black and white photographer. In fact, this is the technique that convinced me to move into the digital darkroom! With this method you can lighten and darken subtle detail work with the precision of a paintbrush. This is dodging and burning control and accuracy never dreamed possible!

Photoshop CS4 has made improvements to the Dodge, Burn, and Sponge tools – doing a much better job of maintaining the original color of an image, and maintaining exposure sensibility longer as you dodge and burn. However, as the Dodge and Burn tools are destructive unless used on a duplicate layer, which increases file size exponentially, I still prefer to use a non-destructive approach built around adjustment layers and blended layers.

 Step 1: Create a new blank layer
At the bottom of the Layers palette, click on the new layer icon or go to Layer Menu > New > Layer.

Step 2: Go to the Edit Menu > Fill.

Step 3: Select, for the Contents, Use: 50% Gray. Make sure the other settings read 100% for opacity and "Normal" for the blending mode.

Step 4: In the Layers palette, set the blending mode to "Soft Light" or "Overlay".

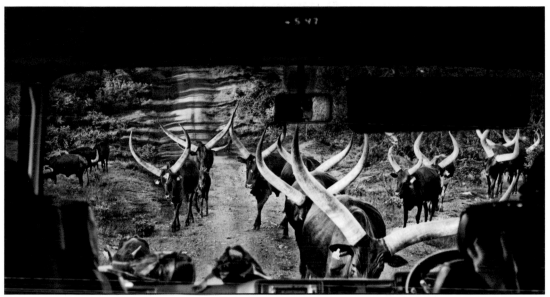

Step 5: Pick a paintbrush from the Tool palette and reduce the brush opacity to 20%. Use a soft brush to blend and soften edges.

Step 6: Set your color picker to the default colors of black and white by clicking on the two little black and white square icons, or hit the "D" key on the keyboard.

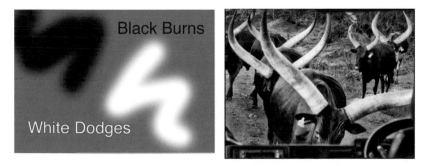

Step 7: Paint with black in areas of the image you wish to burn, and paint with white to dodge. Be sure to zoom in so that you can really accentuate fine image detail.

Step 8: Use the "X" key to toggle quickly between black and white.

Dodging and Burning with Adjustment Layers

Making separate adjustments to the highlights, midtones and shadow values is a digital technique that would be nearly impossible to reproduce in the traditional darkroom. Use this technique with the Color range selection tool as outlined below, or with any selection tools that isolate an area for tonal adjustments.

Step 1: Go to Select Menu > Color Range.

Step 2: In the Color Range dialog box drop-down menu next to Select: Sampled Colors choose Highlights. Click OK.

Step 3: Select Refine Edge: Go to Select Menu >Refine Edge. This opens a dialog box for the Selection tool. From here you can control Radius and Contrast, as well as feather the selection, increase or decrease the selection size (by small amounts), smooth the selection edges to remove "the jaggies" without blurring the edges of the selection, and any number of combinations of these settings to refine the edge. You get to watch the adjustment in realtime, ensuring before you accept it that the selection is exactly what you want.

Step 4: Create an adjustment layer of Levels or Curves to modify the selected area. Go to the Adjustment panel, or the Adjustment layer menu at the bottom of the Layers palette, and choose Levels or Curves. Pull up on the curve to dodge the selected highlight areas, pull down on the curve to burn them, or try one of the presets for increased contrast. The adjustment will only affect the selected highlight areas.

Step 5: Repeat Steps 1–4 for the shadows and midtones, creating two more adjustment layers if desired.

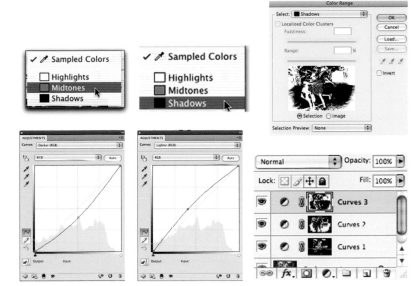

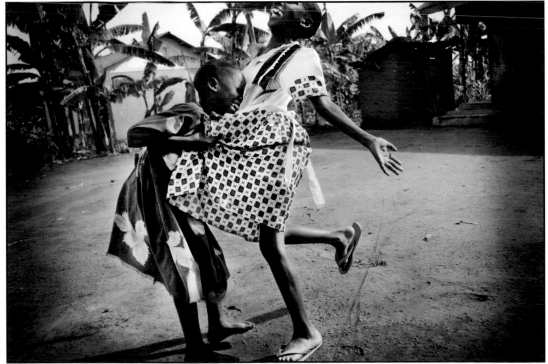

Creating a Neutral Density Filter

Most traditional photographers are familiar with the graduated and split neutral density filters. These filters reduce the exposure over part of the image in either a graduated or abruptly graduated manner. Often neutral density filters are used to equalize exposure when shooting a large amount of sky in the image. Used properly, metering and exposure can be adjusted for the foreground details, while preserving highlight detail in the sky and clouds. As demonstarted in Lightroom, this objective can also be achieved in Photoshop.

Step 1: Use Bridge to find and open an image that needs a graduated or neutral density exposure adjustment.

Step 2: Create a Curves adjustment layer by clicking on the Adjustment panel or adjustment layer icon at the bottom of the Layers palette, or go to the Layer Menu > New Adjustment Layer > Curves.

Create a Curves adjustment layer that darkens the area desired to burn. This will actually darken the entire image, but don't worry, the filter we create will correct the exposure in the areas we do not wish to darken. In this example, we pulled a curve that darkened down the sky for a more dramatic effect.

Step 3: Gradient tool: Click on the gradient tool in the tool bar. Hit the "D" key on your keyboard to return the color picker to the default settings of black as the foreground, and white as the background.

Step 4: Choose linear gradient
Look to your option bar from the Gradient tool. Make sure that you have the first icon, the linear gradient selected.

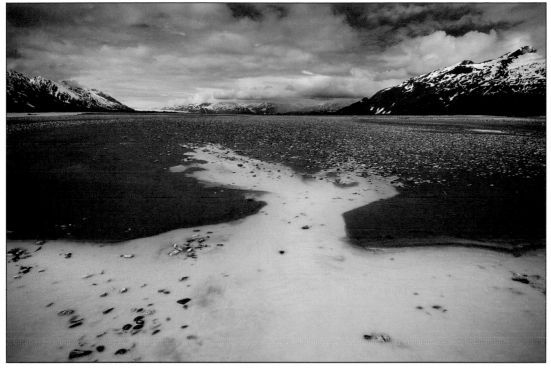

© Leslie Alsheimer

Curves 1

Curves 1

Step 5: Draw a gradient

Target the Curves layer mask by clicking on the mask icon in the Layers palette. Use the Gradient tool to draw a line from the top of the image to the bottom of the image area. Hold the Shift key to keep the line perfectly straight. Place the black of the gradient on the area you wish to protect from darkening and draw the white over the area of the image you wish to darken (black conceals the adjustment while white reveals the adjustment). The gray area in between will create the transition between the darkened area and the protected area. The longer the drag with the Gradient tool, the greater the transition area will be. For a shorter and more abrupt transition, try a short quick drag with the Gradient tool.

Step 6: Apply a Levels adjustment directly onto the Neutral Density mask filter to adjust the transition area visually. Go to the Image Menu > Adjustments > Levels or CMD "L" (Control "L" on the PC). Pull the Midtone slider back and forth to suit the image. This will affect the transition edge of the gradient.

Vignetting

Burn Edges w/ Geometric Selection Tools

A classic fine art printing technique used by many masters was to burn the edges for a finishing touch on prints, or used more dramatically to create portrait vignettes. Photoshop's geometric selection tools allow us not only to do this quickly and easily, but also to soften the edges of an image by using the same technique coupled with a Blur filter.

Choose a document that needs edge burning.

Step 1: Choose the rectangle or elliptical marquee and drag a rectangular selection a few inches from the image border.

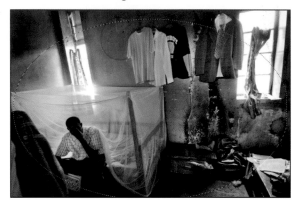

Step 2: Feather the Selection. Go to the Select Menu > Modify > Feather. Choose a pixel radius depending on file size or use "Refine Edge" to soften the edges of the selection.

Step 3: Select the inverse. Select Menu > Inverse.

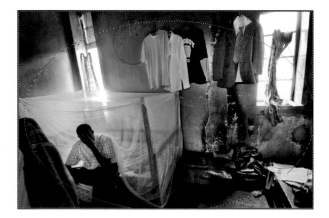

Step 4: Choose a Curves adjustment layer. Darken the selected area by clicking once in the middle of the curve and slowly pulling the curve down.

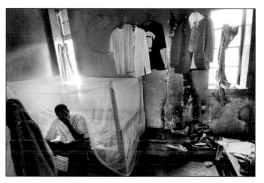

Before

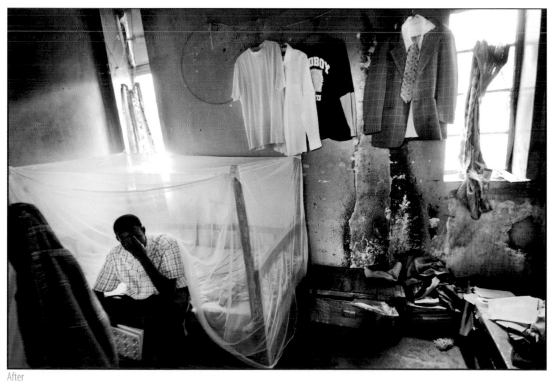

After

221

© Leslie Alsheimer

Try this technique with portraits!

To blur the background, repeat Steps 1–3 then choose Filter menu > Blur > Gaussian Blur to soften the edges.

Correcting Exposure Issues with Adjustment Layers

If you have an image that is a little over- or underexposed, then there is no need to worry – a quick and simple adjustment in Photoshop will have your image looking like it was correctly exposed in no time at all.

Create an adjustment layer for Levels or Curves with the Adjustment panel, or with the adjustment layer icon at the bottom of the Layers palette. I usually choose Curves. or go to the Adjustment Panel > New Adjustment Layer > Curves.

Do not adjust.

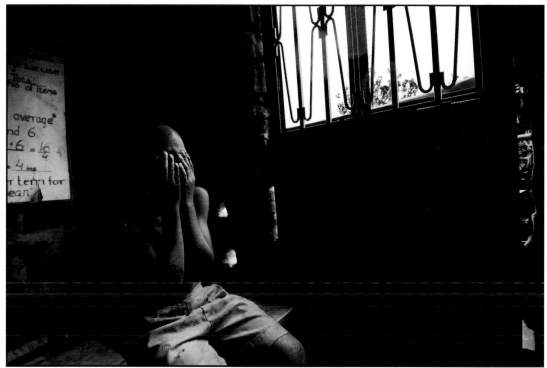

© Leslie Alsheimer

Set the blending mode in the Layers palette to Screen to correct for underexposure (lighten an image), or to Multiply for overexposure (darken an image).

Decrease layer opacity 36% for 1 full stop adjustment.

36% = 1 stop

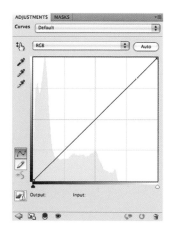
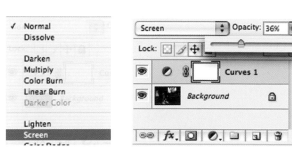

223

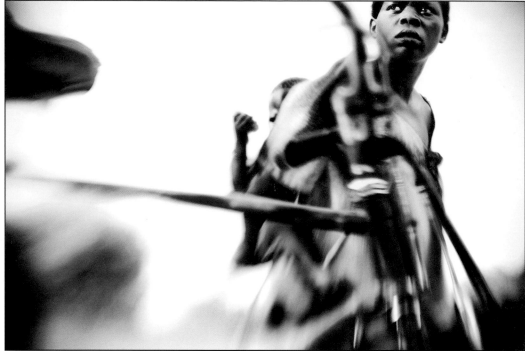

© Leslie Alsheimer

Grain Effects

There are many ways to create this effect in Photoshop – with third-party plugs-ins or stand-alone software. Almost all are created by doing one or more of the following steps.

Method 1

Take a piece of film with an empty frame from the ends of a roll and scan it! Copy and paste the scan into your image document and transform the size to fit your image. Set the blend mode to Multiply and reduce the opacity to taste.

Method 2

Step 1: Create a new empty layer on the top of your layers stack. Go to The Edit Menu > Fill > /and Choose 50% gray from the drop-down menu.

Step 2: Go to the Filter Menu and choose Noise > Add Noise. Be sure to check "Monochrome" and "Gaussian" and choose an amount to your liking. I choose 12 for this image. You can always reduce the opacity of the layer.

Step 3: Change the blend mode on the layer from Normal to Softlight or Overlay (experiment with which looks best to you.)

Step 4: Reduce the opacity if need be to suit your image preference.

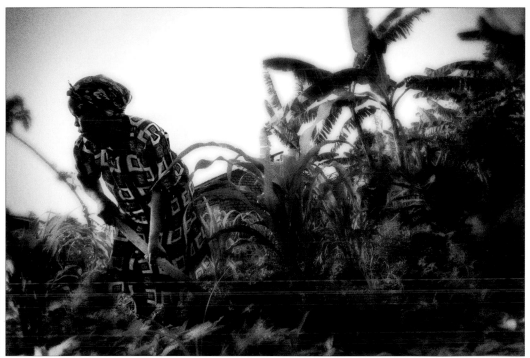

Digital Infrared

Digital Infrared

Infrared was one of my absolute favorite films to experiment with in undergraduate school. Although extremely difficult to expose well, the grainy and glowing quality of infrared gave it an ethereal feel I really loved. As the film responded to infrared radiation rather than to light, which is just outside the visible spectrum, learning to back off the focus just the right amount and expose infrared properly was quite an experimental process. The heat produced by green foliage and other living

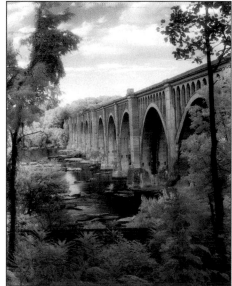

Straight Image Capture

Film Infrared

225

things creates the glowing surreal quality we are not able to view with our eyes. The images of the bridge and the hurdeler were exposed with infrared film and printed in the silver process. In the following lesson, we will recreate this effect digitally, which, I have to concede, is far easier than it was the traditional way!

In order to simulate the infrared effect, there are two different methods I have found to work most effectively. The key to both methods is in accentuating the green foilage within an image.

Step 1: Convert to Monochrome and accentuate Green
Create a black and white conversion adjustment layer using either the Channel Mixer or the Black and White stand-alone feature in Photoshop. Try both and see which one works best for your image.

With the Black and White stand-alone feature, you need to increase the values of the Green and Yellow sliders so that the foliage in the image becomes very light, paying close attention not to blow out detail within the image.

With the Channel Mixer, increase the value of the Green channel to close to 200%, and reduce it slowly paying close attention not to blow out detail in the image. Reduce the Blue and Red channels so that the sum of all three channels is roughly 100%. Totals can really be what looks best, give or take a few! Start with Red −50 and Blue −50 and fudge the three until the image looks right to you.

Step 2: Filter Diffuse Glow
The easy next step is to target the background layer (the image must be in 8-bit), or create a new merged layer on top, and go the Filter menu and choose Distort > Diffuse Glow.

Choose a grain factor of about 5 to begin with, a relatively small glow about a value of 2, and a clear amount of 10.

Note:
Make sure your background colors are set to the default of black and white before you initiate the filter.

If you do not like the way the diffuse glow filter looks, or just want to experiment further, undo the diffuse glow and we will next create the effect manually.

Step 3: Blur Green channel

In order to do this, activate the Channels palette, and click on the Green channel. Go to the Filter menu and choose > Blur > Gaussian Blur. We do not want to get too wild at first, so start with a radius of 5.

Step 4: Fade Blur

Go to the Edit menu and Fade the Blur to Screen and reduce the opacity.

Step 5: Add noise

Create a new empty layer with the new layer icon at the bottom of the Layers palette. Next go to the Edit menu and choose "Fill". From the drop-down menu choose "50% Gray". Go the Filter Menu and choose Noise > Add Noise. I usually choose an amount of 12 and make it Monochromatic and Gaussian. Next change the blend mode to Overlay in the Layers palette, and reduce the opacity until it looks right to you.

Reducing Noise with Photoshop

The truth is that all digital cameras create noise. The more advanced and expensive cameras, at lower ISOs, will not produce much obvious detectable noise at first glance; however, as we raise the camera's ISO settings or underexpose an image, noise can become a serious problem. In most cases, the noise is predominantly more visible in the Blue channel of an image. Some people feel the noise resembles film grain, and even like the look, while others find it unacceptable in their image files. While we cannot remove all noise altogether when it appears at extreme levels, there are some things we can do to reduce some of the effects at lower levels if the noise is not making us happy.

There are many available methods and techniques that produce excellent to moderate results depending on several factors, such as amount of noise, bit depth, file size and the type of noise. Just like the many different ways to convert an image to monochrome have advantages and disadvantages, so too do the noise reduction techniques. Whichever method you choose to support, it is most important to be mindful that noise reduction does introduce a certain level of blur, which is effectively sharpened back. Finding the right balance between technique, loss of image detail and acceptable noise is a tricky endeavor for even the most experienced digital users. The following Lab method is often a good starting point for a attacking an often very complex problem.

SMART FILTERS IN CS4

Using filter layers, reduce noise can be applied, changed or even turned off for previewing, web, saving, printing, etc. Working in layers also allows you to apply noise reduction using a myriad of blend modes and opacities.

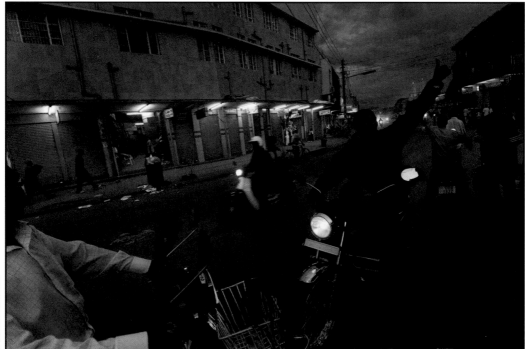

© Leslie Alsheimer

Blurring the Lab "B" channel – The method

Step 1: Go to the Image Menu > Mode > Lab Color.

Step 2: Activate the Channels palette and click the "b" channel to make it active.

Step 3: Go to the Filter Menu > Noise > Dust and Scratches. Move the Radius until you blur the chunky look of the noise out of the image. Click OK. The "b" channel is where the majority of your noise will be.

Step 4: Do the same to the "a" channel, but to a lesser degree.

Step 5: Click back to the Image Menu > Mode, and change the image back to RGB.

Another quick method: try converting your image to a smart filter. Filter Menu > Convert to Smart Filter. Then choose Filter > Noise > Reduce Noise. Fade and edit the filter to suit the image.

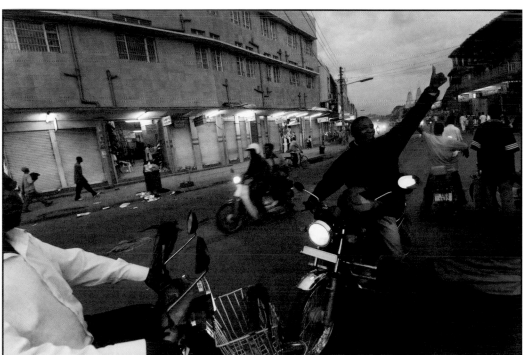

© Leslie Alsheimer

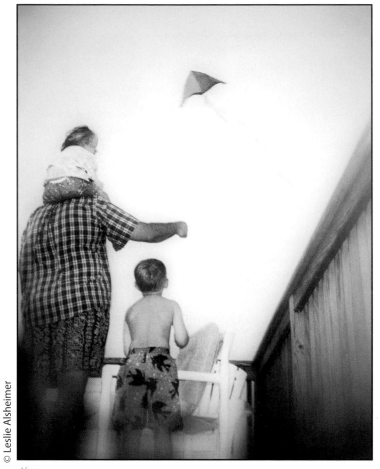

© Leslie Alsheimer

After

Hand Color Black and White

There are a number of techniques that can be used on black and white images to give them an interesting twist, and adding hand coloring is just one such method. By using the old fashioned Marshall Oil hand colored look you can give new life and vibrancy to a black and white image. In order to do this technique you will need to be relatively familiar with layers, selections, brushes and the color picker, although all of these tools are covered briefly here.

The Method

Step 1: Open
Open a black and white or toned image.

Step 2: Change the mode to RGB
Make sure that the Image mode is RGB Image > Mode > RGB color in order for the document to be able to receive and display color values.

Step 3: Choose a color

At the bottom of the Tool palette, you will see two square boxes filled with color. The default foreground color is black and the default background color is white. Foreground color is the color on the upper left of the display. In this example, my foreground is black and background is white.

To choose a new color, double-click on the foreground square, and the Adobe Color Picker dialog box will open. You can choose a color by clicking anywhere inside the box and/or sliding the Hue slider up and down to choose a different hue. You must click on the tone of color you want to actually pick a new color. Click to Pick! Click OK.

Step 4: Create a new Layer

In the Layers palette, click on the new layer icon. It is a good idea to get in the habit of naming your layers, so go ahead and do it at this time. Just double-click on the words "Layer 1" and you can edit text.

Step 5: Select an area and paint or fill with color

Choose an area you wish to color and select it with any of the selection tools, or just get a brush and start painting the area free hand.

If you have an active selection, you can choose to fill that selection with a color by choosing the Edit Menu > Fill. The Fill dialog box will appear. For contents, choose "Foreground Color" and click OK.

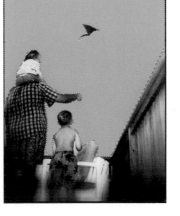

Before

Step 6: Change the blend mode to Color

Change the blending mode to color. Normal is the default blend mode for the Layers palette. This technique requires changing that to Color. Target the new color layer and choose Color for the blend mode.

Step 7: Reduce the opacity

Reducing the opacity gives this method the appearance of the old time look. Type in a percentage value number or click the blue arrow next to the opacity value window to activate the slider. View in real time how the outcome will look while sliding.

Step 8: Repeat Steps 3–8

Create new layers, choose different colors and paint in different areas until you are satisfied with the image.

**Remember

Be sure to create a **new layer** for every different color pick. This way each color can be adjusted independently with more or less opacity.

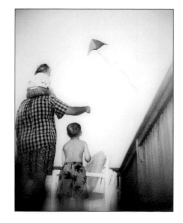

© Leslie Alsheimer

Sandwiching Negatives

Creative compositing with blend modes

This technique was originally created by combining two negatives or slides into the film carrier of the enlarger and printing them together onto one sheet of paper as a single image. This technique was often used to create a juxaposition of image elements within a single image. Utilizing blend modes with two digital images combined into one document, creative interpretation becomes almost limitless! Experiment further by combining techniques.

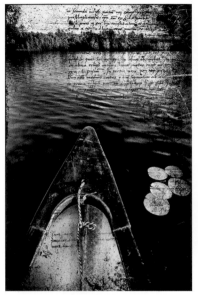

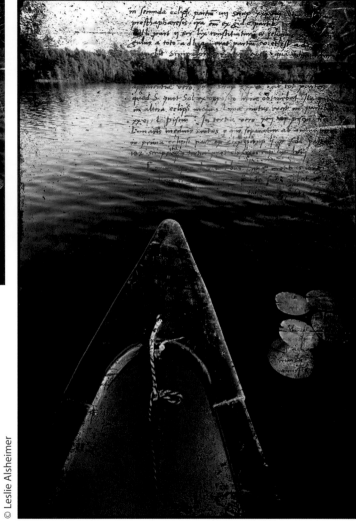

© Leslie Alsheimer

Step 1: Open two images you would like to combine together and resize both images so that they share the same width, height and resolution. Image Menu > Image Size.

Step 2: Choose one image to select and go to the Select Menu > Select All.

Step 3: Edit Menu > Copy.

Step 4: Activate the destination document (or the second image) by clicking on the image.

Select	Filter	Analysis
All		⌘A

Step 5: Edit Menu > Paste. The first image should appear in the Layers palette completely covering the image below.

Step 6: Scroll through the different blend modes in the Layers palette to find one that works with the images. Keep in mind that many blend modes may not produce pleasing effects at all. The blend mode Darken worked best for my images.

Step 7: Experiment with reducing the opacity of the image in the top layer.

Darken

Step 8: Combine this technique with other techniques. I added color. (See "Hand Color Black and White", page 230.)

© Leslie Alsheimer

© Leslie Alsheimer

Toning Techniques with Photoshop

Most traditional photographers will be familiar with the range of aesthetically pleasing toners available in the wet darkroom, as well as their ability to infuse images with subtle, and more evocative, moods. Traditional photographic prints have been toned since their beginnings for archival stability purposes and creative interpretation. Selenium, sepia, brown, copper, gold and blue toners are but a few of the time honored chemical processes for achieving tonal variations in prints. With the dawning of the digital age, we can now not only emulate the toning of traditional processes, but also utilize a whole new spectrum of toning possibilities never before possible, creating unique and wonderful new effects in the print making process.

As with every process and tool in Photoshop, there are many different ways to add tone to an image. Let us start with some of the more simple methods and work our way into more complex ones. Keep in mind that these tutorials will create digital emulations that draw visual inspiration from their traditional sources, but can never fully recreate the truly distinctive look and feel of the actual processes. It is also important to note that the type of paper, tonality and brightness of the paper base will affect the results of these processes. Experiment with recreating some of the old processes, and use these methods to create some new ones of your own!

© Leslie Alsheimer

© Leslie Alsheimer

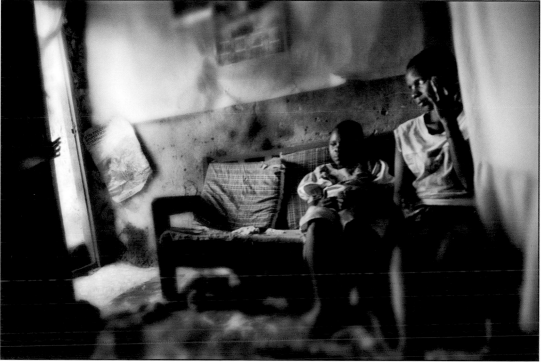

© Leslie Alsheimer

Sepia Tone 1: Photo Filter

Step 1: Convert the photo to black and white using your conversion method of choice. Then make sure the image is in RGB color mode to add color and tone.

Step 2: Create a new Photo Filter Adjustment Layer. Go to the Layer Menu > New Adjustment Layer > Photo Filter, or choose Photo Filter from the adjustment layer icon at the bottom of the Layers palette.

Solid Color...
Gradient...
Pattern...

Levels...
Curves...
Color Balance...
Brightness/Contrast...

Black & White...
Hue/Saturation...
Selective Color...
Channel Mixer...
Gradient Map...
Photo Filter...

Step 3: Change the filter to Sepia. Make sure "Preserve Luminosity" is selected and adjust the density to your liking; for this example I used 44%.

Photo Filter

Use
⦿ Filter: Sepia
○ Color:

OK
Cancel
☑ Preview

Density: 44 %

☑ Preserve Luminosity

Albumen Print: A Method for Split Toning

Albumen prints (1850–1890s) were made by coating ordinary paper with an emulsion composed of light-sensitive salts of silver suspended in albumen (egg white). Although these prints have been seen in many different color tones, the albumen print is most recognized by its very warm, creamy colored highlight areas and magenta to purple tone to the shadow values. With any color bias however, this process can be utilized as an easy method for split toning an image! (See page 243 for more info on split toning.)

Note:
You can choose any color interpretation you like.

Step 1: Convert the photo to black and white using your conversion method of choice. Then make sure the image is in RGB color mode to add color and tone.

Step 2: Create a new Color Balance Adjustment Layer. Go to the Adjustment Panel > New Adjustment Layer > Color Balance, or choose "Color Balance" from the adjustment layer icon at the bottom of the Layers palette.

Step 3: For this image, I started with the highlight values and set the Color Levels input values to 0, −8, −52. For the shadow values I set the Color Levels input values to, −2, −16, 49.

Step 4: I found the results of these settings to be quite garish, so I next reduced the opacity of the adjustment layer to a pleasing interpretation. For this image I found about 30% to do the trick!

© Leslie Alsheimer

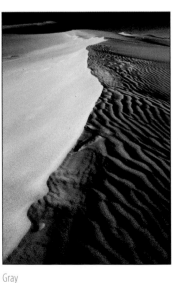

Gray

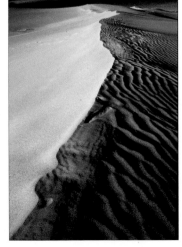

Split

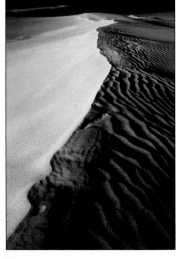

Albumen

Sepia Tone 2: Hue/Saturation

Step 1: Convert the photo to black and white using your conversion method of choice. Then make sure the image is in RGB color mode to add color and tone.

Step 2: Create a new Hue/Saturation adjustment layer. Go to the Layer Menu > New Adjustment Layer > Hue Saturation, or choose Hue/Saturation from the adjustment panel or adjustment layer icon at the bottom of the Layers palette.

Step 3: Click "Colorize" at the bottom of the dialog box and choose a hue that has a nice sepia feel. I chose a hue of 25 for this image and an opacity of 6. You should reduce the opacity, however, to something pleasing to you.

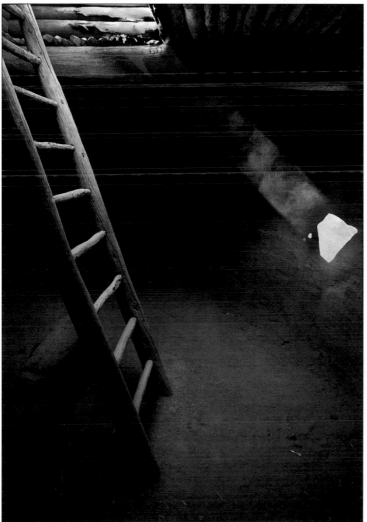

Note:
You can also use the On-Image control feature to change colors dynamically as you click and drag.

© Leslie Alsheimer

239

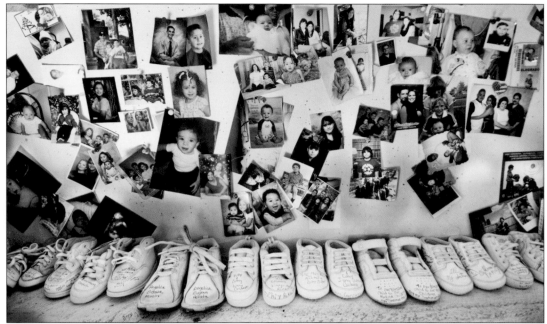

© Leslie Alsheimer

© Leslie Alsheimer

Also using a Color Balance adjustment layer, try emulating the Van Dyke Brown tone, sepia tone and cyanotype print.

The cyanotype print was created by an iron salt sensitizer which could be exposed in sunlight and developed in water. Cyanotype prints are characterized by a very moody dark, deep blue tonality. For the image below, I set the midtone Color Levels input values to −60, 0, 96.

© Leslie Alsheimer

Toning with Curves

Using an adjustment layer of Curves is another powerful way to add tonality to a monochrome image. Any color imaginable can be achieved using Curves simply by moving from the Master channel (RGB) into the individual channels of Red, Green and Blue. Placing a point in the midtone value, highlight, shadow, or any value on the curve and raising or lowering the curve will alter the tone of the image. Here are the steps:

Step 1: Create an adjustment layer of Curves.

Step 2: Click on the Master channel (RGB) drop-down menu and click into the individual channels of Red, Green and/or Blue. Place a point in the midtone value of the curve to begin, and raise or lower the curve to alter the tone of the image. For a browner sepia tone, as in this example, you need to add red by raising the curve in the Red channel, and simultaneously remove some of its complement color cyan by lowering the curve in the Blue channel.

Step 3: Creating tonal adjustments with Curves is a sophisticated method that requires a bit of control. Curves tend to shift the density of the overall image in the process of adding tonality. To compensate for this, change the blending mode of the adjustment at the top of the Layers palette layer to "Hue" or "Color".

© Leslie Alsheimer

Split Toning with Selections
Use this technique to create depth with still life, add energy to portraits, or mood to landscapes.

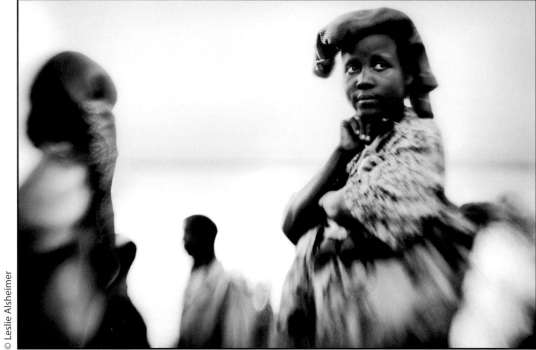

© Leslie Alsheimer

Split toned

© Leslie Alsheimer

Black and white

Split toning is a traditional process that originated in the wet darkroom where the toners applied to an image would adhere to only certain areas of the print, like to the shadow values alone, for example, while leaving the remaining portions unchanged. One common technique with this method was to warm the highlights and cool the shadows. This technique would add more apparent depth to an image, as well as a greater amount of visual complexity.

Step 1: Apply your grayscale conversion of choice.

Step 2: Isolate the area you wish to tone. For this image I chose to select the highlights. Go to the Select Menu > Color Range > Highlights.

Note:
Color Range dialog now includes:
• a new more accurate algorithm.
• the ability to select from multiple colors
• the ability to directly load as masks (from the New Mask panel.)
• the ability to adjust density and feathering of masks.

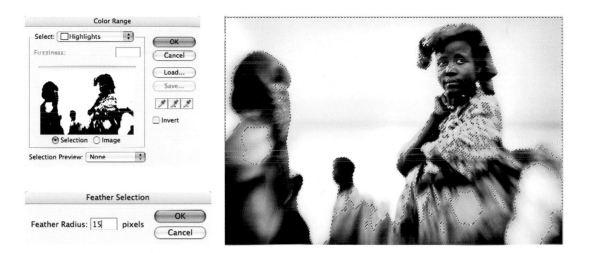

Step 3: Feather the selection to soften the transition edges. Go to Select Menu > Refine Edge, or Select Menu > Modify > Feather. Choose a value that works for the area selected relative to the image size dimensions. For this image I chose a value of 15 and a smooth value of 4.

Step 4: Create a new Hue/Saturation adjustment layer. Go to the Adjustment Panel > Hue Saturation, or choose Hue/Saturation from the adjustment panel or adjustment layer icon at the bottom of the Layers palette.

Step 5: Click "Colorize" at the bottom of the dialog box and choose a hue that has a nice sepia feel. I chose a hue of 45 for this image and an opacity of 10. You should choose the hue and reduce the opacity, however, to your liking.

243

Step 6: Select the Shadows. Go to the Select Menu > Color Range > Shadows.

Step 7: Feather the selection to soften the transition edges. Go to Select Menu > Modify > Feather or Refine Edge. Choose a value that works for the area selected relative to the image size dimensions. For this image I chose a value of 15.

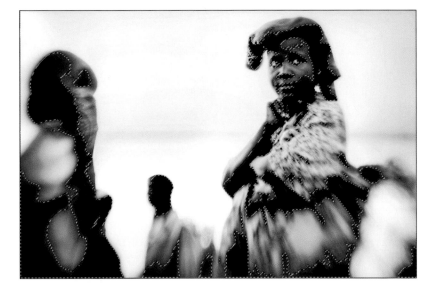

Step 8: Repeat Step 4 to create another Hue/Saturation adjustment layer. Click "Colorize" at the bottom of the dialog box and choose a hue that has a cool selenium feel. I chose a hue of 45 for this image and an opacity of 10. You should choose a hue and reduce the opacity, however, to suit your vision of the image. For this image, I chose a hue of 222 and a saturation of 72. Experiment with what looks best to you.

The advantage of working with selections is that changes can be edited and refined with precision and mastery via layer masks. With a selected area active, Photoshop automatically creates a layer mask for you as an adjustment layer is applied. Editing masks is easy. Activate the mask by clicking on it, and with a paintbrush paint with black in areas to conceal the adjustment, with white to reveal, and with gray to reduce the intensity of the adjustment. Experiment with just how many different and compelling tonal variations you can create!

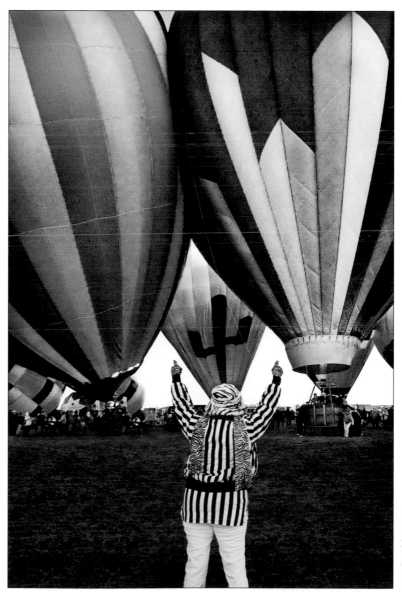

© Leslie Alsheimer

Duotone, tritones and quadtones

Duotones, tritones and quadtones are yet another wonderful method to add tonality to a monochrome print, especially in the prepress world. A duotone takes a monochrome grayscale image and typically uses a black ink color for the shadow information and a lighter tone of another color for the midtones and highlights. Tritones and quadtones use a third or fourth color for finer gradations of control. As tritones and quadtones are the same basic concept as duotones, just with more colors in the mix, for the purposes of this text we decided to discuss duotones alone.

Duotones are created by printing a grayscale image in two different ink colors. Printing photographs by the duotone method produces a richer and far greater tonal scale than is possible using only one color. Like split toning, duotones allow you to work within the tonal range of an image and specify a different color to any particular value within the image's tonal range.

Duotones require a color proofing system that can substitute PMS colors in place of the CYMK 4-color process, which, typically, most inkjet printers cannot accurately reproduce. Before taking on a duotone project, it is recommended that you consult your printer or service bureau.

Photoshop has some great preset duotone templates, as well as curves developed by my good friend Stephen Johnson. Use these as a great starting point to create some pleasing effects. To access the curves, click the Load button in the Duotone options box and find the "Goodies" folder

From the youth documentry *Reality from the Barrio,* awarded in Best Photos of the year 2003 by PDN magazine, photographer Erasmo Valdiviezo comments on his photograph:

"This is my Grandma Natty. She is 84 years old and she still smokes cigarettes, and she slapped me after I took this picture."
~ Erasmo Valdiviezo
Age 15.

For more information on *Reality from the Barrio,* See Outreach:
santafedigitaldarkroom.com

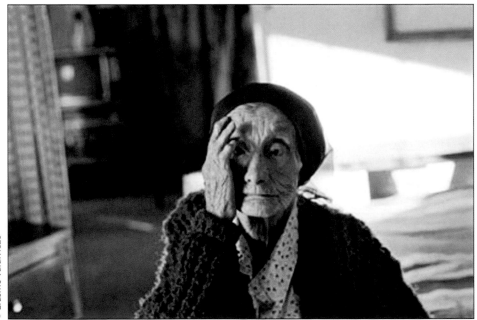

© Erasmo Valdiviezo

in the "Photoshop" folder for the duotone presets. These can be modified indefinitely or utilized as they were created.

Taken from the book *Reality from the Barrio*, the image (on the previous page) by photographer Erasmo Valdiviezo, aged 15, was printed with the duotone colors Pantone Warm Gray 7 CVC and Process Black U, with customized tonality curves created by Stephen Johnson specifically for this project. For more in-depth information on duotones as well as everything else digital, check out *Stephen Johnson On Digital Photography*, *Perspectives & Techniques from a Digital Photography Pioneer Exploring the Intersection of Art & Technology*.

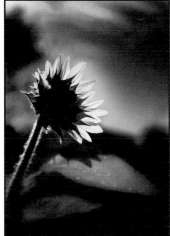

© Leslie Alsheimer

© Leslie Alsheimer

© Leslie Alsheimer

Pantone warm gray 7 CVC Curve

Pantone process Black U Curve

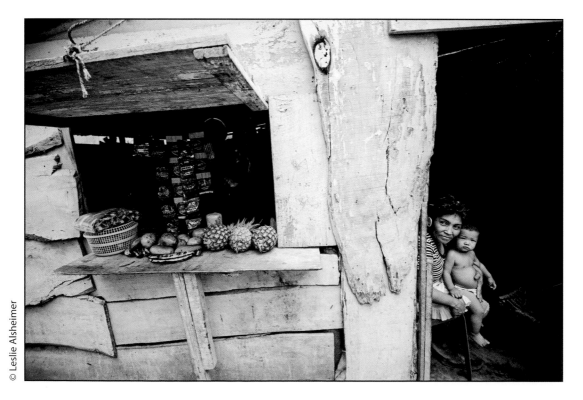

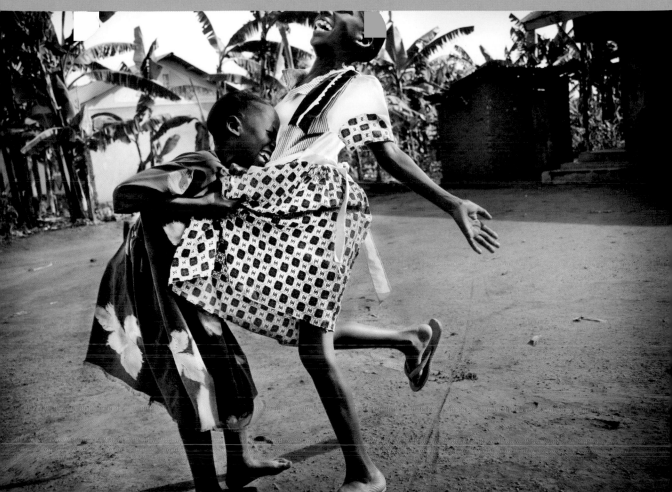

© Leslie Alsheimer

Printing *by Leslie Alsheimer, with contribution by Bryan O'Neil Hughes*

With today's rapid technological advances in the quality of digital processes, many fine art black and white photographers are making the switch from darkroom enlarger printing to digital processes. For those that are doing so, this is truly an exciting time to make the move! The latest advances in digital printing technology have made it possible to create beautiful high quality prints with relative ease and affordability. Although the passionate fine art photographer seeking the highest quality will find that the process still requires a fair amount of compromise, digital technology offers many compelling new advantages to the print making process worth exploring. It is, therefore, time for photographers to take the printing concept into a new era, not by replacing the old processes, but by integrating the methodology and tools into a new quiver for the craft. If we look at the digital process not as how we can merely recreate and mimic the silver process, nor at the strengths and weaknesses of each by comparison, but as a new and different format for translating our imagery onto fine art surfaces, then we will realize that the possibilities have grown beyond what was ever thought possible.

Traditional chemical processes utilize metals such as silver, platinum or palladium to create an image on surfaces coated with light-sensitive materials. The unique aesthetic quality of the metallic print has long been a beautiful sight to behold. Inkjet, or *giclee* (French for fine spray) prints also have a unique look and feel because they are created by placing millions of tiny ink droplets onto the paper in order to simulate the continuous tone of emulsion prints. It is important to differentiate the unique beauty digital prints have on their own – as they cannot actually ever be the same as a chemically processed print – just as the movie version of a novel will never be the same as the book itself. The world renowned print maker, Jonathan Singer of Singer Editions in Boston, Mass., comments that he often has a difficult time working with photographers who want to reprint their favorite darkroom prints in a digital format. When their mindset is to copy what was, Singer feels that he must sometimes make an inferior print. As the technology allows for far greater precision – and with skill and mastery he can produce far more profound results – he often wonders why those who want to mimic do not just stay in the darkroom altogether.

While we still cannot mimic the silver gelatin look digitally, technology has refined the tools in ways that allow our digital darkroom to be far more refined than was ever possible in the traditional darkroom. Digital technology and software innovations have made it possible to apply controlled contrast and tonal adjustments to precisely selected areas, with a degree of precision and control not possible using traditional methods. There have also been vast improvements with dynamic range capabilities that expand the shadow and highlight information to measurably more tonal latitude than conventional silver prints. Experienced fine art photographers who have switched to digital print making profess that they can make better prints than they ever could with an enlarger. This text will show you how to reproduce many traditional looks in digital format and, more importantly, it will help you realize that the scope of what is possible in the digital darkroom is far greater than ever before because of the combination of the old and the new.

Silver Changing Form

For many of us who started in the chemical darkroom, the concept of loving the smell of fixer or hypo on our hands is a memory, or still a reality, that conveys a certain idea of tradition that is difficult to leave behind. It has been 25 years since my first venture into a darkroom; the alchemy, the magic, the smells, and the aesthetic quality of the results are all profound and powerful memories in my life. Not only was the darkroom a place to lose myself, a place where I was able to share photography with others as an educator, but it was also a process that – like many others – I fell in love with. With the rapid changes brought about by digital photography today, the reality is that fewer photographers are spending time in the traditional darkroom. Many are even starting to put black and white silver printing on the veritable endangered species list of artistic

processes. Eastman Kodak has announced that it will no longer manufacture black and white photographic papers, Agfa is no longer in the black and white photographic market, and there are rumors concerning the stability of the remaining companies who manufacture and distribute black and white silver materials. While many of the rumors are predominantly true, the black and white silver process is not necessarily dying, but changing form. All these disheartening gloom and doom scenarios do not necessarily have to equate to the death of black and white silver process, however, if we recognize that we can still embrace them in the digital domain.

Since I found the digital darkroom, I do spend most of my time working digitally, but I know that I have not left the chemical darkroom for good. I strongly believe that the traditional darkroom still has a secure future in the photographic world. Just as platinum, cyanotype and gum printing have survived as "alternative processes", so will silver processes find their place among the beautiful and well-respected forms of artistic printing. It may be comforting to know that Ilford Photo is now leading the resurgence of black and white photography as the only manufacturer providing a full range of film, paper, photochemistry and ancillary products. Further, the process of "digital negatives", created with digital darkroom processes and output onto clear acetate, can be printed onto fine art papers with various traditional chemical methods such as platinum, ziatype and silver. Digital negatives are but one of the new and exciting ways to integrate the benefits of both the traditional and digital worlds into a new medium altogether. This digital negative process, introduced to me by Dan Burkholder, was not only reminiscent of the processes of the chemical darkroom that made me fall in love with photography in the first place, but brought it all back to life! The combined strengths of the different technologies and processes are just one of the many benefits and creative innovations that the digital domain brings to the medium of photography. The savvy photographer who has both traditional and digital methods in their bag of tricks simply has more choices that can only serve to broaden the scope of creative possibility.

There are almost as many different types of photographic users, each with varying and disparate interests and levels of technical proficiency, as there are possibilities in the digital print making process. Although this text could neither cover the full gamut of makes, models, manufactures, brands, inks, etc. on the market today nor advocate any one particular printing method as "best" for all users, we can, however, give you a strong overview of what to look for in your output decision-making process.

Black and white output options

There are an overwhelming array of options available today for the black and white photographer to output digital files onto paper and other fine art surfaces. Here are a few to consider:

1. **Traditional photographic papers** such as the Fuji Crystal Archive or Ilfochrome. This process requires working with a service bureau that will

produce your prints for you. This is a wonderful way to output digital files onto traditional photographic archival materials. Having someone else do the work for you is a great advantage, however it does also take your hands and artistic interpretation out of the print making process. You will have to consult a service provider near you for information and pricing.

2. **Digital negatives:** Images are inverted to negative form in Photoshop and printed on a clear acetate in traditional chemical processes. The greatest advantage the digital negative provides is getting to work with traditional chemical processes and papers; a beautiful marriage of the strengths of the two mediums, and one of my personal favorites! For more in-depth information, take a workshop in making digital negatives, with us at Santa Fe Digital Darkroom or check out Dan Burkholder's book *Making Digital Negatives*.

 Digital negatives can be made in two ways. The first requires working with a service bureau that can output your files as negatives onto lithographic film with a halftone screen. These negatives print extremely consistently, however some of the disadvantages include poor enlargement capacity, as one would be required to make new film for each enlargement to keep the dot structure intact. Although more expensive, a service bureau can also output using Light Value Technology, aka LVT, onto real film like T-Max or Plus-X with all the advantages that real film has to offer. The second method, much less expensive and time-consuming, utilizes the inkjet printer to output the file as a negative onto a transparent substrate such as Pictorico. If you know your way around the traditional processes of silver, platinum, palladium, Ziatype, etc., this is an extraordinarily fun and fabulous way to make mind-blowing prints with both mediums and produce consistent results every time!

3. **Iris: digital print by Pro:** As the first large format printer capable of producing a highly refined fine art print, the Iris printer is in a class all by itself. The Iris uses inkjet technology to produce fairly consistent, continuous-tone, photorealistic output on several varieties of paper, canvas, silk, linen and other low-fiber textiles. Iris prints are widely noted for their color accuracy and ability to match printing and proofing standards. They are also known for their superior dynamic range in reproduction of shadow information as well as for their low-cost inks compared to other technologies. The Iris printer is also typically a fairly expensive machine that is quite difficult to maintain and requires a rather specialized CMYK skill set. Today, with more simplified technologies, more professionals are moving away from the Iris, giving the Iris the noteworthy status of the digital "alternative" process.

 The Iris printer has the unique ability to print on natural surfaces, rather than papers with coating, which is one of its many selling points for the Fine Art printer. Desktop printers use glycols in their ink sets which are designed

to keep the heads of the inkjets themselves from clogging up. The glycols, however, have a tendency to cause advanced dot gain, which basically causes the ink to spread more rapidly across the paper surfaces. The papers are therefore coated in a way that freezes the ink droplets in order for the paper to receive the ink and prevent it from spreading in a controlled manner. So inkjet surfaces are limited to papers whose surfaces have coating rather than a natural surface. In contrast, the Iris printer embeds the droplets of ink into the paper surfaces instead of floating them on top of the coatings, allowing for a much richer look and feel to the prints similar to traditional processes.

In side by side comparative tests, Jonathan Singer of Singer Editions in Boston, demonstrates the differences in shadow detail performance from the two types of printers. He shows how he is able to get a wider tonal range in the shadows in particular because he is able to build up different densities of black ink within the blacks. "I am attached to the print as an object," he said. "With the Iris I can print on natural surfaces and the materials themselves, the way ink is embedded into the papers, the natural surfaces, torn edges and texture, create a beautiful object in and of itself, image withstanding".

As these are large format very expensive printers, prints from these guns are typically made through a service provider who knows how to use them. The prints are exceptionally exquisite, and well worth trying one on to see for yourself. For more information, visit Jonathan at Singer Editions, www.singereditions.com.

4. **Inkjet (or Giclee, French for fine spray):** As the most easily accessible and readily affordable option, many photographers are now choosing inkjet printers. Within the inkjet option, however, there is a significant variety of options and considerations for the black and white printer.

Ink

Types of ink

Dye and Pigment
Color inks can be divided into two primary types: dye-based inks and pigment-based inks. Most non-photo specialized printers utilize dye-based inks, while more specialized photo models tend to utilize the pigment inkjets. Most of today's longevity issues stem from the dye-based ink sets, which typically have a brighter color palette capacity, but tend to fade fairly quickly. Pigment inks, however, last much longer than dye-based inks but in the past have been plagued with neutrality issues and difficulty for the black and white photographer.

Also, in the color ink sets, the color pigments are made of various materials, and only the black ink is carbon-based. While all pigment-based inks do typically last much longer than dyes, the color inks (not carbon-based) do not

last as long as the blacks. There is some concern that over time the color inks will fade at different rates than the blacks. Depending on the purpose of the print, this may or may not be a concern for you.

Grayscale

Mostly known today as Quadtone and Piezography, these are gray ink sets designed to replace the color inks with various shades of gray in desktop printers. Most of these grayscale inks use carbon as the pigment for the black ink and create the lighter inks with various dilutions of the black inkjet. These grayscale ink sets can produce astounding results, maintaining neutrality throughout the entire tonal scale. As the carbon base is one of the oldest photographic materials, grayscale ink sets have marked longevity – considerably over 125 years. Although these ink sets can be purchased in warm or cool tones, one is limited to the single tonality of the ink sets as these inks are not easily toned in any other manner. Another consideration is that Quadtone and Piezography inks are not yet distributed by major printer manufacturers and must be obtained from third-party distributors, whereby typically voiding your warranty on the printers if utilized. These inks also require custom profiles. Some manufactures will provide them for certain printer and paper combinations, while others do not.

Issues with Ink

Neutrality and Metamerism

As inkjet printers use a mixture of the colored inks in an attempt to create the black and white tones, pigment inks historically tended to introduce slight color casts to the prints, giving the inks the reputation of having an incapacity for neutrality. Another issue for the black and white printer was the problem of metamerism. Viewed under different light sources of different temperatures, the effect of metamerism was to cause prints to dramatically shift color. For example, a print could have a greenish cast when viewed in daylight, a brownish cast under tungsten light on the market today and a magenta cast when viewed under fluorescent lighting. The latest generation of pigment inks on the market today, however, have improved tremendously. The days of metamersim are mostly behind us and the capacity for printing neutral tones from our desktop printers with the latest professional models has truly arrived.

Image Permanence

Image permanence, also referred to as longevity and stability, has always been an important consideration in digital print making since the first fine art digital prints were created in 1989. Since then, there have been many significant advances in the development of more permanent inks, making the question of longevity less pertinent.

Today, the very best ink and paper combinations are rated at well over 100 years under normal display conditions and over 200 years in controlled storage environments with acid-free materials.

Materials used for digital print making and traditional photography are independently tested by Wilhelm Imaging Research, Inc., a company considered the authority on the testing of image permanence. For comparison, Wilhelm reports on the number of years that display prints under framed glass will last until noticeable fading occurs. Traditional Chromogenic color prints such as the Fuji Crystal Archive paper, considered the most stable traditional silver halide color print, are rated at 60 years, Ilford Cibachrome are rated at 29 years and the Kodak Ektacolor at 22 years. For more extensive information on longevity visit Henry Wilhelm online at www.wilhelm-research.com.

Two alternatives of note have developed to overcome some of the black and white limitations to the inkjet approach.

Alternatives to Black and White Inkjet Limitations

Black only printing

One of the first solutions that comes to most people's minds in resolving the color bias issue is to turn off the color ink altogether and print with black ink only. Choosing the black ink only option in the printer driver options is certainly an easy solution to eliminating unwanted color casts. If made from a newer high-end printer, this approach will result in a fairly decent inkjet print and produce more of a grainy looking result with an older lower-end printer. This process is quick and easy and good enough for many users. Black only printing is a reliable, inexpensive and easy way to get started making beautiful prints with the highest possible archival longevity (using only a pure carbon black ink). It allows you to get started with the least expense and without committing to a particular system or software while you hone your skills and experiment with different papers. For the fine art printer, however, striving for better results, what we sacrifice for neutrality is dot structure. All the other colors in the CMYK or CMYKLBLMLC ink sets, in addition to the black, make the dot structure and tonal range of the print dramatically smoother, as there are exceptionally more droplets of ink hitting the printed surface. Using only black ink will be notably less rich in tonality and density by comparison.

RIP software (Raster Image Processing)

A RIP is really just software that replaces the printer driver that comes with your printer. It controls how ink flows to the print heads in a different way than the standard drivers, and gives the user more control over the tone and density of a print. The better quality RIPs produce beautiful results and offer a broad range of tones from neutral to sepia. Some RIPs are even capable of working with grayscale ink sets, allowing the photographer an even greater amount of control in the print making process. Sounds fabulous right? Before you get too excited, there are a few downfalls to note in the RIP process. First, RIPs are heavily technical, requiring the use of curves and profiles to control the inks. For the technically savvy, this is an approach well worth exploring; for the technically challenged, however, RIPs can be difficult to

master. Also, RIPs can be very expensive, although there have been a few exceptions that work as GIMP printers. A little research can help you travel this path if you so choose. GIMP printers can cause significant headaches and operating system problems if you choose not to use it to make a color print for example. Additionally, RIPs were developed in the days when pigmented inks had an issue with color shifting which has been mostly resolved with today's professional inkjet printers. Most RIPs also typically add small amounts of cyan and magenta and sometimes yellow to the print in order to control the tonality. Although invisible to most viewers, the well trained eye might find upon close inspection (like through a 6 × loupe) that the color ink dots can be seen.

Latest Developments

The result of all these choices has made digital printing quite confusing, as no clear single best path presents itself. In order to print from home using an inkjet printer and produce variable tonality, the reality is that color inks must be used. Whether the color inks are mixed on the paper as color dots or mixed in grayscale inks as toners, to date there is no other way.

Previous technology for the color inkjet required an RIP to optimize neutrality and was considered less lightfast than toned grayscale inks. The newest generation of pigment inks on the market today, however, have vastly improved in all of these previously problematic areas including stability for the color inks, longevity and neutrality. Although it is still recommended to research the latest results for any inks you want to use, today most of the latest developments in ink sets use carbon-based black ink and can achieve beautiful results right from your desktop.

Papers and Profiles

Matte vs. glossy
Choosing a paper type is an aesthetic choice or preference much like chocolate is to vanilla, or fiberbase was to RC. Each paper type will carry with it inherent strengths and weaknesses in addition to its unique aesthetic. The latest glossy and semi-matte papers can produce a maximum density black (also called dmax) equal to or greater than silver papers. Matte papers however, typically do not match the dmax of silver papers. This creates a bit of a quandary for photographers who prefer the look and feel of the fine matte papers, and simultaneously want richer blacks. In addition, the choice of digital papers is complicated by the fact that many printers require different black ink sets, matte black and photo black, for the different types of paper surfaces. Although some new printers carry both cartridges (eliminating the need to swap inks) the resulting headache and wasted ink in switching back and forth has caused many to choose one type and stick with it. Although I am not sponsored by any company to date, it

is worth mentioning that Canon has recently developed some impressive new professional printers that do not require ink swapping, which is worth checking out. There are also now many high quality fine art papers on the market. The 100% cotton, acid-free matte papers are predominantly considered to maintain the greatest longevity.

Profiles

Whatever paper choice you make, the greatest issue to keep in mind is its profile for the color management system. Hopefully, you would not have skipped over Chapter 1 color management and will, of course, remember that profiles are an essential piece of the digital print making process. Profiles are the translators that communicate the information in the image file from its source to its destination. Each type of inkjet printer, paper type, paper surface and paper manufacturer combination will require a unique profile that translates the image information accurately to its unique destination.

Printer manufacturers typically provide free profiles installed automatically with the printer drivers. The catch, however, is that the profiles provided are only for the papers and inks made by the same manufacturer. For example, Epson will provide free profiles for Epson papers printed with Epson inks using Epson printers. Change any one variable and those profiles will no longer be accurate. The easiest way to deal with color management on the output end is, therefore, to stick to the papers and inks made by the same manufacturer of your printer. Of course, you must operate the driver properly and choose the correct profile, which is the next topic we will address in the printing workflow.

In order to work with papers not made by your printer manufacturer, you need to obtain profiles for each type of paper. Frequently, the paper manufacturer will provide free profiles, typically available for download from their website. If however, a paper manufacturer does not provide adequate profiles for their paper using your specific model printer with the ink sets you have chosen, producing a decent print will be far from easy. You are then faced with creating your own custom profile, purchasing one, or experiential learning by tweaking and trial and error. This typically requires a fairly extensive amount of wasted time, paper and ink resources.

Custom profiles are created specifically for your printer and ink set, and built separately for each type of output surface you choose to print on. Custom profiles can be created at home by purchasing a profiling device, which can be expensive, complicated and time consuming. Creating a custom profile will require you to print a target with all color management turned off using your printer and inks on the paper you wish to profile. You need to purchase a separate profile for each and every paper you wish to use. Custom profiles can also be purchased online relatively inexpensively these days with results well worth the effort and expense.

Note: For more information on affordable custom profiles, email Mac Reid at Santa Fe Camera Center at www.santafecameracenter.com.

Workflow Phase 5: Printing Workflow

Whatever output path you choose, at some point in your editing process you will decide that you are ready to see the image in a printed format. Whether you have created extensive layers in Photoshop or choose to print straight from Lightroom, there is one essential concept to understand: your first print will not be your final award-winning portfolio piece. If you have ever printed in the traditional darkroom, you will remember that a final print was a celebration of many attempts toward your vision on paper. The digital process is exactly the same. Your first print will be for evaluative purposes. It may take several prints, over the course of many long work sessions, to realize your aesthetic vision in its final portfolio piece format. As we learned with color management, the system is imperfect and the key to the inkjet output process is reducing the number of variables through a color managed system, and the rest is all in the tweaking! Just like in the darkroom we controlled the variables of temperature and dilution as consistently as possible, made a print, studied it, and made changes again and again until we were aesthetically pleased with the results. The digital darkroom is no different.

Monitor Tonal Detail from Monitor to Print: Creating a Step Wedge

If we have chosen an inkjet path – whether for prints or negatives – we need to be able to evaluate the first print effectively. Often times, we are able to see the shadow detail of an image on the monitor, but lose the tonal detail in the translation to the print. In order to easily monitor and evaluate what is happening, we are going to create a grayscale step wedge and print it out.

Step 1: Go to the File Menu > New.
Make the document 10 × 3.5 inches at 300 dpi.
Choose "Color Mode Grayscale".

Step 2: Select the Gradient tool and set the default color to black and white by hitting the "D" key. Turn off "Dither". Hold the Shift key and click and drag a line from one end of the document to the other, making sure it starts and stops within the document itself.

Step 3: Go to Image Menu > Adjust > Posterize and type in "21" in the open text field. You should see 21 steps on screen.

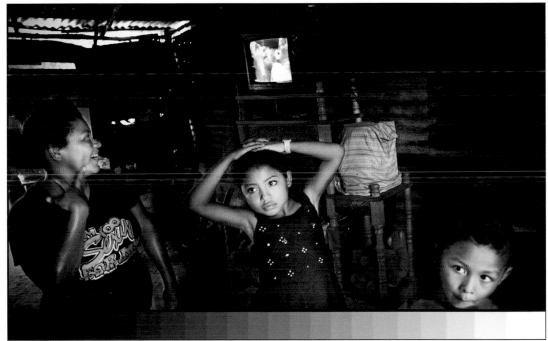

Print this out and check how consistent the step is on your monitor as compared to the print. Many fine art printers also like to add this file to their image test prints with a layer in Photoshop outside the image area to help evaluate each print as it comes out of the printer. Simply drag and drop the background layer of this file onto your image prior to printing, or Select All, Copy and Paste. You may need to enlarge the Canvas size, Image Menu > Canvas size.

© Leslie Alsheimer

Printing Workflow Overview

A. Printing from Photoshop

I: Set Image Size and Resolution
• Size the image for output with appropriate resolution and print size specifications.

II: Softproof
• Simulate how the image will look with various media and profile combinations.

Note:
By using smart filters users can re-edit sharpen settings for various needs: web, print, screen, etc.

III: Sharpening
• Choose a sharpening method and sharpen according to file size, image content and output specifications.

IV: Set Your Print Driver for Color Managed Output
• Select: Color management strategy, rendering intent, profile and media type.
 Method 1: Photoshop Managed Color
 Method 2: Printer Managed Color
 Method 3: No Color Management (specific to newest Epson printers: Advanced Black and White Mode)

V: Tweaking
• Evaluate the print under the correct lighting source.
• Return to Photoshop to make digital darkroom adjustments and corrections based on the printed results.
• Reprint and repeat until satisfied.

B. Printing from Lightroom

Easy! Size, Sharpen, And More All In A Single Unified Interface

I: Print Job
• Select: Color Management strategy, rendering intent, profile and media type.
 Method 1: Photoshop Managed Color
 Method 2: Printer Managed Color

II: Tweaking (See V: Tweaking above)

Drydown
As many fiber-based silver prints tended to dry down a bit darker, digital papers sometimes have a similar effect.

Try to give a print enough time to set before you do any major evaluations to be sure it has stabilized.

A. Photoshop Printing Workflow

I. Set Image Size and Resolution

Image size in Photoshop
Whether the final output destination of your image is to an inkjet printer, offset press, Iris printer or even the web, understanding image size and output resolution is an extremely important lesson. A digital image, whether from a digital camera or from a film scanning device, has a finite number of pixels set in width and height dimensions. This number is determined by the camera or scanner capture settings. If you chose to shoot in Raw format with a digital

camera, these numbers will be the maximum size your camera is capable of capturing at its native resolution. The top portion of the Image Size dialog box will illustrate what those pixel dimensions are. Be warned, however, these numbers can be easily and haphazardly changed having potentially detrimental effects on your image.

Resolution

For printing purposes, the term "resolution" in the Image Size dialog box refers to the number of pixels per inch that would be required to produce a final output print. Resolution can be presented with the formula: image size = physical dimension \times (ppi or pixel per inch) resolution. This means that there is a reciprocal relationship between pixel size, the physical dimensions of the image and resolution.

Digital images are made up of pixels which are resolution-dependent. An image can be scaled up, but as the size of the image is increased, the finite information and number of pixels available can only be stretched and diluted so much before the image begins to deteriorate, and the underlying pixel structure becomes increasingly visible.

File Size

The file size of an image is measured in bytes, kilobytes, megabytes or gigabytes. This refers to the sum total of pixel information or simply the total number of pixels.

The Image Size dialog box

There are two important checkboxes within the dialog box: Constrain Proportions and Resample Image. Unless you find a creative aesthetic for distorted images, "Constrain Proportions" should always remain checked. The Resample Image checkbox is where you take control of pixel allocation, resampling, interpolation and subtraction.

It is the best practice to always start with the Resample Image box unchecked, as this will protect your image from any potential haphazard up or down sampling. This will constrain the width, height and resolution of the image and merely redistributes the pixel allocation. The actual pixel count and total file size within the image will remain unchanged no matter what numbers you type in each field. Type in the desired resolution for the image's output destination. Screen resolution is 72 ppi, which is best for web work, while inkjet printers need between 180 and 360 ppi for quality rendering, and offset printing (books, magazines, etc.) requires 300 ppi. Be sure to ask your service bureau for their recommendation.

Once you have set the resolution, check to see if the width and height dimensions of the image now presented meet your specifications.

Note:
Always begin with "Resample Image" unchecked. This protects your image, and you can reallocate pixels within the width, height and resolution fields, without changing the actual image file size.

Some great Plug-in alternatives worth exploring are:
• Genuine Fractals (now by OnOne)
• Alien Skin Blow Up

Downsampling & Upsampling (Danger!)

If the image is larger or smaller than what you need for print, you can check the Resample Image checkbox. Notice that the pixel dimension fields become editable, and type in the desired dimensions. The file size of the document will change and the size differences will be noted at the top of the box. It is recommended to use the "Bicubic Sharper" algorithm for downsizing images and "Bicubic Smoother" for enlargement. While downsizing an image is not problematic to image data, extreme care should be taken in the enlargement process, as upsizing stretches and dilutes the pixel information. The finite information and number of pixels available can only be stretched and diluted so much before the image begins to deteriorate, and the underlying pixel structure becomes increasingly visible.

Notice the two size adjustments below. "Resample Image" is unchecked and both adjustments have different heights, widths and resolutions, but the total file size of each is the same (indicated at the top of the box next to "Pixel Dimensions").

With the Resample box checked, you alter the number of pixels that make up the image. Notice the total file size change indicated next to "Pixel Dimensions" with the "Resampled" adjustment: 11.7 MB of actual image data increased to 202.7 is a lot of diluting! For the highest quality reproduction it is best to output images at their native file size. If upsizing is absolutely necessary, it is best to never exceed a 20–30% increase, and that is still pushing it.

Image size and scanning

One of the most important factors in scanning an image or a negative is determining the final size you wish to achieve for output. If you plan on having multiple output versions for the web, inkjet print, film recorder, Iris, etc., the image should be scanned at the largest optical resolution the scanner can produce, and then downsized with various version sizes to achieve the image size variance necessary for each output purpose.

Calculating the file size with Photoshop

Photoshop has a built-in calculation that can determine file size for you. In Photoshop, go to the File Menu > New. Next, type in the width and height dimensions of the image you would ultimately like to print and the resolution of your output device. Set the mode to RGB. The MB file size that is shown once these fields are entered is your approximate target file size for an 8-bit image. For maximum quality, we recommend doubling this number and scan in 16-bit. Also keep in mind the true aspect ratio of your image capture, and be mindful of the possibility of cropping the image when entering standard print dimensions such as 8 × 10, 11 × 14. (See "Scanning Capture: an Overview", page 64 for more details on scan sizing.)

As of CS4, Photoshop has broken free of the 30k pixel barrier. The only size limitation is that governed by the OS itself.

Lightroom did have a prior limit of 10k and has now reached the 30k barrier.

DPI (dots per inch). Refers to the resolution of a printing device.

PPI (pixels per inch). Describes the digital, pixel resolution of an image.

Output Devices and Resolution Requirements

Device	DPI
Inkjet Printers	180–480, 240 is a good average; best for prints 11 × 14 and larger *8 × 12 prints and smaller* *360–480 optimal*
Dye Sublimation Digital Printers IRIS, CMYK prepress,	300
LightJet	5000
Film Recoders	2000
Web	72–96

263

II. Softproofing

Softproofing is a technique used to simulate on your monitor what your image will look like when it is printed, before actually printing the image. Softproofing will show you potential shifts in color, contrast and tonality that will result from the printer, paper, ink and profile combinations chosen for output. I call this the "reality checker" because it can show you a great deal about the differences you will see as the image is translated from the illuminated monitor to various papers with individual profile settings. In the long run this feature can save you lots of money in ink and paper because you are instantly able to see changes that may disappoint you in comparison to what you are seeing on the monitor, and afford you the opportunity to go back to your digital darkroom and make modifications to the image based on the softproofing previews.

Photoshop offers a softproofing feature in the Print dialog window with Match Print colors and show Paper White checkboxes, or simulate a full-screen softproof under the View menu in Photoshop.

For full-screen Softproofing in Photoshop CS4

1. **Go to View > Proof Set Up > Custom**

2. **Specify the correct profile for the desired printer and paper.** Turn the Preview button on and off to see the difference between what your monitor displays, and what you will actually see from the printer.

Note:
This feature necessitates an accurate ICC profile for both the monitor and for the output device.

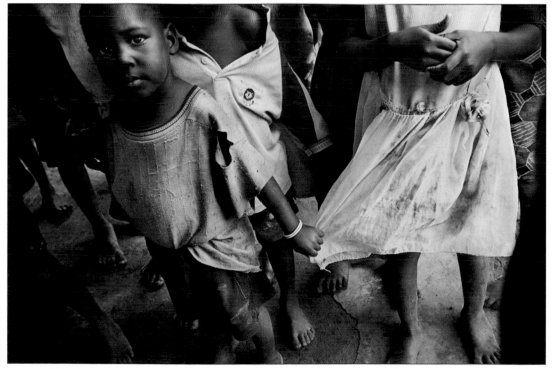

Customize Proof Condition

Custom Proof Condition: Custom

Proof Conditions
Device to Simulate: Pro38 VFAP
☐ Preserve RGB Numbers
Rendering Intent: Perceptual
☑ Black Point Compensation

Display Options (On-Screen)
☑ Simulate Paper Color
☑ Simulate Black Ink

OK
Cancel
Load...
Save...
☑ Preview

3. **Go to View > Gamut Warning** to see what colors in your image are or are not reproduceable with the paper, ink and printer selections chosen. The colors that are not printable, or are "out of gamut", will be represented with gray.

© Leslie Alsheimer

4. **Preserve Color Numbers** to simulate how the document will appear without converting colors from the document space to the proof profile space. This simulates the color shifts that may occur when the document's color values are interpreted using the proof profile instead of the document profile. Usually leave this deselected.

Simulate paper color

To preview, in the monitor space, the specific shade of white exhibited by the print medium described by the proof profile.

Simulate ink black

To preview, in the monitor space the actual dynamic range defined by the proof profile. Selecting this option automatically selects the Simulate Black Ink option.

If you are not happy with the results, tweak the file Before printing

1. Duplicate the file. Go to Image Menu > Duplicate.

2. Softproof the duplicate (not the original).

3. Create adjustment layers to compensate for unwanted results. Use these adjustment layers for printing the image to the specific printer/paper/ profile combination chosen. Only out of gamut colors cannot be further saturated to achieve intensity; however, adding contrast will make the image appear more luminous.

4. Archive these adjustments in a layer group, named for the specific output.

III. Sharpening

Sharpening overview

Determining the correct sharpening technique for your images is always a difficult task. There are many advanced techniques for sharpening that include using the Find Edges filter, sharpening in channels, high pass sharpening, smart sharpen and many third-party plug-ins. Different output devices and print mediums require different amounts of sharpening, and that amount is based on image content and file size. Sharpening is the last thing you do before printing. Dodge and Burn, retouch, make image adjustments and corrections, and size the image for output before you sharpen your image. Sharpening is best achieved on a separate merged layer or duplicate layer.

Photoshop: Unsharp Mask overview

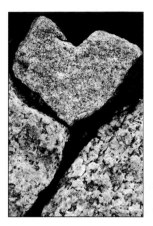

Using the Unsharp Mask filter is the simplest way to sharpen up your images. It works by increasing the contrast along edge lines, thus giving the impression of a sharper image. Other methods include the High Pass Filter method and the Smart Sharpen tool.

The Basic Method

1. Always zoom into 100%.

2. Choose Filter > Sharpen > Unsharp Mask.

3. Choose an amount, radius and threshold.

Amount:
Controls the intensity of the sharpening applied to the image. The higher the amount the greater the sharpening effect will be. Be careful, too high a setting will create halos around high contrast areas. Different output devices and print mediums require different amounts of sharpening.

Radius:
Affects the distribution of the sharpening effect. Determines how far out Photoshop looks to determine the width of edge contrast increase. The setting you choose will depend on the subject matter and the size of your output.

Threshold:
Controls which pixels will be sharpened based on how much the pixels to sharpen deviate in brightness from their neighbors. A higher setting applies the filter only to neighboring pixels which are markedly different in tonal brightness, that is edge outlines. At a lower setting, more or all pixels are sharpened including smooth continuous tones. For example, a Threshold of 5 will ignore all tones that are within 5 level values of each other. Using a setting between 3 and 6 will protect tonal similar areas from being sharpened.

Tips:

1. Sharpen at 100%.

2. Try not to sharpen skies, skin, wrinkles or high speed film grain.

3. Use Fade USM to soften filter.

4. Experiment with selective sharpening by masking out image areas that do not need to be sharp.

5. Use the preview button in the USM dialog box.

267

High Pass filter method

The Method

1. Duplicate layer to be sharpened.

2. Change the blend mode of the duplicate layer to Hard Light or Soft Light.

3. Filter > Other > High Pass (recommended values of 1–10).

4. If sharpened too much, reduce duplicate layer's opacity (globally or locally). This is definitley a technique where less is more!

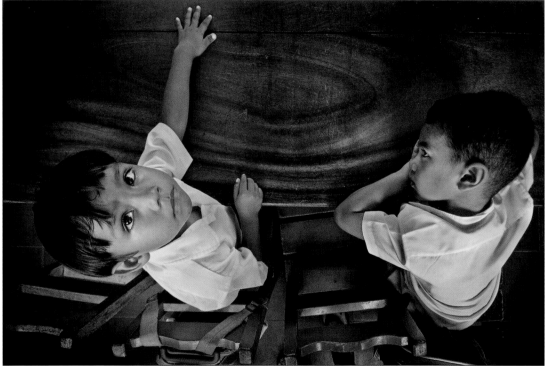

© Leslie Alsheimer

Smart Sharpen

Smart Sharpen was introduced in Photoshop CS2 to provide a modern tool for a common problem and to solve a number of issues with the aging and counterintuitive (to many) Unsharp Mask. Smart Sharpen's advantages over Unsharp Mask are numerous:

- Superior algorithms: while Unsharp Mask combats Gaussian Blurs, Smart Sharpen offers, too, the ability to sharpen Lens Blur and Motion Blur.

- Accuracy: Smart Sharpen has an option to apply multiple iterations, thus assuring more accurate results.
- Less Halos: Unsharp Mask shows ghosting or "halos" around contrasted edges when used with strong settings, whereas Smart Sharpen, on the other hand, allows for selective sharpening control in the shadows and highlights, virtually eliminating halos.
- A larger preview: details are everything when sharpening, and with a larger preview comes more detail.
- The ability to save and load settings: whether it means saving steps or sharing settings, this feature makes huge strides in workflow productivity.

A closer look at Smart Sharpen

As of Photoshop CS3, sharpening can be done non-destructively! First navigate to the Filter menu and select "Convert to Smart Filter". Now you have a filter layer and can change or turn off parameters at any time. No more saving various versions for preview, print and web!

1. Navigate to Filter > Sharpen > Smart Sharpen.

2. For photographs, the Default target of Lens Blur removal is best.

3. For superior results, always be certain to check "More Accurate".

4. While previewing at 100%, move Amount slider to desired level.

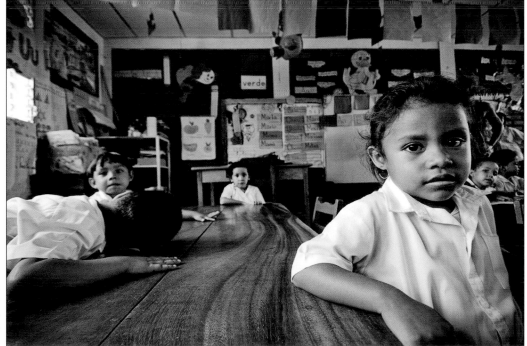

© Leslie Alsheimer

skills. The best rendering intent will be the one that looks the best to you. You can select a rendering intent when you set color conversion options for the color management system, softproof colors and in the print dialog interface.

Adobe Defines Rendering Intents as Follows:

Perceptual: The goal of this intent is to preserve the visual relationship between colors, so it is perceived as natural to the human eye, even though the color values themselves may change. This intent is suitable for photographic images with lots of out-of-gamut colors. This is the standard rendering intent for the Japanese printing industry.

Saturation: Attempts to produce vivid colors in an image at the expense of color accuracy. This rendering intent is suitable for business graphics like graphs or charts, where bright saturated colors are more important than the exact relationship between colors.

Relative colorimetric: Compares the extreme highlight of the source color space to that of the destination color space and shifts all colors accordingly. Out-of-gamut colors are shifted to the closest reproducible color in the destination color space. "Relative colorimetric" preserves more of the original colors in an image than "Perceptual". This is the standard rendering intent for printing in North America and Europe.

Absolute colorimetric: Leaves colors that fall inside the destination gamut unchanged. Out-of-gamut colors are clipped. No scaling of colors to destination white point is performed. This intent aims to maintain color accuracy at the expense of preserving relationships between colors and is suitable for proofing to simulate the output of a particular device. This intent is particularly useful for previewing how paper color affects printed colors.

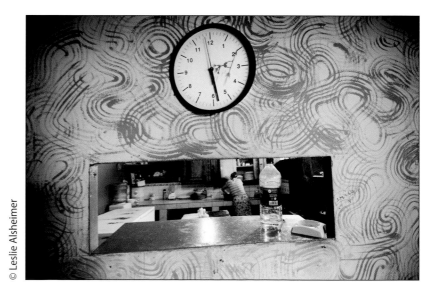

© Leslie Alsheimer

Method 1: Photoshop managed color

After you have sized and softproofed the image appropriately for output, go to the File menu and choose > Print. Best practice is to follow the dialog box top down, left column first and then the right column.

Printer: EPSON Stylus Pro 3800

Step 1: Choose your printer from the print drop-down menu.

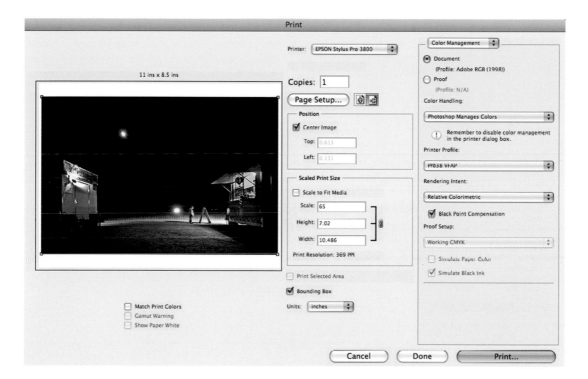

Step 2: Set resolution and image size according to output preference. Center and scaling preferences can be set from the output settings drop-down menu at the top right of the dialog box. (See "Set Image Size and Resolution", page 260, for more details.)

Step 3: Softproofing options can be toggled on or off by checking and unchecking the boxes. This is a softproofing feature built into the print dialog box in CS4 to simulate how the image will print on the chosen paper with the chosen profile. WAY COOL CS4! (See "Softproof," page 27, for more information.)

Note:
"Photoshop manages colors" must be checked for this feature to work.

Step 4: On the right side of the box at the top, select "Output" from the Color Management drop-down menu. Here you will be able to select "Send 16-bit data", fix other output settings such as bleeds, background, and borders separately and return to color management. If your printer manufacturer supports high-bit printing, check "16 Bit Output". The latest Epson and Canon Plug-In drivers have this option already (at least on Mac Leopard systems). 16 Bit Output will deliver smoother tones, transitions, gradients, shadows, midtones, and highlights will print with more visible detail, fabulous additions for fine art black and white print making.

Step 5: Color Handling. With this method, choose Photoshop Manages Colors. CS4 will give you a friendly reminder to disable the printer color management. Thanks Adobe!

Color Handling:

Photoshop Manages Colors

⊙ Remember to disable color management in the printer dialog box.

Pro38 ARMP
Pro38 EMP
Pro38 PGPP
Pro38 PLPP
Pro38 PPSmC
Pro38 PQUP_MK
Pro38 PSPP
Pro38 SWMP
Pro38 SWMP_LD
Pro38 USFAP
Pro38 VFAP
Pro38 WCRW
Pro3800 3800C 3850 Standard

Step 6: Pick the Printer Profile. Specify the appropriate printer, paper surface and ink set. Your print driver should have installed profiles for the manufacturer's papers and inks. It is always best to stick with the same brand of printers, papers and inks in order to use the given profiles with best results. Custom profiles produce much greater results, however they can be timely and expensive. (See "Papers and Profile", page 256.)

Printer Profile:

Pro38 VFAP

Step 7: Experiment with rendering intents. "Relative colorimetric" and "Perceptual" will most likely produce the most pleasing results. The best choice will depend on the image and profile. (See "Rendering Intents", page 271 for more details.)

✓ Perceptual
Saturation
Relative Colorimetric
Absolute Colorimetric

Rendering Intent:

Perceptual

Step 8: Click "Print". This should exit the Adobe print interface and launch the operating system print interface.

Step 9: Click on "Copies and Pages" and drop down to choose "Print Settings".

1. Choose Media Type.

2. Make sure the Advanced mode is chosen. Choose Photo 1440 or Superphoto 2880 for larger final prints. (For proof prints it is not necessary to waste the ink with 2880 as the difference is not easily discernible.)

3. Choose "Print Quality".

Step 10: Return to the Print Settings drop-down menu and click it again. This time choose the next interface "Color Management".

Color Management

Since Photoshop will be handling color, we need to turn off the printer's color management system here, by clicking "No Color Adjustment".

Layout
Paper Handling
Cover Page
Scheduler

Print Settings
✓ Printer Color Management
Paper Configuration
Expansion

Summary

○ Color Controls
○ ColorSync
◉ No Color Adjustment

Print

Printer: EPSON Stylus Pro 3800
Presets: Last Used Settings

Copies: 1 ☑ Collated
Pages: ◉ All
○ From: 1 to: 1

Printer Color Management

○ Color Controls
○ ColorSync
◉ Off (No Color Adjustment)

? PDF ▾ Preview Supplies... Cancel Print

Step 11: Now you can click "Print".

Print

Method 2: Printer Managed Color

This approach typically produces more neutral results with older model Epson printers. Experiment with your printer to see which method does a better job!

Depending on your printer, printing neutral black and white images on a color printer can be a tricky task. Here are a few changes in the print driver options that sometimes achieve better results.

Step 1: Before you go to print, duplicate your image and convert to Grayscale mode: Image > Mode > Grayscale

◉ Document (Profile: Gray Gamma 2.2)

Step 2: Choose File > Print

Make sure that the Print Document space is in Gray.

Print

8.5 ins x 11 ins

Printer: EPSON Stylus Pro 3800

Copies: 1

Page Setup...

Position
☐ Center Image
Top: 0.236
Left: 0.625

Scaled Print Size
☐ Scale to Fit Media
Scale: 92%
Height: 10.139
Width: 6.93
Print Resolution: 260 PPI

☐ Print Selected Area
☑ Bounding Box

Units: inches

☐ Match Print Colors
☐ Gamut Warning
☐ Show Paper White

Color Management
● Document
 (Profile: Gray Gamma 2.2)
○ Proof
 (Profile: N/A)
Color Handling:
Printer Manages Colors

(!) Remember to enable color management in the printer dialog box.

Printer Profile:
Pro38 VFAP

Rendering Intent:
Perceptual

☐ Black Point Compensation
Proof Setup:
Working CMYK

☐ Simulate Paper Color
☑ Simulate Black Ink

Cancel Done Print...

Step 3: Choose your printer from the Print drop-down menu.

Printer: EPSON Stylus Pro 3800

Step 4: Set resolution and image size according to output preference. Center and scaling preferences can be set from the output settings drop-down menu at the top right of the dialog box. (See "Set Image Size and Resolution", page 260 for more details.)

Scaled Print Size
☐ Scale to Fit Media
Scale: 100%
Height: 8.145
Width: 12.562
Unit: inches
Print Resolution: 240 PPI

277

Step 5: On the right side of the box at the top, you need to make sure that "Color Management" is active from the drop-down menu. Fix your output settings separately and return to color management.

Step 6: Color Handling. Set to Printer Manages Colors. Photoshop offers a nice friendly reminder to be sure to enable color management in the printer dialog.

Step 7: Select your rendering intent. Remember to experiment with different choices.

Step 8: Click on "Copies and Pages" and drop down to choose "Print Settings".

1. Choose Media Type.

2. Make sure the Advanced mode is chosen.

Choose Photo 1440 or Superphoto 2880 for larger final prints. (For proof prints it is not necessary to waste the ink with 2880 as the difference is not easily discernible.)

Step 9: Return to the Print Settings drop-down menu and click it again. This time choose the next interface "Color Management".

Step 10: Set to color controls: Photo Realistic for older models, and Adobe RGB for newer models, with a gamma setting of 2.2.

Step 11: Click "Print".

Method 3: No Color Management!

Among the latest technological advances in black and white printing, Epson's Advanced Black and White Mode is worth mentioning. The Epson driver can now take color or grayscale files and use its three black inks predominantly mixed with small amounts of the remaining colors. The advantage is greater longevity (as the black inks are carbon based), greater dmax capabilities, and a print more neutral than ever before!

After you have sized and softproofed the image appropriately for output, go to the File Menu > Print. Best practice is to follow the dialog box top down, left column first and then the right column.

Step 1: Choose your printer from the print drop-down menu.

Printer: [EPSON Stylus Pro 3800]

Step 2: Set resolution and image size according to output preference. Center and scaling preferences can be set from the output settings drop-down menu at the top right of the dialog box. (See "Set Image Size and Resolution", page 260 for more details.)

Output

Scaled Print Size

☐ Scale to Fit Media

Scale: 100%

Height: 8.145

Width: 12.562

Unit: inches

Print Resolution: 240 PPI

Step 3: On the right side of the box at the top, you need to make sure that "Color Management" is active from the drop-down menu. Fix your output settings separately and return to color management.

Color Management

Print...

Color Handling:

No Color Management

⚠ Remember to disable color management in the printer dialog box.

Step 4: Click "Print". This should exit the Adobe print interface and launch the operating system print interface.

Step 5: Click on "Copies and Pages" and drop down to choose "Print Settings".

1. Set Page Setup: it is best to use the Manual Rear setting for heavy fine art papers.

2. Set Media Type: select the type of paper you are printing on.

3. Color: choose Advanced B & W Photo.

4. Select the Advanced radial button and choose a print quality setting, SuperFine-1440 dpi, or SuperPhoto-2880 dpi for larger final prints.

Copies & Pages

✓ Print Settings
 Printer Color Management
 Paper Configuration
 Expansion

Media Type
Color Color
Mode ✓ Advanced B&W Photo
 Black

Print

Printer: EPSON Stylus Pro 3800
Presets: Standard
Copies: 1 ☑ Collated
Pages: ⦿ All
 ○ From: 1 to: 1
 Print Settings
Page Setup: Manual – Rear
Media Type: UltraSmooth Fine Art Paper
Color: Advanced B&W Photo
Mode: ○ Automatic
 ○ Custom
 ⦿ Advanced Settings
Print Quality: SuperFine – 1440dpi
 ☑ High Speed
 ☐ Flip Horizontal
 ☑ Finest Detail
Color Toning: Neutral
⚠ Print quality in the bottom area may decline or the area may be smeared.

? PDF ▼ Preview Supplies... Cancel Print

5. Check finest detail.

6. Color Toning: begin with Neutral for black and white; experiment with other toning options here for cool, warm or sepia.

Step 6: Click on "Copies and Pages" again, and drop down to choose "Printer Color Management".

The tone settings and color toning options will require some experimentation if you choose to tone using this method.

Under the tone settings there are several options, listed as Darkest, Darker, Dark, Normal and Light. These are basically gamma adjustment settings. You will want to experiment with the choices to find the best settings for your images. However, try starting with the Dark setting for a gray gamma of 2.2 and Darker for a gray gamma of 1.8.

Color toning options in this interface are relatively limited, and the toning is applied uniformly over the entire image. The choices include Neutral, Cool, Warm and Sepia. The neutral setting may be more or less neutral depending on the media and profiles. The color wheel at the bottom of the dialog allows for fine-tuning the color tint applied to the image.

Method 4: Plug-In, Monochrome Photo Mode, Specific for new Canon professional Printers

Also worth mentioning among the latest technological advances in black and white printing are Canon's new imagePROGRAF professional printers with Plug-In. The black and white output from these printers is impressive and shows excellent detail on most media types, finally giving Epson some competition in the black and white arena. The monochrome photo mode will produce neutral, high quality monochrome images with the primary use of the Black, Gray and Photo Gray inks. This mode helps to ensure minimal shifts in color that are commonly caused by the use of color inks in black and white prints, thus outputting neutral tones with smooth gradation.

All Canon imagePROGRAF printers print through a standard driver or through a Print Plug-In from Photoshop. The Plug-In offers many great benefits, including increased image quality with 16-bit image rendering, whereas the standard driver offers only 8-bit, and ease of use as there are a lot less clicks involved to execute a print. The Canon Plug-In also eliminates the common mistake of double color management (when color management is enabled in both Photoshop and the print driver, causing serious color problems) by automatically disabling the printer's color management. Very cool.

V. Tweaking

This is actually the heart and soul of the fine art print making process. The process of tweaking occurs after you have followed all of the previous steps and suggestions in the printing workflow, with specific attention to color management, and you are still not completely happy with the results. Remember, your first print will be for evaluative purposes. It may take several prints, over the course of many long work sessions to realize your aesthetic vision in its final portfolio piece format. As we learned with color management, the system is imperfect and the key to the inkjet output process is reducing the number of variables through a color managed system, and the rest is all in the tweaking! Just as we controlled the variables of temperature and dilution as consistently as possible in the traditional darkroom, made a print, studied it and made changes again and again until we were aesthetically pleased with the results, the digital darkroom is no different.

You will need to go back to your working file and use your digital darkroom processes, tools and skills to make additional changes based on the look and feel of the print. Typically, prints translate darker than the monitor portrays the image, because monitors transmit light while ink on paper reflects light, and reflective light is darker than transmitted light. Make sure to evaluate the print under the correct lighting source in which the print is intended to be viewed, that is, not the kitchen fluorescent. Bring the image back into Photoshop to make digital darkroom adjustments and corrections, and repeat the entire process until you are satisfied with the results. Tweaking is really the art of the fine print, the extra attention that makes a print worthy of the portfolio or exhibition.

B. Printing from Lightroom

The Print Module in Lightroom offers the creative user a wonderful variety of options for image output. From a potpourri of quick and easy contact sheets, picture packages, and page layout presets, to the ability to create and save your own layouts, borders and image overlay integrations – Lightroom is not only easy, but also offers an abundance of creative options.

Lightroom Print Module

Print

While Lightroom has many quick and easy user-friendly features, worth discussion, there is only so much that the fine art printer can do in the Print Module without needing to move the image over to Photoshop. A few major drawbacks to printing from Lightroom include RGB-only printing, lack of sharpening control, and the inability to softproof your images prior to printing. Hopefully, these issues will soon be addressed, but until such time my recommendation for highest quality output, with the greatest amount of control, is to export and print from Photoshop as previously outlined.

Overview of Features

The main window previews your layout and interactively allows you to click inside the image grid lines and dynamically set the print layout upon the page visually.

The Template Browser: the Lightroom Print Module interface is fairly straightforward. The left panel contains the Preview window and

Template Browser as well as the Add and Remove buttons for saving and removing printing templates. The default templates are very useful, including the three contact sheet templates. If you mouse over the templates, you will get to see a preview of the corresponding layout in the preview window above them. You can also create your own templates and arrangements. Play with different creative layouts by editing the columns, rows and cell spacing.

The right side of the Print Module is laid out in six phases, containing the Layout engine, Image settings, Layout, Guides, Overlays and the Print Job interfaces.

Layout engine

In the Layout engine, you can design a contact sheet to catalog all your images from a shoot, make creative layouts, tryptics, or even a picture package with several sizes of the same image on a sheet. Lightroom even provides a cutlines feature! These are incredible powerful and useful components of Lightroom.

While you could always put multiple copies of an image on a single page in Lightroom, "Picture Packages" now allows you the ability to put different size images on the page with a simple mouse click. It comes with six presets for common sizes, and you can edit any of these for custom sizes if needed. As you add more images to the layout, Lightroom will automatically add pages as needed.

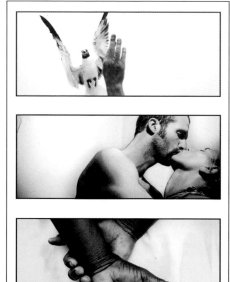

© Leslie Alsheimer

© Leslie Alsheimer

Image Settings

Image Settings ◄

The Image Settings dialog is easy to follow. Work top down and play a little with each function and you will get the hang of it all in no time!

The "Zoom to Fill Frame" does exactly what it says and fills the frame of whatever template you have chosen.

The Auto-Rotate to Fit function will rotate the image to fit the frame. Lightroom only displays paper in a vertical layout.

The Repeat One Photo per Page function allows you to print out the same image multiple times on one sheet of paper.

Stroke Border: this feature allows you to add a simple border around your image. The Border width is easy to adjust with the slider.

Layout

Layout ◄

The Layout dialog addresses the Margins, Page Grid, Cell Size, Spacing and Guides.

There is a toggle arrow next to Ruler Units that allows you to choose centimeters, millimeters, points or picas instead of inches.

The Margins sliders are a nice addition to help setting up your pages. You can also work interactively in the image window and grab the guides with your mouse and move them dynamically, which will simultaneously move the Margin sliders for you.

With the Page Grid sliders, you can adjust how many images fit on a page. This is a great feature for customizing contact sheets. "Cell Spacing" adjusts the spacing between the images in the grid, and the Cell size adjusts the size of each cell in the grid layout. You can also constrain them to a square cell by checking the Constrain to square box.

The Show Guides section toggles the guides on and off. It also allows you to turn on or off the Page Bleed, Margins and Gutters and Image Cells guides as well.

Overlays

The Overlays dialog includes options to add an identity plate, watermark, page options, photo information, font size, borders, page numbers, crop marks and much more.

To create an Identity plate, click on the checkered box and the Custom plate flyout menu will appear. Click on the display name in the gray grid and choose "Edit" to select font sizes, and type whatever you want. You can also adjust the opacity and scale of the Identity plate, and select if they will be printed on every image or behind the images. Check "Use a graphical identity plate" to add a logo or custom file.

The Page Options dialog allows even more custom features. Here you can add page numbers, page information and crop marks to your image.

© Leslie Alsheimer

leslie alsheimer
PHOTOGRAPHY

lesliealsheimer.com

The Photo Info dialog allows the addition of any combination of metadata including filename, date, exposure, equipment, rating, title, caption, copyright or keywords. Just below these checkboxes, you can also adjust the font size for this information as well.

Print Job

The Print Job dialog is where we deal with the Printing mode, resolution, sharpening and color management.

A great new feature to Lightroom is the ability to print directly to a JPEG file rather than the printer, and set not only the file size, but also specify the color management options so you can embed a profile if you need to. This is a great new feature that will really appeal to anyone that uses a lab or the web for printing.

Draft mode printing is as easy as checking the box.

Print resolution is changed just by clicking on the dpi box and typing in a new resolution.

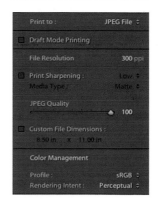

"Print Sharpening" allows you to add rudimentary sharpening to your image with little control. The options are low, standard and high. My best recommendation is to uncheck this box for no additional sharpening, as you will not be able to see how much sharpening any setting applies, nor the effects until you print the image. This is certainly one of the larger downsides of printing from Lightroom.

If your printer manufacturer supports high-bit printing, check "16 Bit Output". The latest Epson and Canon Plug-In drivers have this option already (at least on Mac Leopard systems). 16 Bit Output will deliver smoother tones, transitions, gradients, shadows, midtones, and highlights will print more visible detail.

Set Your Print Driver for Color Managed Output
Color Management

Method 1: Color Managed by Printer

Just as with the Photoshop techniques previously illustrated, we can also approach the print output using the Printer Color Management in Lightroom.

In the Print Job panel, by default the Color Management setting is set to "Managed by Printer". Many printer drivers seems to have problems properly accepting Lightroom's color output.

After choosing "Color Managed by Printer", Lightroom will gray out your options for choosing a rendering intent, and provide a friendly reminder to remember to turn on the printer color management controls once you hit "Print".

At this point you will exit Lightroom and enter the Operating System interface.

Continue to pages 290–291 for print settings in the OS.

Method 2: Color Managed by Other: Profile

Most of Lightroom's Print Module features are fairly self-evident. Our greatest concern here is in the color management portion at the bottom of the interface. There are several important considerations and dropdown selections that must be made correctly in this module in order to get a print that looks anything like what you see on the monitor.

In the Print Job panel, by default the Color Management setting is set to "Managed by Printer". Move to the bottom of the interface to the Color management box. Click on the drop-down next to profile and choose "Other".

When you select "Other", Lightroom will show you a listing of all output profiles currently installed on your system. Be sure to place a checkmark by the best

choice for your specific printer, paper and ink output selection. I am choosing Epson Ultra Smooth Fine Art with MK inks for a 3800.

Lightroom offers a nice reminder to remember to turn off color management in the Print dialog before printing. It also comments that black point compensation will be used for this print.

When selecting a custom profile, remember to turn off printer color management in the Print dialog before printing. Black Point Compensation will be used for this print.

Next, choose a rendering intent. There are only two choices in Lightroom: "Perceptual" and "Relative colormetric". Experiment with both (see "Rendering Intents," page 271, for more information).

Move down to the print settings in the drop-down menu. At this point you will hit the Print button, exit Lightroom and enter the Operating System interface. Follow Steps 9–11 for Photoshop Managed Color, pages 275–276.

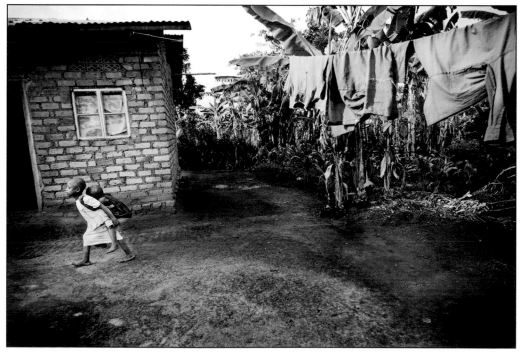

© Leslie Alsheimer

Print Settings for Macintosh

Many printer drivers seem to have problems properly accepting Lightroom's color output another good reason to print from Photoshop if you can.

Once you've told Lightroom to use the proper profile for your printer, paper and ink selection, you will next need to choose the print driver specific settings based on the Operating System you are running. The settings outlined below are for OS X 10.4.x. The Windows settings are outlined on the following page.

Once you click on "Print" in the Lightroom Print Module you will be choosing settings based on the Print driver and Operating System. Follow Steps 9–11 for Photoshop Managed Color, pages 275–276.

Remember, in the Print Settings drop-down under "Media Type" be sure to select the appropriate type of paper you will be printing on. I chose "Velvet Fine Art Paper". Which selection you make will depend on the printer you are using.

Next, in the Print Settings drop-down, under Advanced Settings, select either 1440 or 2880. The profiles can be used for either, but they were designed to provide maximum quality when using SuperPhoto 2880 dpi. If you have properly run the auto-align procedures for your printer, you will have the option to print the highest quality even in High Speed mode, thus making your printer capable of printing 2X the speed than if printing in Uni-directional mode. Otherwise, it is best to uncheck "High Speed".

Under the Printer Color Management drop-down, be sure to click on the "Off (No Color Management)" option.

There is an issue with Apple's ColorSync and Lightroom where the ColorSync will automatically mis-apply a "generic RGB" profile if the printer you are printing to is not set as the "default" printer in OS X 10.4.x. This will result in unwanted modifications of certain colors, particularly reds and skin tones. As long as the current printer is set as the default printer, this issue can be avoided.

To set your chosen printer as the default printer in Printer Setup Utility, select the printer and click on the Make Default button.

Print Settings for Windows

Once you've told Lightroom to use the proper profile for your printer, paper and ink selection, you will next need to choose the print driver specific settings based on the Operating System you are running. The settings below are for Windows XP and Vista.

Once you click on "Print" in the Lightroom Print Module you'll be in the Printer driver. In the Main panel of the Properties dialog, be sure to select the appropriate paper type, such as "Premium Luster Photo Paper" or "Enhanced Matte". Which selection you make will depend on the printer and output media you are using. Click on the "Advanced" button to make further selections.

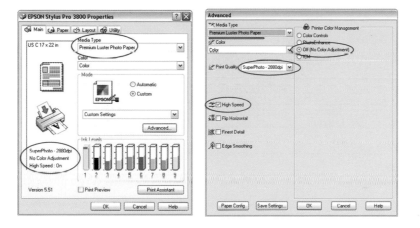

In the Advanced dialog box, be sure to select "Off (No Color Adjustment)" in the Printer Color Management section. The profiles can be used for either 1440 or 2880, but they were designed to provide maximum quality when using SuperPhoto 2880 dpi. The profiles can be used for either, but they were designed to provide maximum quality when using SuperPhoto 2880 dpi. If you have properly run the auto-align procedures for your printer, you will have the option to print the highest quality even in High Speed mode, thus making your printer capable of printing 2X the speed than if printing in Uni-directional mode. Otherwise, it is best to uncheck High speed.

Lightroom Printing Templates Mac and PC

To make printing easier and less error prone in Lightroom, I strongly encourage making printing templates. Whenever you change anything in the Lightroom Print Module, you will see your saved template will be dimmed, meaning that the current template is no longer active. If you wish to save all the current settings in the template, you will want to CTRL-click (Mac) or right-click (PC) on the template and choose "Update With Current Settings".

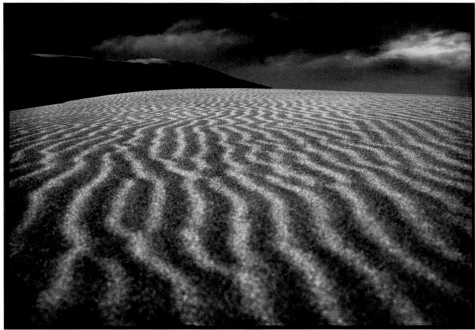

© Leslie Alsheimer

AFTERWORD

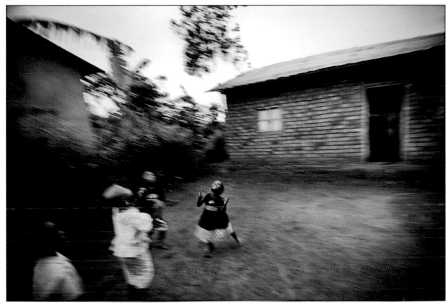

© Leslie Alsheimer

Since its inception, the photographic medium has been in an almost constant state of metamorphosis while developing into a legitimate art form. In 1839, when photography was first introduced, many artists of the time were fearful, disputed the medium, and even prophesized, that photography would signal the end of painting as an art form altogether. The evolution of color photography in the early 20th century placed the established traditional monochromatic image in direct conflict with the newly introduced polychromatic image again challenging the integrity of the newer medium. Of course, as history has shown, photography never replaced painting, and color was eventually accepted and valued for the new and exciting dimension it added to the artistic photograph. Over 150 years later, color, black and white, daguerreotype, wet plate collodian, calotype, and the many other photographic processes that have come since, have survived and have found their place, separately, as valid and accepted forms, all within the singular medium of photography.

Change is inevitable and photography does not stand outside of that axiom. Today, the contemporary photographer has a choice whether to maintain a traditional "film is better" stance, ride the digital wave, or assimilate the strengths of either to any varying degree. Recognizing the history and understanding the growing pains in photography in making that choice will serve us all well as the medium continues to evolve and transform for the better.

It is our hope that this text will have illustrated that both film and digital have many rich and disparate characteristics – each with its own set of strengths and weaknesses – and yet can still complement one another quite well in the photographic process. Utilizing their combined strengths, the contemporary black and white photographer now has a quiver of tools that serve to broaden the artistic options at his or her disposal.

During the civil war era, John Moran debated whether photography itself could be considered an art form. He proposed that the essence of art is the stimulation of an emotional response by the viewer. Moran suggested that the standards of art by which photography could be tested were "its ability to imitate present truth and communicate beauty". This broad definition of art does not exclude on the basis of technique, but rather values the end product and its ability to stimulate response. Both traditional photography and its digital form most certainly fall within this definition.

So, with that, we hope you will put down the book, pick up your camera and go out shooting. After all, isn't it the images that really matter?

Happy image making!
With every good wish,
Leslie and Bryan

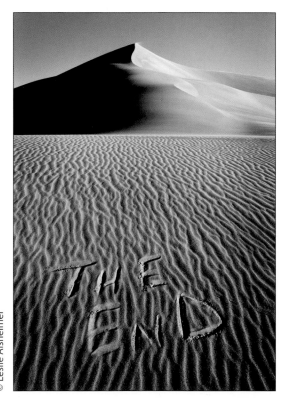

© Leslie Alsheimer

ABOUT THE AUTHORS

LESLIE ALSHEIMER

Leslie Alsheimer is an internationally published and award winning photographer, author, and photo-educator based in Santa Fe, New Mexico. She was recently honored at Photoshop World 2008 as a NAPP Photoshop GURU Award recipient, with the Vincent Versace Award for Photographic Excellence. Leslie is most known for her documentary projects with non-profits & NGOs addressing the human condition worldwide. Her work – spanning editorial, fine art and documentary genres – has appeared in the Corcoran Gallery of Art as well as numerous books and publications including *PDN*, *Nikon World*, *Focus Santa Fe Arts*, and *Outside* magazines.

Through a forward and positive focus, Leslie's fine art vision incorporates light, technique, and technology into a unique style rooted in a passion for creating images that parallel and interconnect her work as a social worker and her vision of the human spirit. Leslie's deeper perspective documentary essays were recently awarded and published in *National Geographic Traveler* and PDN magazine's "World in Focus" competition, and received two Honorable Mention LUCIE Awards at the 2008 International Photography Awards.

As the Founder and Director of the Santa Fe Digital Darkroom Photographic Workshops & Tours, and an instructor with the Nikon Mentor Series, American Photo, and Eddie Adams Workshops, Leslie works as a photo-educator, mentor, organizer, and host for personalized photography workshops, and photographic journeys around the globe. Leslie's knowledge and expertise of both traditional and digital photography allows her to design programs that inspire photographers and artists to develop new ways of seeing, create a signature style, market and brand their work, and realize creative projects and goals.

Leslie believes in using photography to help empower others to find their own creative voice and vision. Inspired by a traditional wet darkroom teen photography program that she developed, and directed for a non-profit organization's gang diversion program, Leslie served as the creative director of the published social documentary book, *Reality from the Barrio*. The book was honored in the PDN Photography Annual 2003 Best Photos of the Year and became a thesis project for Leslie's master's degree in social work.

Combining her love for photography and background in social services, Leslie also developed Community Photography Outreach, a project-based, non-profit organization, collecting and disseminating donated cameras to organizations and programs in need, and Forward Focus: Photography and Workshops with Creative Purpose, a pioneering organization for experienced and emerging photographers who want to use imagery to help promote developmental, environmental and relief efforts worldwide.

Leslie can be found on the web at: www.lesliealsheimer.com and www.santafedigitaldarkroom.com.

Photo by: Kelly Castro
http://www.flickr.com/photos/kelco/

BRYAN O'NEIL HUGHES

Bryan O'Neil Hughes fell in love with photography when he was only seven years old. He began collecting cameras and experimenting with the medium anywhere he found himself; from his mother's office parties to the sprawling Carmel Valley ranch he grew up on. Bryan was a teacher's assistant in his photography courses throughout high school, and could always be found working in the darkroom.

After school, Bryan began a lifelong passion for world travel, and he would venture overseas with little more than a camera, film and backpack. Upon returning to the States, he worked in the high-end photo retail environment: from custom prints, to framing, to sorting, to sales and even repair, Bryan has always had an insatiable appetite for anything related to photography. Hoping to combine a passion for racing cars with his love for photography, Bryan shot professionally for a brief time. When he began to notice that both passions were waning, he looked to the future. In 1996, upon seeing Photoshop 4.0 demonstrated at Seybold, Bryan knew what he wanted to do with his life.

Bryan O'Neil Hughes has been with Adobe since 1999, helping to test, develop, drive and demonstrate Adobe's digital imaging applications. Bryan is a Product Manager for the Photoshop Team and Product Evangelist for the Lightroom Team. Bryan's name, energy and even photos can be found within Photoshop 6.0 forward, PhotoDeluxe 4.0, Photoshop Elements 1.0, Photoshop Lightroom 1.0 and beyond. Bryan speaks worldwide on behalf of Adobe and can often be found leading seminars and workshops.

Beyond Adobe, Bryan is a published photographer, editor and author. He still loves his time spent driving race-tracks, traveling the world over and taking photos. Bryan lives in the Santa Cruz Mountains with his wife, Alex, and son, Miles.